THE ARDUINO INVENTOR'S GUIDE

THE ARDUINO INVENTOR'S GUIDE

LEARN ELECTRONICS BY MAKING 10 AWESOME PROJECTS

BY BRIAN HUANG
AND DEREK RUNBERG

no starch
press

SAN FRANCISCO

Printed in USA

First printing

21 20 19 18 17 1 2 3 4 5 6 7 8 9

ISBN-10: 1-59327-652-4
ISBN-13: 978-1-59327-652-2

Publisher: William Pollock
Production Editors: Alison Law and Riley Hoffman
Cover Illustration: Brian Cook
Interior Design: Beth Middleworth
Photographer: Juan Peña
Illustrations: Pete Holm
Developmental Editors: Jennifer Griffith-Delgado and Liz Chadwick
Technical Reviewer: Daniel Hienzsch
Copyeditor: Rachel Monaghan
Compositors: Susan Glinert Stevens and Riley Hoffman
Proofreader: Lisa Devoto Farrell

The following image is reproduced with permission: Figure 8-1 © Richard Hall.
Circuit diagrams and schematics were created using Fritzing (*http://fritzing.org/*).

For information on distribution, translations, or bulk sales, please contact No Starch Press, Inc. directly:

No Starch Press, Inc.
245 8th Street, San Francisco, CA 94103
phone: 1.415.863.9900; info@nostarch.com
www.nostarch.com

Library of Congress Cataloging-in-Publication Data
Names: Huang, Brian, author. | Runberg, Derek, author.
Title: The Arduino inventor's guide: learn electronics by making 10 awesome
 projects / Brian Huang and Derek Runberg.
Description: San Francisco : No Starch Press, Inc., [2017]
Identifiers: LCCN 2017005801 (print) | LCCN 2017023025 (ebook) | ISBN
 9781593278397 (epub) | ISBN 159327839X (epub) | ISBN 9781593278403 (mobi)
 | ISBN 1593278403 (mobi) | ISBN 9781593276522 (pbk.) | ISBN 1593276524
 (pbk.)
Subjects: LCSH: Arduino (Programmable controller) | Electronics--Amateurs'
 manuals.
Classification: LCC TJ223.P76 (ebook) | LCC TJ223.P76 R86 2017 (print) | DDC
 006.2/2--dc23
LC record available at https://lccn.loc.gov/2017005801

TO LINDSAY DIAMOND, FOR YOUR
AMAZING LEADERSHIP AND GUIDANCE;
TO THE ENTIRE TEAM AT SPARKFUN;
AND TO ALL THE FUTURE TINKERERS
AND INVENTORS WE INSPIRE!

ABOUT SPARKFUN ELECTRONICS

SparkFun is an online retailer that produces and sells the widgets and parts that end up in a lot of maker projects, prototypes, and even the International Space Station. Nathan Seidle started the company after blowing a circuit board in 2003, while he was an undergraduate at the University of Colorado Boulder. At the time, circuit boards were really hard to get; you had to fax your credit card to another country and hope that you got your hardware in six to eight weeks. Nathan felt he could do better, and he did. SparkFun. com was born, and it now sells over 3,000 different parts of all shapes and sizes for your digital electronic needs. From a basic Arduino to GPS modules, you can find them and all of the documentation you need to get up and running at SparkFun.

SparkFun's Department of Education develops curricula and runs professional development programs for educators of all kinds. The department is at the forefront of a number of computer science and maker initiatives that are making headway in the classroom. You can learn more about SparkFun and the Department of Education at *https://www.sparkfun.com/* and *http://www.sparkfuneducation.com/*.

ABOUT THE AUTHORS

Brian Huang and Derek Runberg were both teachers at one point. Brian was a high school physics teacher with an affinity for robots, and Derek was a middle school technology teacher obsessed with pushing the limits of middle school students. They've taken very different paths to get where they are now, including how they learned programming and electronics, their teaching philosophies, and their viewpoints on how students learn, so they are a bit of an odd couple. They hope that this book will serve you well as you set off on your adventure into the world of inventing.

ABOUT THE TECHNICAL REVIEWER

Daniel Hienzsch is the founder of Rheingold Heavy, which delivers educational content and materials to electronics enthusiasts and students. He previously worked in IT for 20 years, including 10 years as the IT director for an investment bank. Dan is passionate about education, and Rheingold Heavy is his effort to provide the maker community with materials he wished he had when he was first getting started in electronics and technology. He is also a certified scuba instructor.

A NOTE FROM BRIAN

Although I am a formally trained engineer (I went to school to study electrical engineering), my education focused a lot on theory, simulations, and modeling, and I was never taught how to solder, machine, or really build things. After graduating from college, I worked as an engineer during the week, and found myself volunteering at the Science Museum of Minnesota on the weekends. It was at the museum where I discovered my love of teaching. I was given the opportunity to inspire children to be curious, ask questions, and wonder about the world. My experiences in the museum set me on a course to change careers, pursue a master's in education, and become a high school physics teacher.

Derek and I complement each other's experience and background. This book is a culmination of both of our experiences in teaching and in learning how best to use Arduino in the classroom. As Derek puts it, the Arduino is simply another material that we use in our projects. The faculty and students at NYU's Integrated Telecommunications Program (ITP) have long known this. The way you interact with electronics changes immediately when you enclose or cover them. Even something as simple as using a ping-pong ball to diffuse an LED immediately affects your interaction with the project. The way the light diffuses and blends through materials teases your emotions in a way that you wouldn't get with just an LED in a breadboard.

We've put a lot of thought into how to make learning electronics and programming accessible for anyone. We hope that these projects will help to unleash your inner inventor!

A NOTE FROM DEREK

Unlike Brian, I have no formal background in electronics or computer programming; I am completely self-taught. I learned Arduino so that I could give my students access to a technology they could control and build with. I was a middle school technology teacher asked to dream up a shop class for the 21st century. Electronics was part of that vision, and over a three-year process, Arduino (and, later, the Processing language) took center stage in my classroom. I learned electronics and programming so that I could teach it in my class.

Many of these projects come directly from my classroom experience teaching Arduino. My students learned computer science and electronics out of necessity, in order to develop their ideas rather than

have a teacher telling them "because you need to." I hope that my contribution to this book honors my students and puts electronics and programming into a format that sparks your imagination.

CONTENTS

INTRODUCTION.. xviii

ELECTRONICS PRIMER .. 1

PROJECT 1: GETTING STARTED WITH ARDUINO 12

PROJECT 2: A STOPLIGHT FOR YOUR HOUSE........................ 36

PROJECT 3: THE NINE-PIXEL ANIMATION MACHINE............... 66

PROJECT 4: REACTION TIMER ... 94

PROJECT 5: A COLOR-MIXING NIGHT-LIGHT 122

PROJECT 6: BALANCE BEAM ... 152

PROJECT 7: TINY DESKTOP GREENHOUSE.......................... 182

PROJECT 8: DRAWBOT, THE ROBOTIC ARTIST 220

PROJECT 9: DRAG RACE TIMER 246

PROJECT 10: TINY ELECTRIC PIANO 276

APPENDIX: MORE ELECTRONICS KNOW-HOW..................... 297

AFTERWORD ... 310

CONTENTS IN DETAIL

INTRODUCTION...xviii
WHAT IS THIS BOOK ABOUT?.................................xviii
WHY ARDUINO? ...xviii
HOW IS THIS BOOK DIFFERENT FROM OTHERS?...........xix
MATERIALS ..xx
REQUIRED TOOLS ...xxi
REQUIRED COMPUTER ..xxii
WHAT'S IN THIS BOOK? ...xxii
ONLINE RESOURCES ..xxiv
SPREAD THE WORD: SHARING YOUR WORK...............xxiv

ELECTRONICS PRIMER ...1
ELECTRICITY, CONDUCTIVITY, AND BASIC TERMS2
 WHAT IS ELECTRICITY?.......................................2
 TYPES OF ELECTRICITY3
 WHAT IS A CIRCUIT?..3
 OHM'S LAW ..4
 VISUALIZING ELECTRICITY AS WATER IN A PIPE4
SCHEMATICS, CIRCUIT BLUEPRINTS, AND WIRING DIAGRAMS5
PROTOTYPING CIRCUITS...6
DISCRETE COMPONENTS VS. BREAKOUT BOARDS8
ANALOG VS. DIGITAL ...10
WHAT IS A MICROCONTROLLER?10

PROJECT 1
GETTING STARTED WITH ARDUINO.............................12
MATERIALS TO GATHER ...14
ABOUT THE ARDUINO...14
 AN ACCESSIBLE HARDWARE PLATFORM14
 ABOUT THE SPARKFUN REDBOARD15
INSTALLING THE ARDUINO IDE AND DRIVERS17
 INSTALLING ON WINDOWS..................................18
 INSTALLING ON OS X...19
 INSTALLING ON LINUX..20
A BRIEF IDE TOUR...21
CHANGING THE DEFAULT PREFERENCES22

TEST DRIVE: PLUGGING IN THE ARDUINO FOR THE FIRST TIME........ 23
 CHOOSING YOUR BOARD IN THE IDE 24
 SELECTING THE COMMUNICATION PORT 24
AN ARDUINO "HELLO, WORLD!".. 25
BASIC ARDUINO TROUBLESHOOTING .. 27
ANATOMY OF AN ARDUINO SKETCH .. 27
 KEY SKETCH ELEMENTS... 29
 THE SETUP() FUNCTION .. 30
 THE LOOP() FUNCTION ... 31
 YOUR FIRST PIECE OF HARDWARE 32
GOING FURTHER... 33
 HACK.. 33
 MODIFY ... 34
SAVING YOUR SKETCH ... 35

PROJECT 2
A STOPLIGHT FOR YOUR HOUSE ... 36
MATERIALS TO GATHER ... 38
 ELECTRONIC PARTS .. 38
 OTHER MATERIALS AND TOOLS 39
NEW COMPONENT: THE RESISTOR 40
BUILD THE STOPLIGHT PROTOTYPE 42
 CONNECT THE RED LED TO THE BREADBOARD 44
 ADD POWER TO THE BREADBOARD 45
 ADD THE YELLOW AND GREEN LEDS 46
PROGRAM THE STOPLIGHT ... 47
 CONFIRM YOUR IDE SETTINGS................................. 47
 CREATE PLACEHOLDERS FOR PIN NUMBERS 47
 WRITE THE SETUP() FUNCTION 49
 WRITE THE LOOP() FUNCTION 50
 UPLOAD THE SKETCH .. 51
 MAKE THE STOPLIGHT PORTABLE............................. 52
BUILD THE STOPLIGHT ENCLOSURE 53
 CARDBOARD CONSTRUCTION................................... 54
 MAKE THE STOPLIGHT LENSES................................ 59
 MAKE THE SHADES... 60
 MOUNT THE LEDS AND ARDUINO............................... 61

GOING FURTHER..64
 HACK..64
 MODIFY..65

PROJECT 3

THE NINE-PIXEL ANIMATION MACHINE...................66

MATERIALS TO GATHER...68
 ELECTRONIC PARTS...68
 OTHER MATERIALS AND TOOLS......................69
BUILD THE NINE-PIXEL ANIMATION MACHINE PROTOTYPE.............70
PROGRAM THE NINE-PIXEL ANIMATION MACHINE..........72
 WHAT ARE CUSTOM FUNCTIONS?.................72
 DESIGN YOUR ARTWORK..................................75
 THE TEST SKETCH..76
BUILD THE NINE-PIXEL ANIMATION MACHINE ENCLOSURE.............83
 CARDBOARD CONSTRUCTION.........................83
 CONNECT THE ELECTRONICS.........................87
CREATE AN LED ANIMATION......................................89
 PLAN THE ANIMATION SEQUENCE................89
 WRITE CUSTOM FUNCTIONS............................90
 TWEAK YOUR LOOP() FUNCTION...................92
GOING FURTHER..92
 HACK..93
 MODIFY..93

PROJECT 4

REACTION TIMER..94

MATERIALS TO GATHER...96
 ELECTRONIC PARTS...96
 OTHER MATERIALS AND TOOLS......................97
NEW COMPONENT: THE PUSH BUTTON.....................98
 HOW PUSH BUTTONS WORK............................98
 USING RESISTORS WITH PUSH BUTTONS.......99
BUILD THE REACTION TIMER PROTOTYPE.................100
PROGRAM THE REACTION TIMER...............................102
 WRITE THE SETUP() FUNCTION......................102
 WRITE THE LOOP() FUNCTION........................103
 TEST THE REACTION TIMER SKETCH.............108
 PLAY AGAIN?..110

ADD A GAME ELEMENT ... 110
UPLOAD THE COMPLETE CODE FOR
 THE REACTION TIMER 113
BUILD THE REACTION TIMER ENCLOSURE 114
 CUT OUT THE CARDBOARD 115
 ASSEMBLE THE ELECTRONICS 116
 SPICE UP YOUR GAME ENCLOSURE 119
GOING FURTHER... 119
 HACK ... 119
 MODIFY ... 121

PROJECT 5
A COLOR-MIXING NIGHT-LIGHT 122
MATERIALS TO GATHER 124
 ELECTRONIC PARTS 124
 OTHER MATERIALS AND TOOLS 125
NEW COMPONENTS .. 126
 THE RGB LED 126
 THE PHOTORESISTOR 127
BUILD THE NIGHT-LIGHT PROTOTYPE 130
 WIRE THE VOLTAGE DIVIDER 131
 WIRE THE RGB LED 133
TEST THE NIGHT-LIGHT WITH BASIC COLOR MIXING 134
PROGRAM THE NIGHT-LIGHT.................................... 135
 PREPARE TO CHECK THE LIGHT LEVEL................... 136
 CONTROL THE NIGHT-LIGHT BASED ON
 THE LIGHT LEVEL 136
 PREVENT FALSE ALARMS 137
 RECALIBRATE THE NIGHT-LIGHT 138
CREATE MORE COLORS WITH ANALOGWRITE()..................... 138
 CREATE ANALOG SIGNALS WITH PWM 139
 MIX COLORS WITH ANALOGWRITE() 140
 FIND RGB VALUES WITH COLOR PICKER 141
 THE CUSTOM-COLOR NIGHT-LIGHT CODE................. 142
BUILD THE NIGHT-LIGHT ENCLOSURE........................... 143
 CARDSTOCK CONSTRUCTION............................. 143
 PUT THE ELECTRONICS INSIDE 148
 LET IT GLOW!...................................... 150
GOING FURTHER.. 150
 HACK .. 150
 MODIFY .. 151

PROJECT 6
BALANCE BEAM.. 152
MATERIALS TO GATHER .. 154
 ELECTRONIC PARTS ... 154
 OTHER MATERIALS AND TOOLS 155
NEW COMPONENTS .. 156
 THE POTENTIOMETER .. 156
 THE SERVO MOTOR .. 158
BUILD THE BALANCE BEAM PROTOTYPE 160
PROGRAM THE BALANCE BEAM .. 163
 TEST THE SERVO ... 163
 COMPLETE THE BALANCE BEAM SKETCH 165
BUILD THE BALANCE BEAM ... 167
 CUT OUT THE PARTS ... 167
 BUILD THE BEAM .. 168
 BUILD THE BASE AND ATTACH THE SERVO 171
 FINAL ASSEMBLY .. 175
GOING FURTHER... 180
 HACK ... 180
 MODIFY .. 180

PROJECT 7
TINY DESKTOP GREENHOUSE ... 182
MATERIALS TO GATHER .. 185
 ELECTRONIC PARTS ... 185
 OTHER MATERIALS AND TOOLS 186
NEW COMPONENTS .. 187
 TMP36 TEMPERATURE SENSOR 187
 STANDARD HOBBY MOTOR ... 187
 NPN TRANSISTOR .. 188
TAKING A SYSTEMS APPROACH ... 188
BUILD THE TEMPERATURE MONITOR 189
 MEASURE TEMPERATURE WITH THE TMP36 190
 CONNECT THE TEMPERATURE SENSOR 190
 PROGRAM THE TEMPERATURE SENSOR....................... 191
BUILD THE SERVO MOTOR AUTOVENT 198
PROGRAM THE AUTOVENT .. 199
BUILD THE FAN MOTOR ... 200
 PROGRAM THE FAN MOTOR .. 205
 ISOLATE THE MOTOR EFFECT..................................... 207

BUILD THE TINY DESKTOP GREENHOUSE ENCLOSURE......................207
 ADD THE AUTOVENT WINDOW SERVO..................................210
 CREATE THE PAPER CLIP LINKAGE.................................211
 ADD THE ROOF ...212
 BUILD THE FAN-MOTOR BOX.......................................214
 CONNECT IT UP...216
GOING FURTHER..218
 HACK..218
 MODIFY..219

PROJECT 8
DRAWBOT, THE ROBOTIC ARTIST..220
MATERIALS TO GATHER..222
 ELECTRONIC PARTS ...223
 OTHER MATERIALS AND TOOLS223
NEW COMPONENTS...224
 THE H-BRIDGE MOTOR DRIVER INTEGRATED CIRCUIT224
 GEARED HOBBY MOTOR...226
BUILD THE DRAWBOT PROTOTYPE ...227
PROGRAM THE DRAWBOT ...228
 CREATE A CUSTOM FUNCTION......................................230
 CLEAN UP THE CODE..231
WIRE THE SECOND MOTOR..231
DRIVE BOTH MOTORS ...233
BUILD THE DRAWBOT CHASSIS..234
 TEST AND TROUBLESHOOT..237
 TURN AND MAKE PATTERNS: A ROBOT SQUARE DANCE.....238
GOING FURTHER..244
 HACK..244
 MODIFY..245
 BONUS ..245

PROJECT 9
DRAG RACE TIMER...246
MATERIALS TO GATHER..248
 ELECTRONIC PARTS ...248
 OTHER MATERIALS AND TOOLS249
NEW COMPONENT: THE 16 × 2 CHARACTER LCD250
DRAG RACE TIMER OPERATION...252

BUILD THE LCD CIRCUIT ... 253
 POWER THE LCD ... 253
 CONTROL THE CONTRAST 254
 CONNECT THE DATA AND CONTROL WIRING 255
 TEST THE LCD .. 257
ADD THE REST OF THE ELECTRONICS 259
PROGRAM THE DRAG RACE TIMER 260
A QUICK TEST .. 264
BUILD THE DRAG RACE TRACK ... 265
 BUILD THE STARTING TOWER 266
 ASSEMBLE THE STARTING GATE 268
 BUILD YOUR OWN TRACK 270
 ADD THE PHOTORESISTOR 270
 TEST AND TROUBLESHOOT 272
GOING FURTHER ... 273
 HACK ... 273
 MODIFY ... 275

PROJECT 10
TINY ELECTRIC PIANO ... 276
MATERIALS TO GATHER ... 278
 ELECTRONIC PARTS .. 278
 OTHER MATERIALS AND TOOLS 279
NEW COMPONENTS ... 280
 THE SOFTPOT MEMBRANE POTENTIOMETER 280
 THE PIEZO BUZZER ... 281
BUILD THE CIRCUIT ... 281
PROGRAM THE TINY ELECTRIC PIANO 283
 TEST THE BUZZER ... 283
 CREATE SPECIFIC NOTES 286
 GENERATE SOUND WITH THE SOFTPOT 286
 PLAY A SONG ... 288
BUILD THE PIANO ... 291
GOING FURTHER ... 292
 HACK ... 293
 MODIFY ... 293
 BONUS PROJECT: BINARY TRUMPET 294

APPENDIX

MORE ELECTRONICS KNOW-HOW .. 297

MEASURING ELECTRICITY WITH A MULTIMETER 298
 PARTS OF A MULTIMETER .. 298
 MEASURING CONTINUITY .. 299
 MEASURING RESISTANCE .. 299
 MEASURING VOLTAGE .. 300
 MEASURING CURRENT .. 301
HOW TO SOLDER .. 302
 HEATING THE IRON ... 303
 PERFECTING YOUR SOLDERING TECHNIQUE 304
 CLEANING THE IRON ... 305
 SOLDERING TIPS ... 306
ADDITIONAL SOLDERING TOOLS .. 306
 THIRD HAND .. 306
 FLUX PEN .. 307
 SOLDER WICK .. 307
 SOLDER VACUUM ... 308
RESISTORS AND BANDS ... 308

AFTERWORD .. 310
ADDITIONAL RESOURCES .. 310
ACKNOWLEDGMENTS ... 310

INTRODUCTION

Welcome to *The Arduino Inventor's Guide*! This book will get you started working with electronics, programming, and making cool things. Anyone can be an inventor, and this guide will walk you through a series of projects that combine common materials with the powerful Arduino to help inspire you to start making your own inventions.

WHAT IS THIS BOOK ABOUT?

At the heart of this book is the Arduino (*https://www.arduino.cc/*), an open source microcontroller board that you can program to control LEDs, measure temperature, react to light, interface to GPS satellites, and do much more. Arduino is also the name of the programming language and development environment that we will use throughout this book.

Arduino is the ultimate tool for makers looking to add control to their projects. A quick search online for "Arduino projects" returns millions of hits. There are thousands of projects and ideas available on sites like Instructables, hackster.io, and YouTube. That shows just how many makers out there are using Arduino.

At SparkFun Electronics, we encourage people to experiment, play, and tinker with common household items by altering and integrating electronics components. This is sometimes known as *hacking*. This book will teach you some core electronics and coding skills, and we hope it will inspire you to build something new and unique with materials you find around your house.

WHY ARDUINO?

There are dozens of different microcontrollers and development platforms out there, so why are we creating another set of projects for Arduino?

The answer lies in the simple fact that Arduino was not originally created for makers, engineers, or hobbyists but for design students in Ivrea, Italy, as a learning platform to help them make their projects function without needing years of electrical engineering courses or tons of math and theory. It was designed to shorten the time from

"nothing" to "awesome!"—that is, from idea to physical product—for nontechnical people.

Arduino did its job so well that the maker community and hobbyists picked up the platform and ran with it. This is due to a number of factors—low price, good documentation, open source hardware— but we think the core reason Arduino is so popular is that it is easy to learn on. Arduino is a gateway for anyone into making, inventing, and prototyping projects. The projects in this book are designed for someone who wants to learn and is driven by the initial spirit of Arduino: to bring an idea to fruition.

HOW IS THIS BOOK DIFFERENT FROM OTHERS?

A lot of programming books read like reference manuals, jumping right away into coding or electrical concepts before providing context, and collecting dust on your bookshelf until you need to look up a command or concept you've forgotten.

This book is not like that. It aims to teach new concepts through fun, interesting, and practical projects. The projects progress in complexity and difficulty incrementally from Project 1 to Project 10, and they will help answer the age-old questions: Why am I learning this? Why is it important? And why should I care?

We assume you're reading this book because you're eager to learn something new or looking for materials to share with others. Whether you're an interested novice, a teacher, a librarian, or a parent, this book is a hands-on guide for people who want to learn and is not meant as a reference manual to sit on your bookshelf.

You don't need any experience with electronics or programming to get started with Arduino. We assume you know nothing at the start and that you may be a little apprehensive about diving in. That's okay! This book progresses steadily from introductory material to more complicated and challenging projects.

We also know that there are plenty of people out there with experience looking for something new—maybe a new spin on an old topic, such as a fresh look at blinking LEDs. Many of these projects can be used as starting points for you to hack and develop further or build out of better materials for a more polished and durable finish. In the end, this book is for someone who is proactive—a problem solver who jumps in with both feet.

We encourage you to build the projects as you go, learning by doing. These projects have been carefully designed to introduce both the tools and skills for programming and circuit building, as well as fabricating using cardboard, scraps, and other household items. The fun of learning is in playing out the entire process, and that is what this book offers.

MATERIALS

The electronics components used throughout this book are based around our flagship product, the SparkFun Inventor's Kit (KIT-13969), and are also readily available individually from a number of sources online. We've also used a few parts that aren't in the Inventor's Kit, and these additional parts are available as a single kit as well (*https://www.sparkfun.com/NoStarchArduino/*).

If you already have an electronics starter kit or want to buy the components separately rather than getting the Inventor's Kit, you can find the full Bill of Materials (BOM) for the book in Tables 1 and 2. We've included individual lists of materials at the beginning of each project as well.

We'll also be using many basic building materials like cardboard, cardstock, construction paper, drinking straws, and paper plates to build the enclosures for the projects. As you start working with electronics and integrating them with common materials, you'll find yourself looking at everyday household items in a new way.

TABLE 1:

SparkFun Inventor's Kit parts used in the book

QTY	PART NUMBER	DESCRIPTION
1	DEV-13975	SparkFun RedBoard (or other Arduino-compatible board)
1	CAB-11301	USB Mini-B cable
1	PRT-12002	Solderless breadboard
1	PRT-11026	Male-to-male jumper wires (qty 30)
1	COM-12062	Assorted color LEDs (qty 20)
1	COM-09264	RGB LED (common cathode)
1	COM-11508	10 kΩ resistors (qty 20)
1	COM-11507	330 Ω resistors (qty 20)
2	COM-10302 or COM-09190	Push buttons
1	COM-08588	Diode
1	COM-09806	10 kΩ potentiometer
1	COM-13689	NPN transistor - 2N2222 or BC337

QTY	PART NUMBER	DESCRIPTION
1	SEN-09088	Photoresistor
1	SEN-10988	TMP36 temperature sensor
1	SEN-08680	50 mm SoftPot membrane potentiometer
1	COM-07950	Piezo buzzer
1	LCD-00709	16 × 2 character LCD
1	ROB-09065	Submicro size servo motor
1	ROB-11696	Hobby motor

QTY	PART NUMBER	DESCRIPTION
1	PRT-12043	Mini breadboard
1	PRT-13870	Short 4-inch male-to-male jumper wires (qty 30)
2	PRT-09140	Male-to-female jumper wires (qty 10)
1	COM-12062	Assorted color LEDs (qty 20) (additional LEDs)
1	SEN-09088	Photoresistor (additional)
1	PRT-09835	4 AA battery holder
4	PRT-09100	AA battery
1	ROB-13845	TB6612FNG H-bridge motor driver
1	ROB-13302	Geared hobby motors (qty 2)
1	ROB-13259	Rubber wheel fit for the geared hobby motor (qty 2)
1	COM-00102	Mini slide switch

TABLE 2:

Additional parts used in the book (not included in the SparkFun Inventor's Kit)

REQUIRED TOOLS

The only tools you'll need for these projects are a pair of scissors, a craft knife, and a hot glue gun. However, don't feel limited to these tools. If you have a laser cutter available to you, use it. If you are itching to 3D-print a project, feel free. Our designs are made with paper craft and cardboard in mind, but they can be combined with any fabrication technique you want.

You shouldn't have to spend any money on the materials for this book if you don't want to. In fact, there are probably a few projects you could use the book itself as a material for. If you do, that's awesome! As former teachers, we are familiar with working with very small budgets, and our focus is always on the most cost-effective building materials, such as cardboard, paper, wood, and recycled plastics and metals.

Most of the projects in this book are designed to be built as prototypes that can be easily taken apart and reused. However, if you really like a project and want to make it permanent, check out the appendix to see how to solder your project. The tools for soldering and electronics prototyping are relatively inexpensive, and you can buy them from SparkFun (*https://www.sparkfun.com/*) or any hardware store near you.

REQUIRED COMPUTER

Finally, you'll program the Arduino using a computer and a specific set of software tools. Just about any average computer can handle the Arduino software. If you have a PC running Windows, you'll need to be running Windows XP, Vista, 7, 8/8.1, 10, or newer. For Mac users, currently the latest version of Arduino is compatible with OS X 10.7 Lion or newer. If you're running a fairly standard version of Linux, odds are there is a version of Arduino available.

As of this writing, iOS and Android devices are supported only through beta-release software packages still under testing and development. You're welcome to try these, but they may not work, and if they do, they may not be reliable.

For Windows, Mac, or Linux users, we'll walk you through the process of setting up your computer in the first project.

WHAT'S IN THIS BOOK?

This book includes 10 hands-on projects, as well as a primer on electronics and an appendix that covers soldering and other handy tips. The projects start with a simple blinking LED and gradually incorporate different electrical components, programming concepts, and layers of construction sophistication as the projects progress. Each project has separate sections on wiring, programming, and construction so that you can focus on individual aspects. We wrap up each project with a "Going Further" section that gives you ideas for hacking and modifying the project. Remember, we want you to use these projects as launching points for your own inventions, not as end goals.

- **Electronics Primer** Before jumping into the projects, we present the foundations of electricity and electronics and introduce key concepts used throughout the book.

- **Project 1: Getting Started with Arduino** Covers installing software and gives you a foundation in building and programming circuits by walking you through a project that lights up an LED.

- **Project 2: A Stoplight for Your House** Explores using a breadboard and controlling multiple components at once to build a three-LED stoplight.

- **Project 3: The Nine-Pixel Animation Machine** Extends the stoplight to nine LEDs in a 3 × 3 matrix and teaches you about custom functions in Arduino.

- **Project 4: Reaction Timer** Walks you through using a button and an LED to make a game that tests your reaction times.

- **Project 5: A Color-Mixing Night-Light** Explores using a voltage divider and a light sensor to detect a room's light level and automatically turn a multicolored LED on or off depending on how dark it is.

- **Project 6: Balance Beam** Introduces the servo motor and how to control it with an external device to make a balance beam desk game.

- **Project 7: Tiny Desktop Greenhouse** Teaches you how to make a greenhouse that senses temperature and automatically turns a fan on and opens an air vent when it's too hot. This project introduces concepts like controlling a motor with a transistor.

- **Project 8: Drawbot, the Robotic Artist** Explores simple tabletop robotics using an H-bridge motor controller. You'll build a simple robot that you can program to draw a picture for you.

- **Project 9: Drag Race Timer** Shows you how to build a racetrack for toy cars that records their speeds. You'll use the servo motor, light sensor, and LCD to build a race timer. This project is a Christmas morning dream!

- **Project 10: Tiny Electric Piano** Teaches you how to make music with your Arduino, using a soft potentiometer as a small keyboard. This project explores the piezo buzzer and how to use the tone() function. Time to get your piano man on!

- **Appendix: More Electronics Know-How** Includes handy tips for using a multimeter, soldering, and reading the color bands on resistors.

ONLINE RESOURCES

All the resources you'll need for these projects are available for you to download, reference, use, and modify. The resources include all the example code shown and discussed in the book, the cutting templates for the final builds, and code to get you started with hacking and modifying your projects to experiment further.

You'll find all of these resources in a single ZIP file that you can download from *https://www.nostarch.com/arduinoinventor/*. If you get stuck or something doesn't seem to work, you can always reference these files as a guide and a fallback.

SPREAD THE WORD: SHARING YOUR WORK

SparkFun is a hardware and electronics company with a strong focus on being open source—it is one of the core tenets the company was founded on. When we build projects, we love to share our ideas, code, and design files with our community so that you can leverage our knowledge base to use in your next project. As you build up your projects, we encourage you to share what you're doing, too. Show a friend, or post it online. There are many different places that we'd love to see your work!

Use social media like Twitter, Instagram, or Facebook to tell us about what you're making. Tag us *@sparkfunedu* and *@nostarch*. We also have an online project gallery called InventorSpace at *https://invent.sparkfun.com/*. If you have an idea or a project that you want to show off, post it there. We hope this book provides you with some inspiration to start something amazing!

Finally, you can also email us with your projects, photos, or general comments and questions at *ArduinoInventorsGuide@sparkfun.com*. We'll occasionally pick some great photos and projects to highlight on our blog. Who knows, we might end up asking to use one of your projects in our next book!

ELECTRONICS PRIMER

THIS CHAPTER PROVIDES A BROAD OVERVIEW OF ELECTRONICS TO READERS WHO HAVE LITTLE TO NO EXPERIENCE WITH ELECTRONICS AND ELECTRICITY. IF YOU'RE ALREADY COMFORTABLE WITH SOME OF THE TOPICS IN THIS CHAPTER, YOU CAN TREAT IT LIKE A <u>CHOOSE YOUR OWN ADVENTURE</u> BOOK AND SKIP TO SUBJECTS YOU WANT TO LEARN MORE ABOUT OR EVEN MOVE DIRECTLY ON TO PROJECT 1.

If you're new to electronics or just want a refresher, we suggest reading this chapter in full. While it's not a complete guide to electronics (there are whole books, classes, and degrees on the subject), this chapter is a handy reference designed to arm you with basic concepts and vocabulary. If you're looking for more in-depth information on electricity, electronics, and circuits, please see the recommended reading list at the end of this chapter.

ELECTRICITY, CONDUCTIVITY, AND BASIC TERMS

Electricity is an odd beast. In a lot of ways it's predictable, but it can be a little sneaky at times. If you look up *electricity* in the dictionary, you'll probably find the definition sheds little light on what it is, how it works, or, most importantly, how you can use it. Let's start with the basics.

What Is Electricity?

To understand electricity, you first need to understand the structure of an atom. Atoms are the building blocks of everything around you. An atom is made up of protons, neutrons, and electrons. The electrons have a negative charge, and the protons have a positive charge. A typical atom has the same number of electrons as protons and therefore is neutral in charge. Electricity is a form of energy that involves the movement or storage of charges; it is the phenomenon that occurs when we push or force charges to move in a prescribed manner or a defined path. If you've ever seen a lightning storm, you've seen evidence of the transfer of charges between the clouds and the ground. These charges are transferred through the air molecules of our atmosphere, lighting up the sky as they move. The movement and transfer of charges is called *current*. Current is measured in units called amperes (A) or milliamperes (mA).

Except for lightning, arc welding, and the odd static shock, we don't normally see electricity directly. Even the bright light we see in lightning is merely the air molecules changing form as charges move through them.

Charges move when there is an electrical force that acts on them and a path for the charges to move along. That electrical force is created by an *electrical potential difference*, or what we commonly call *voltage*. Voltage is what ultimately causes charges to move, and it's measured in volts (V). For a reference, typical batteries range in

NOTE

Conventionally, we refer to current as the movement of a positive charge. Though technically the electron is the part of the atom that can be moved, it is still common to refer to current as the movement from positive to negative.

voltage from about 1.5 V to 12 V. A 12 V battery will cause charges to move faster than a 1.5 V battery.

Types of Electricity

In general, electricity can be broken down into two basic types: *direct current (DC)* and *alternating current (AC)*. AC is the kind of electricity in the power lines outside your house and in your wall outlets. AC electricity is great for power generation (for example, power plants), transmitting power over long distances (like from the power plant to your home), and driving large devices (like motors and heaters). We don't use AC electricity for most of our household electronics, however. Most small appliances and household electronics that plug into the wall outlet require DC electricity and use a *transformer* to convert from AC to DC. Further details on AC and DC are beyond the scope of this book, but the projects you build here will focus on DC electricity.

What Is a Circuit?

Even with the electrical forces pushing them, charges need a path to follow from a point of higher potential to a point of lower potential. The path by which charges move from the positive (+) side of a battery (high potential) to the negative (–) side of the battery (low potential) is called a *circuit*. A circuit consists of a closed path from the positive terminal to the negative terminal through a device such as a light-emitting diode (LED), resistor, light, or motor. Figure 1 shows a simple circuit containing an LED, a battery, and a resistor. Notice that the shape of the circuit loosely resembles a loop or a circle, hence the name *circuit*.

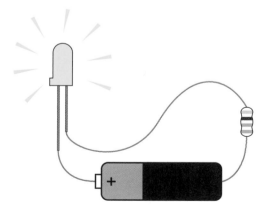

FIGURE 1:

A basic DC circuit

In order for charges to move, the path must be made out of a material that is *conductive*. Conductivity is not an absolute measure but more of a continuum. While some materials are generally considered conductors and nonconductors, most materials occupy a range of values for conductivity. In other words, some materials allow charges to move more freely than others. Think of driving a car on different surfaces. On the smoothly paved interstate, you can go much faster than if you were off-roading or driving down dirt roads. Different roads allow for different speeds the same way that different materials allow for more or less conductivity. We use the term *resistance* to describe how much a material slows down the movement of charges.

Ohm's Law

As you may already have guessed, there is a relationship between current, voltage, and resistance. This relationship is commonly called *Ohm's Law*, and it is represented mathematically as follows:

$$V = I \times R$$

In this equation, *V* represents the voltage, *I* represents the current, and *R* is the resistance. (Don't let this bit of math scare you: this is one of only about three equations you'll see in this book.)

Visualizing Electricity as Water in a Pipe

To understand what's going on in a circuit, it's useful to think of electricity like water moving through pipes. Imagine water flowing through a garden hose. When you turn on the valve, water starts to flow through the hose to the other end, as shown in Figure 2.

FIGURE 2:

Water and electricity model

WATER STORAGE/
HEIGHT OF TANK
(VOLTAGE)

FLOW RATE
(CURRENT)

VALVE
(RESISTANCE)

OUTPUT
(WORK)

The water molecules moving in the hose represent the flow of charges (current). If we turn the water valve up or down, we can change the water pressure in the hose. The water pressure in the hose is similar to the voltage in a circuit. If you increase the water

pressure, the flow also increases. This is the same with circuits: if you increase the voltage, the current also increases. The final part of the analogy is in the hose itself. If we put a kink in the hose or restrict its diameter, we create resistance. The increase in resistance slows down the flow (lowers the current).

This model works pretty well to describe the flow of electricity, but you don't want to set up this whole system of hoses, valves, and pipes to just let water run out onto the ground (unless your goal is to water the lawn). You want to do something with it; you want it to do *work*. In terms of circuits, we use devices that change electricity into other forms of useful energy, such as illuminating a light, rotating a motor, or sounding a buzzer. A device that converts electrical energy to other forms of energy is called a *load*. Thomas Edison discovered that he could convert electrical energy into light energy with the light bulb; you will do that and a whole lot more throughout this book.

SCHEMATICS, CIRCUIT BLUEPRINTS, AND WIRING DIAGRAMS

While pictures are nice, it's not efficient to meticulously draw out every component to show how a circuit is wired up. Throughout the book, you will see *schematics* like the one in Figure 3 as well as illustrations to help you with your circuits.

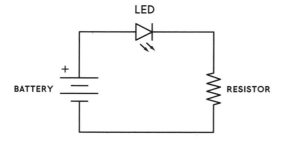

FIGURE 3:
This simple schematic shows a battery, an LED, and a resistor.

Schematics are simplified drawings of circuits. We sometimes also call these *wiring diagrams* or *circuit blueprints*. A schematic shows what is connected to what and which components to use in building the circuit. We will use the IEEE (Institute of Electrical and Electronics Engineers) US standard for drawing circuits in this book. The schematic in Figure 3 actually represents the same circuit as the illustration in Figure 1. The straight lines represent wires, and each component has its own unique symbol. Figure 4 shows some common schematic symbols you'll see in this book.

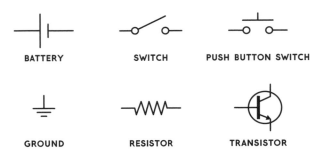

The IEEE schematic symbol format is internationally recognized and used to communicate and share circuit drawings across the world. It's intended to quickly represent components using very simple lines and drawings.

PROTOTYPING CIRCUITS

As you work through the projects in this book, you will build and test a variety of designs. As you build a circuit, you may also want to rearrange parts, swap things around, or add new components. This process is called *prototyping*. You can prototype electronics in a way that is similar to building with wooden blocks or LEGO bricks by using a *solderless breadboard* like the one shown in Figure 5.

FIGURE 5:

A translucent solderless
breadboard with
horizontal rows and
vertical power rails

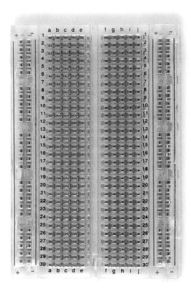

A solderless breadboard is a plastic rectangle with a lot of holes in it. These holes are spaced on a 0.100-inch grid and sized so that the majority of electronic components fit snugly in them.

Underneath the holes are small clips made out of a soft conductive metal, as shown in Figure 6.

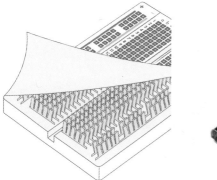

FIGURE 6:

The innards of a solderless breadboard (left) and a close-up of the metal clip inside (right)

Wires that are plugged into holes on the same row are connected together electrically by these metal clips. It's like twisting the wires together without the twisting part. Notice that the clips only span the width of five holes. There is a center "ditch" that divides the two halves of the breadboard, and the clips on the right side are not connected to the clips on the left side.

Breadboards come in a number of shapes and sizes, but most will still have vertical columns on the outer edges of the board. These columns are called *power rails* or *power buses*, and each has a single continuous clip that is connected from top to bottom, as in Figure 7. Breadboards also often have + and − labels to indicate where to plug in your power connection, with matching red and blue color coding.

NOTE

Hold the breadboard so that it is tall and skinny (portrait orientation) and the letters at the top are right side up. We'll refer to the horizontal groupings of five holes as rows *and the vertical sections on the sides of the breadboard as* columns*, assuming this orientation.*

FIGURE 7:

Underside of a breadboard, showing both horizontal rows and vertical power rails

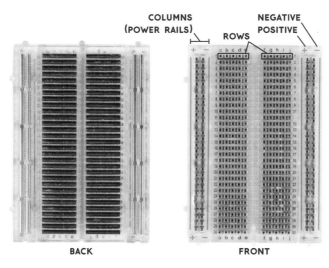

COLUMNS
(POWER RAILS)

ROWS

NEGATIVE
POSITIVE

BACK

FRONT

You can see a solderless breadboard in action in Figure 8, which shows a prototype design of a circuit with eight LEDs.

FIGURE 8:

Circuit on a breadboard

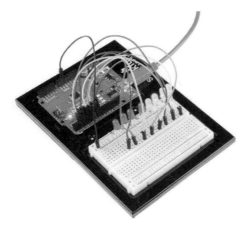

In this book, you'll build circuits with solderless breadboards so that if you make a mistake, you can easily change or fix it, and if you want to explore something further, you can quickly add to the circuit. When you start making bigger and more complex circuits, we suggest that you have multiple breadboards around so that you can build circuits in chunks. This allows you to build and test each part of your project incrementally without having to rework, troubleshoot, or take an entire project apart when something doesn't work.

DISCRETE COMPONENTS VS. BREAKOUT BOARDS

We mentioned components earlier and want to touch on them briefly here. There are hundreds, if not thousands, of different electrical components in the world. When we say *components*, we are talking about *discrete components*—the most rudimentary parts you can buy. For example, the resistor, capacitor, and LED in Figure 9 are discrete components.

On the other hand, a *breakout board* is an assembly of components prewired together onto a single board made to be breadboard friendly. Breakout boards help speed up the prototyping process. You can see a good example of one in Figure 10.

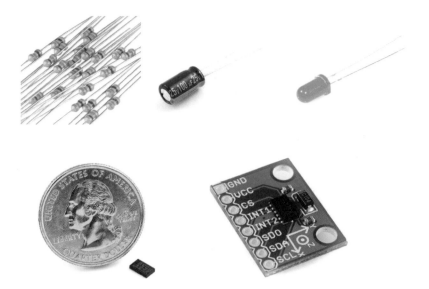

FIGURE 9:
Resistors (left), capacitors (center), and LEDs (right) are examples of discrete components.

FIGURE 10:
A single, tiny accelerometer (left) and its breakout board (right). Notice the plated-through holes on the left side of the breakout board.

Figure 10 compares a complex component—an integrated accelerometer sensor package (P/N ADXL345 from Analog Devices)—and the breakout board SparkFun produces for it. The chip measures a mere 5 × 3 mm! It has tiny metal connection pins that serve a similar purpose to the long metal legs you see on discrete components. They're just so small that connecting wires directly to them is nearly impossible. Breakout boards route these small connection points to *plated-through holes* on the edge of the board, spaced exactly 0.100 inch apart so that the holes on the board line up with the holes on a solderless breadboard. Each hole is metal plated so that you can solder wires directly to it. Or, if you want to use it with a breadboard, you can also solder on male headers as shown in Figure 11. (Don't worry if you've never soldered before; see the instructions in "How to Solder" on page 302.)

Notice that the holes are each labeled with a silkscreen so you know how to connect the sensor. Breakout boards have these so you can use them immediately on a breadboard without the hours of researching and building you'd have to do to use the bare component on its own.

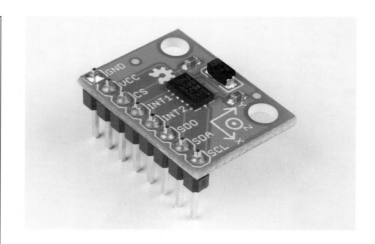

ANALOG VS. DIGITAL

With the concepts of circuits, components, voltage, current, and resistance defined, we can now talk about two different approaches to electronics: *analog* and *digital*. These approaches are not mutually exclusive, and you can't really understand the circuits you build without understanding both concepts.

Analog deals with values that vary within a set range. Think of the dimmer switch in some dining rooms; that is analog. Analog values can be on, off, and anything in between. Digital values, on the other hand, have only two states: on or off.

Digital electronics tend to include a microcontroller or microprocessor that is programmed to turn things on and off in response to conditions, whereas analog circuits tend to use components to vary the current, voltage, and resistance of a circuit to achieve the same result.

There are advantages and disadvantages to both ways of thinking, but you can't solely use one and not the other. For example, you couldn't read the temperature using a microcontroller without using a number of analog components as well.

WHAT IS A MICROCONTROLLER?

A *microcontroller* is a small computer that you can program by uploading a program or set of instructions. Microcontrollers are used to automate simple tasks, like controlling the temperature of your house or watering your lawn when it's dry.

The projects in this book use the SparkFun RedBoard micro-controller board, which is 100% compatible with the Arduino Uno. Both are pictured in Figure 12.

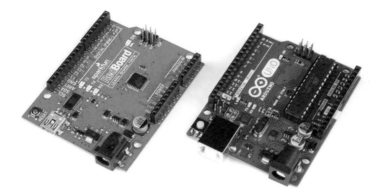

FIGURE 12:

The SparkFun RedBoard (left) and the Arduino Uno (right) microcontroller boards

In an average day, you probably use 15 to 20 microcontrollers and you don't even know it. They are in your coffee maker, alarm clock, and microwave. Your car alone has anywhere from 5 to 10 of them that control the braking, stereo, and ignition systems. Our world practically runs on microcontrollers. This book will help you learn how to harness that fact to take back a bit of control over your world.

We hope that this short primer has given you a little background and a preview of what the rest of this book will cover. We're excited that you've decided to embark on this adventure with us. Now, let's get to building our first project!

NOTE

You will learn more about the Arduino, how to program it, and what its capabilities are as you build the projects. For now, just know that a microcontroller is a programmable brain that makes electronics easier for anyone to build and proto-type ideas that automate the world around them.

ADDITIONAL RESOURCES ON BASIC ELECTRICITY AND ELECTRONICS

If you're eager to learn about electricity and electronics in more detail, we highly recommend you check out the following books:

- *Basic Electricity* by the Bureau of Naval Personnel (Dover Publications, 1970)

- *Arduino Workshop* by John Boxall (No Starch Press, 2013)

- *Getting Started in Electronics* by Forrest M. Mims III (Master Publishing, 2003)

- *Practical Electronics for Inventors, 4th edition* by Paul Scherz and Simon Monk (McGraw-Hill Education, 2016)

GETTING STARTED WITH ARDUINO

THIS PROJECT COVERS EVERYTHING YOU NEED TO GET YOUR ARDUINO UP AND RUNNING! WE'LL INTRODUCE THE HARDWARE, SHOW YOU HOW TO INSTALL THE PROGRAMMING ENVIRONMENT, AND HELP YOU MAKE SURE EVERYTHING WORKS BY LOADING A SIMPLE PROGRAM. AT THE END, YOU SHOULD HAVE YOUR OWN BLINKING LIGHT AND THE EXCITEMENT TO MOVE ON. LET'S GO!

MATERIALS TO GATHER

You'll need the following hardware (shown in Figure 1-1) to complete this project:

- One SparkFun RedBoard (DEV-13975), Arduino Uno (DEV-11021), or any other Arduino-compatible board
- One USB Mini-B cable (CAB-11301 or your board's USB cable)
- One LED (COM-09590, or COM-12062 for a pack of 20)

FIGURE 1-1:

Required components

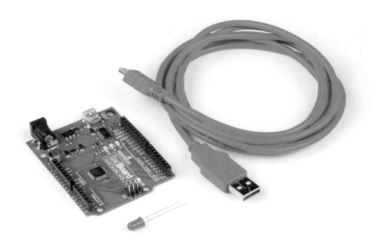

ABOUT THE ARDUINO

An *Arduino* (pronounced är·də'wēn·ō or "arr-dween-oh!") is a small programmable device that can add smarts to nonintelligent things. You can use an Arduino to run robots, create LED art, and even act as a handheld gaming console. In this section, we'll go into more detail on what the Arduino is and how it can change the way you think about the world around you.

An Accessible Hardware Platform

An Arduino is like a small computer. You can program it using very simple instructions, and you can power it with just a few AA batteries. What makes an Arduino really different from a regular computer is that it uses a *microcontroller*, rather than a CPU, to process information and take action. This small chip acts as the brains of your project, and it can receive input from sensors (like light detectors, temperature sensors, or buttons) and output signals to control LEDs, motors,

buzzers, and more. An Arduino board like the one in Figure 1-2 has all of the supporting components and circuitry to make a micro-controller work.

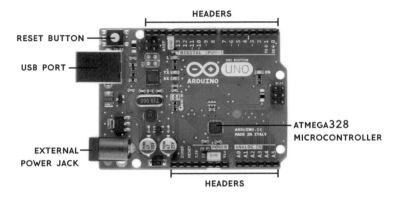

HEADERS

RESET BUTTON

USB PORT

ATMEGA328 MICROCONTROLLER

EXTERNAL POWER JACK

HEADERS

FIGURE 1-2:
The Arduino Uno is an open source, program-mable electronics platform for hobbyists.

The programming language used for the Arduino is essentially a version of C/C++. The programming environment is the *Arduino IDE (integrated development environment)*. The team that developed it bundled it with many prewritten functions and libraries to simplify the process of writing code to interface with hardware. For example, these libraries take the multiple lines of code required to turn on an LED and simplify them into a single instruction!

About the SparkFun RedBoard

There are many officially Arduino-branded boards, but since the platform is *open source* (meaning the source hardware design and software are available for anyone to look at and modify), there are also many Arduino derivatives, clones, and compatible boards. The board designs are all licensed under a Creative Commons Attribution Share-Alike license, and the Arduino FAQ (*https://www.arduino.cc/ en/Main/FAQ*) states that anyone is "free to use and adapt [these designs] for your own needs without asking permission or paying a fee." Derivative boards work with the same programming environ-ment as an official Arduino, but often the hardware has been tweaked or modified in some way.

The SparkFun RedBoard, pictured in Figure 1-3, is an Arduino-compatible derivative board. It is based on the Arduino Uno design but has a more stable USB interface and uses a USB mini connector instead of the Type-A connector. Otherwise, it is exactly the same as the Uno, with the same size and shape.

20268261

FIGURE 1-3:

The Arduino-compatible
SparkFun RedBoard.
Notice how its shape
matches up with
the Arduino Uno in
Figure 1-2.

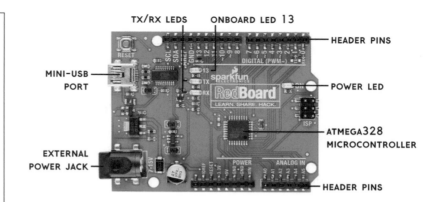

The RedBoard is the go-to Arduino board here at SparkFun and has a few key components that you'll need to know in order to navigate the first few chapters of this book. We have labeled each term for you in Figure 1-3.

ATmega328 microcontroller The square black chip in the middle of the board. It is the brain of the Arduino.

Header pins The tiny metal legs on the microcontroller, which let you read input and send output. They are accessible through the four sets of black headers on either side of the Arduino. They are numbered and labeled for specific uses. The pins you'll care about most are those labeled *Digital* (0–13), *Analog In* (A0–A5), and *Power*.

Mini-USB port This is how you send code to and communicate with the Arduino. You can also power your board using the USB port for most applications in this book. If an external power supply is needed, we'll be sure to point it out.

Power LED This LED is an indicator to show that the Arduino is powered on. If you ever have a short circuit on your board or a bad power connection, this indicator will not turn on.

TX/RX LEDs These LEDs blink when data, such as code or numbers, is being passed back and forth between your Arduino and your laptop.

Onboard LED 13 A debug light. If you're plugging your Arduino in for the first time, LED 13 should blink once per second. It's connected to pin 13 on the Arduino.

External power jack A barrel jack port next to the USB port. The Arduino takes 5 V of power, though you can safely supply the Arduino a voltage between 7 and 15 V without damaging your board. A chip on the Arduino scales this input voltage down to 5 V for the electronics and circuitry to work properly.

Like all Arduino-compatible boards, you'll program the RedBoard with the Arduino IDE.

INSTALLING THE ARDUINO IDE AND DRIVERS

You should install the Arduino IDE before plugging your RedBoard into the USB port for the first time. To install the Arduino IDE, go to *http://www.arduino.cc/download/*. Select the appropriate version for your computer's operating system, and click the link to download (Figure 1-4). You'll be asked whether you'd like to make a contribution; the development and maintenance of the Arduino IDE rely on the help and contributions of the community that uses it.

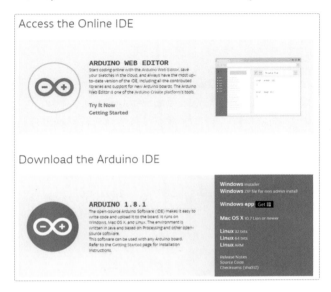

NOTE

If you've already plugged in your board, that's not a problem—you may just need to restart your computer after the installation is complete for the drivers to work properly.

FIGURE 1-4:
You can use the online IDE or download the latest version for your operating system.

Even if you already have the IDE installed, we recommend downloading and installing the latest version. The Arduino IDE is continuously being updated and improved, and it's best to have the newest release. The examples in this book use IDE versions 1.8.1 and later.

The Arduino website also provides an online platform called Arduino Create, which includes a web-based code editor. It allows you to program your device through your web browser and share and view projects with others online. As of the writing of this book, it is supported only on Windows and OS X.

Whether you choose to use Arduino Create or the downloaded IDE, follow the directions online to run the installation process.

NOTE

If you like to be on the bleeding edge of software, the Arduino Downloads page also provides nightly builds that preview the next release. For this book, however, we recommend using the latest stable release.

Installing on Windows

If you're working on a Windows PC, we recommend downloading the Windows Installer version of Arduino. Download this file, open it, and click **Run**. This will bring up the Installation Options dialog (Figure 1-5).

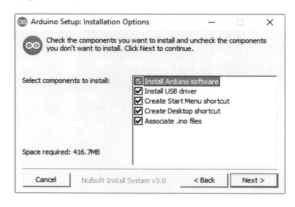

Check the **Install Arduino software** box along with the other options, or you'll have to install the drivers separately. Then, tell the installer where you'd like to install Arduino (we recommend accepting the default directory), and click **Install**.

Once you begin the installation process, have a snack or a cup of coffee, because it could take a few minutes to complete. Depending on your version of Windows, you might again be asked if you want to install drivers and if Arduino LLC is trusted, as pictured in Figure 1-6.

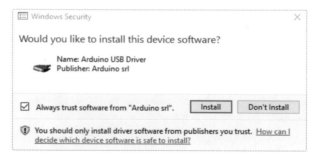

If you don't want to see prompts like this again, check the box that says you trust Arduino. Either way, click **Install** to install the USB drivers. That's it! Arduino typically installs a shortcut on your desktop. Double-click that now to run the Arduino IDE.

Installing on OS X

If you're using a Mac, download the Arduino IDE option for OS X, and follow the directions in this section.

Installing the IDE

After the download is complete, hover your cursor over your *Downloads* folder, and click **Open in Finder** as shown in Figure 1-7.

FIGURE 1-7:
After downloading, the program will be in the *Downloads* folder. Click **Open in Finder** to move it into the *Applications* folder.

Then, simply click and drag the *Arduino* program file into the *Applications* folder, as shown in Figure 1-8. In most cases, you won't need to install anything else, and you should be able to open the Arduino IDE as you would any other program.

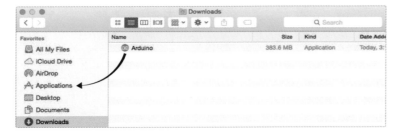

FIGURE 1-8:
Click and drag the *Arduino* file into the *Applications* folder on the left.

Installing the FTDI Driver Manually on OS X

If you're using a standard Arduino Uno board, the drivers should be preinstalled and work out of the box. If you're using the SparkFun RedBoard, there's one extra step needed to manually install a driver. The SparkFun RedBoard uses a USB chip from Future Technology Devices International (FTDI) to communicate with your computer. You need to manually install the FTDI driver for this chip. First, navigate to *http://www.sparkfun.com/ftdi/*. This will take you to our tutorial on installing FTDI drivers (see Figure 1-9).

Click the link for Mac OS X. This will direct you to options for a driver to install based on the version of OS X running on your computer. There is one option if you have Mac OS X 10.3 (Panther) to 10.8 (Mountain Lion) and another option if you have Mac OS X 10.9 (Mavericks) or greater.

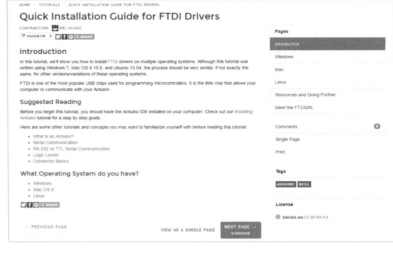

FIGURE 1-9:

SparkFun FTDI

Installation Guide

Download the appropriate driver and double-click it to start the installation process. You should be greeted with the familiar Mac software install window. Select your hard drive once it is found, and click **OK**. Continue through the installation process, and when the progress bar fills up (as in Figure 1-10), the drivers should be installed.

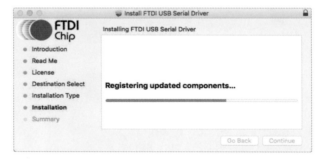

FIGURE 1-10:

Installation of the FTDI drivers on OS X

That's it! Now, double-click the Arduino icon in your *Applications* folder to run the IDE. If you've already opened the IDE before installing the FTDI drivers, you'll need to fully exit and close out of the Arduino IDE and restart it for your serial ports to show up correctly.

Installing on Linux

Arduino is available for Linux users, too. Download the correct Linux file for your system; it comes in 32- and 64-bit flavors. Then, uncompress the file using xz-utils or another file compression utility. If you want to use the latest version of Arduino in Linux, you may need to install some other dependency programs as well. Go to *http://playground.arduino .cc/Learning/Linux/* for distribution-specific information on this.

For most distributions of Linux (including Ubuntu, Debian, and Fedora), you should be able to use the `apt-get` package manager to install Arduino from the command line. Open a terminal and enter the following command:

```
sudo apt-get install arduino
```

Once the process is complete, open the Arduino program you just installed. Arduino uses Java to run the IDE and must be run out of an XWindows or comparable window user interface environment.

A BRIEF IDE TOUR

The IDE is a place for you to write instructions for your Arduino and test them out. These instructions form a program, or in Arduino terminology, a *sketch*. The IDE allows you to *upload* your sketch to your Arduino and control things in the physical world.

If you haven't done so already, open your newly installed Arduino program. After a splash screen, you should see the IDE, which looks something like Figure 1-11.

NOTE

Depending on the package manager for your distribution of Linux, the version you install this way may not be the latest version currently hosted on the Arduino site.

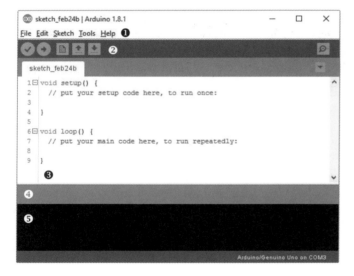

FIGURE 1-11:

The Arduino IDE

You can use the menu bar (which consists of File, Edit, Sketch, Tools, and Help menus) ❶ to open or save files, upload your code to the Arduino, modify settings, and so on. You should also see a set of graphic buttons ❷. In order from left to right, these are Verify/Compile, Upload, New, Open, and Save. We will explore those menus and buttons throughout this book. The majority of the IDE is whitespace ❸; this is where you'll write your code. Underneath the

code area is the *alert bar* ❹, and below it you'll find the console ❺; these report statuses, alerts, and errors. For example, if there's a typo in your sketch (called a *syntax error*), the IDE will show you the error there. If you try typing your name in the code window and click the check mark (Verify/Compile) button, the Arduino IDE will think for a bit and then show an error in the alert bar, highlight your name, and give you more information in the console about the error, as you can see in Figure 1-12.

FIGURE 1-12:

A typical error message
and readout in the
Arduino IDE

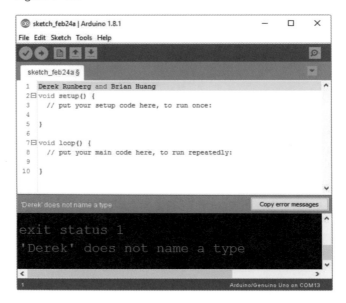

CHANGING THE DEFAULT PREFERENCES

Arduino is a fully open and configurable programming environment. There are a few minor things we like to tweak in the preferences to make it easier to write code, debug, and make cool stuff. Select **File ▸ Preferences** to view and change the general settings of the Arduino IDE. You should see a window similar to Figure 1-13.

We suggest adjusting the editor font size so it's comfortable for you to read. We also like to check **Display line numbers** and uncheck **Save when verifying or uploading**. Line numbers will help you navigate around your code easier, and unchecking the auto-saving feature will allow you to quickly test code without having to save it each time. Arduino is completely open, so if you want to, you can also click the *preferences.txt* file and adjust many other features.

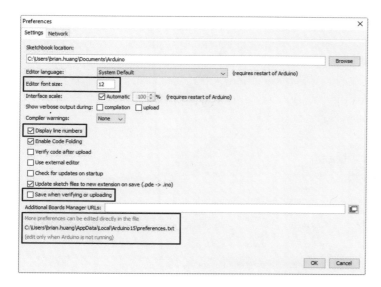

FIGURE 1-13:
Arduino Preferences
window

TEST DRIVE: PLUGGING IN THE ARDUINO FOR THE FIRST TIME

When you have the Arduino IDE and drivers fully installed, connect your Arduino board to the USB port of your computer using the appropriate cable. The power LED should turn on, and if your board is completely new, you should see an LED, labeled 13, blinking as in Figure 1-14. Your computer is powering the Arduino board through the USB cable, and it's running code that was installed at the factory. Unlike a computer, an Arduino can only store and run a single sketch at a time. The standard test sketch loaded onto an Arduino is a simple LED blink. With your board plugged in, you'll set up the IDE so that you can write your own sketch.

NOTE

If you plugged in your board before installing the IDE and drivers, you may need to restart your computer.

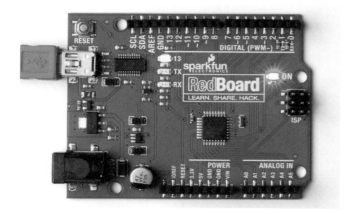

FIGURE 1-14:
The LED labeled 13 blinks when you power a new board.

Choosing Your Board in the IDE

Depending on your computer or operating system, it may take a little bit for the computer to identify the new hardware you just plugged in and associate it with the drivers you installed. After your computer recognizes the new device, click **Tools** and mouse over the **Board** option, as in Figure 1-15.

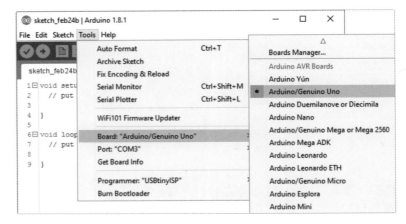

A list of pre-supported Arduino boards should appear. If you're using a standard Arduino Uno or the SparkFun RedBoard, select the option **Arduino/Genuino Uno**. If you end up using a board other than an Uno or RedBoard in the future, select the correct Arduino based on your board's documentation—this book assumes that you're using the Uno or an Uno derivative.

Selecting the Communication Port

Each device that's plugged into your computer has a unique communication port identifier. You need to configure the IDE so that it knows which port your Arduino is connected to. To do this, first select **Tools ▸ Port** to see the communication port options for your device. You'll see different options depending on your operating system.

On Windows

If you're using a Windows PC, you may see COM3, COM4, or another numbered COM port, as shown in Figure 1-16. Select this option. If no options show up, see "Basic Arduino Troubleshooting" on page 27.

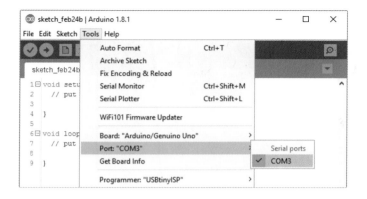

FIGURE 1-16:
Selecting the
communication port
on Windows

On OS X and Linux

On Mac or Linux machines, the communication port should be
listed as */dev/cu.usbserial-A<xxxx>*, where the *<xxxx>* is a string of
random characters unique to your Arduino. Select this option. You
may see more than one port listed, as in Figure 1-17, but only the
one with this unique ID string will map to your Arduino. If no options
show up, see "Basic Arduino Troubleshooting" on page 27.

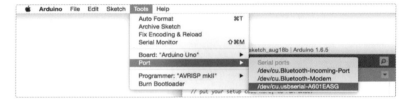

FIGURE 1-17:
Selecting the
communication
port on OS X

AN ARDUINO "HELLO, WORLD!"

"Hello, world!" is the classic first program that many beginning pro-
grammers write. In most other programming languages, this program
displays Hello, world! to the screen. Because the Arduino doesn't
have a screen, its version of "Hello, world!" is a blinking LED.

For your first sketch, we'll show you how to use an example
that comes with the Arduino IDE. With your board connected to your
computer, click the **File** drop-down menu and select **Examples ▶
01.Basics ▶ Blink** as shown in Figure 1-18 to open a sketch called
Blink.

A new IDE window containing the Blink sketch should open.
In this window, click **Sketch ▶ Upload** or click the **Upload** icon.
The IDE will turn this relatively human-readable code into 1s and 0s
that the Arduino understands (a process called *compiling*) and then
upload the sketch to your board.

FIGURE 1-18:

Finding the Blink sketch

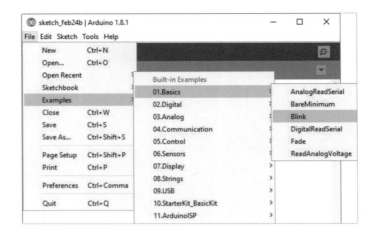

After you click Upload, watch the alert area for status messages. It should say *Compiling sketch…* and show a progress bar. After the compiling is complete, your computer will start to upload the sketch to your Arduino. The RX (receive) and TX (transmit) LEDs on your Arduino board should blink rapidly, indicating that the sketch is being transmitted to the Arduino board. The TX light blinks because you're transmitting something to the Arduino, and the RX light blinks because as the Arduino receives the sketch, it responds to your computer to confirm receipt. When the upload process is done, the status area on the IDE should say *Upload complete*, and the LED labeled 13 on your board should blink, as in Figure 1-19.

FIGURE 1-19:

Turning on LED 13

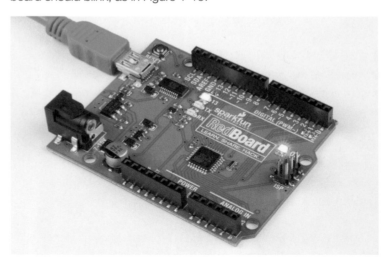

If you get any error messages, your Arduino might not be talking to your computer. Read the next section, "Basic Arduino

Troubleshooting," for some common problems to look out for, and then try uploading the sketch again.

BASIC ARDUINO TROUBLESHOOTING

The Arduino, like any other programmable piece of electronics, is temperamental at times. Here are a few troubleshooting tips for when you have trouble programming your Arduino.

1. Make sure that your Arduino is plugged into your USB cable and that the cable is plugged into your computer all the way. It's easy to have the cable only partially plugged into the board. You can also try unplugging it and plugging it back in.

2. Always confirm the board selected in the Board menu is the board plugged into your computer. For our examples, we will have *Arduino/Genuino Uno* selected.

3. Confirm that the correct communication port is selected in the Tools ▸ Port menu; it should have a checkmark or dot next to it. If you're not sure which port goes with your Arduino, unplug your USB cable from your computer, refresh the communication port listing, and watch to see which port disappears.

4. Make sure you didn't accidentally type some stray characters into your example sketch. The code will not compile if there are any extra characters.

5. On Windows, check your computer's Device Manager. Make sure that there isn't an exclamation mark next to the device. If there is, you need to reinstall the drivers manually.

6. If you're still getting error messages, reinstall the drivers for your board. We have additional instructions available at *www.sparkfun.com/ftdi/*.

These six tips are solutions to common speed bumps for anyone new to Arduino, so start here. If none of these suggestions solves the issue, just stay calm, be patient, and remember that you're not the first one to have a problem. If you get completely stuck, look for solutions on the official Arduino forum at *http://forum.arduino.cc/*.

ANATOMY OF AN ARDUINO SKETCH

In this section, we'll walk you through the Blink sketch that you uploaded to the Arduino in 'An Arduino "Hello, World!"' on page 25. First, Listing 1-1 gives the sketch itself, in all its blinky glory.

LISTING 1-1:

The Blink example

sketch

❶ ```
/*
 Blink
 Turns an LED on for one second, then off for one second,
 repeatedly.

 Most Arduinos have an onboard LED you can control. On the
 UNO, MEGA, and ZERO, it is attached to digital pin 13;
 on the MKR1000 it's on pin 6. LED_BUILTIN is set to the
 correct LED pin independent of which board is used.

 If you want to know which pin the onboard LED is connected
 to on your Arduino model, check the Technical Specs of
 your board at https://www.arduino.cc/en/Main/Products

 This example code is in the public domain.

 modified 8 May 2014
 by Scott Fitzgerald

 modified 2 Sep 2016
 by Arturo Guadalupi

 modified 8 Sep 2016
 by Colby Newman
*/

//the setup function runs once when you press reset or
//power the board
```
❷ ```
void setup() {
    //initialize digital pin LED_BUILTIN as an output
    pinMode(LED_BUILTIN, OUTPUT);
}

//the loop function runs over and over again forever
```
❸ ```
void loop() {
 digitalWrite(LED_BUILTIN, HIGH); //turn the LED on
 //(voltage level is HIGH)
 delay(1000); //wait for a second
 digitalWrite(LED_BUILTIN, LOW); //turn the LED off
 //(voltage level is LOW)
 delay(1000); //wait for a second
}
```

When writing sketches in Arduino, you need to be very specific
with the words, punctuation, and capitalization you use. These ele-
ments are part of a programming language's *syntax*. For the IDE to

compile your sketch properly, you must use words that it recognizes. These are called *keywords*, and you'll notice them when they change to a different color, such as orange, teal, or green. Now, let's look at some of the features used in this first sketch in detail.

## Key Sketch Elements

At the top of the sketch, you declare a new *global namespace* ❶. This is a space that describes what the sketch does and often includes other information such as variable initializations and library statements. Nearly every sketch will include a namespace. This sketch's namespace has comments written to help human readers understand what the sketch does. In the Arduino IDE, comments are gray. Every comment either starts with the characters // or is bounded by the symbols /* and */ if the comment is longer than a few lines. Notice that not all comments come between lines of code; some appear on the same line as the code they clarify. This doesn't affect the sketch, because comments are ignored by the IDE. Unlike with code, you can write anything you want in the comments using regular words, spelling, or punctuation.

The skeleton of any sketch consists of two main function definitions, setup() ❷ and loop() ❸. A *function* is simply a way of grouping multiple instructions or lines of code together. Each function has a data type, a name, and a group of instructions. The word before the function indicates the type of data the function will return. Both setup() and loop() have the type void because they do not return any values.

The name of every function includes a set of parentheses. These parentheses are where you pass *parameters* to the function. Parameters are values that a function needs to do its job. Neither setup() nor loop() needs parameters, but you'll use some functions in later projects that do need them. Finally, the lines of code that make up the function are grouped by an opening curly bracket, {, and closing curly bracket, }.

The setup() and loop() functions are required for every Arduino sketch; when the Arduino is turned on for the first time or is reset, the setup() code runs once and only once, and loop() code repeats continuously over and over. It's like baking cookies: instructions in setup() get out all of your tools and ingredients, and loop() bakes batches over and over until you turn off the oven (that is, the Arduino).

Now, let's figure out what each line of code in `setup()` and `loop()` is actually doing.

## The setup() Function

First, let's take a closer look at the Blink sketch's `setup()` function; see Listing 1-2.

**LISTING 1-2:**

The setup() code for our Blink example

```
void setup() {
 //initialize digital pin LED_BUILTIN as an output
 pinMode(LED_BUILTIN, OUTPUT);
}
```

The only line of code inside the `setup()` function is a call to the `pinMode()` function. Pins 0–13 on the Arduino are considered *general-purpose input/output (GPIO) pins*. They can be used as either inputs or outputs, and `pinMode()` allows you to tell the Arduino how you plan to use a digital pin. You do this by passing two parameters. The first is the pin number, and it can range from 0 to 13. The second parameter is the pin configuration.

For the pin reference, the Blink sketch uses a system constant called `LED_BUILTIN` to specify that you're using the default LED on the device. On most Arduino devices, this is the same as pin 13. Notice that the value is in all caps and colored dark teal. This color indicates that `LED_BUILTIN` is a special keyword with a predefined value used in the IDE.

The second parameter defines the pin configuration as an `OUTPUT`. Notice that the keyword `OUTPUT` is also dark teal because it is another constant used in Arduino. There are a few other choices here, which we'll cover in detail in Projects 4 and 9, but for now just note that Blink sets the pin as an `OUTPUT` for the LED.

If you were to describe this line of code as a sentence, it would say, "Tell pin 13 to output from the Arduino."

The very last character in the `pinMode()` call is a semicolon (;), which marks the end of a line of code. When you start writing your own sketches, always end a finished line of code with a semicolon. If you forget one, don't worry; nearly everyone who's ever programmed forgets a semicolon eventually, so the Arduino IDE will show a handy warning to help you figure out where to put the missing punctuation.

**NOTE**

*The pinMode() function follows a capitalization convention called camel case. In camel case, the first letter is lowercase, and any later letters that start words are capitalized.*

## The loop() Function

Now let's look again at the `loop()` function, which executes each instruction from top to bottom and repeats itself forever. See Listing 1-3.

```
void loop() {
 digitalWrite(LED_BUILTIN, HIGH); //turn the LED on
 //(voltage level is HIGH)
 delay(1000); //wait for a second
 digitalWrite(LED_BUILTIN, LOW); //turn the LED off
 //(voltage level is LOW)
 delay(1000); //wait for a second
}
```

**LISTING 1-3:**

The loop() code for the Blink sketch

The digitalWrite() function allows you to turn the Arduino pins on or off; this is called controlling a pin's *state*. This function also uses two parameters. The first indicates the pin you want to control; in this case, we're using the system constant LED_BUILTIN again. The second parameter is the state you want the pin to be in. To turn the light on, the Blink sketch passes in HIGH. To turn the light off, it passes in LOW.

The second instruction is delay(), which delays your sketch by the number of milliseconds you pass as its parameter. The Arduino Uno and derivative boards like the SparkFun RedBoard execute 16 million instructions per second; that's really fast! It's so fast, in fact, that without a delay, you'd never notice a change in the LED. The delay lets us control how long the LED stays on. In the example, delay(1000) instructs the Arduino to delay for 1,000 ms before executing the next command.

The next two lines of code are similar to the first two; they simply instruct the Arduino to turn the LED off and delay another 1,000 ms. After the last line, the loop() function repeats from the top and turns the LED back on.

---

### HACK THE (HELLO) WORLD

One of the best ways to learn from example code is by changing what it does. Try decreasing the delays to 500. Click **Upload**. How did the blink change? What if you pass delay() the number 5 instead? This is a 5 ms blink! Can you see it? What is the fastest blink rate that you *can* see?

---

## Your First Piece of Hardware

With the LED on your board working and blinking away, the next step is to add your first piece of hardware: an external LED. As we mentioned, the pins on the Arduino are used for hooking up inputs and outputs to the microcontroller, and we can demonstrate that simply with an LED. Grab an LED and take a close look at it. It will look something like Figure 1-20.

You'll notice that the LED has a short leg and a long leg. If you look really closely, you'll also see that the edge of the LED bulb has a flat surface on the same side as the short leg. These help you

identify the *polarity* of the legs; the LED's long leg is the positive leg, and the short leg on the side of the flat bulb surface is the negative, or ground, leg.

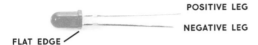

POSITIVE LEG

NEGATIVE LEG

FLAT EDGE

**FIGURE 1-20:**
An LED showing the long and short legs

Remember that `LED_BUILTIN` refers to pin 13 on the Arduino. So, adding your LED to the Arduino is as simple as plugging the long leg of the LED into pin 13 and the short leg of the LED into the GND (ground) pin right next to pin 13. Insert the LED now, with your board powered. If you plug it in correctly, as shown in Figure 1-21, the LED will start blinking. If the LED doesn't blink, you probably have it plugged in backward. Not to worry: pull it out and flip it around.

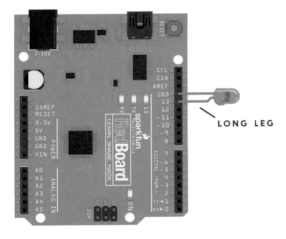

LONG LEG

**FIGURE 1-21:**
An LED added to pin 13 the quick and dirty way

## GOING FURTHER

Each project in this book will have a "Going Further" section, which describes ways to take the concepts you learned in that project to the next level. These sections will include advice on using the existing project, hacking the code, and modifying the project physically.

### Hack

For this project, we suggest you try to create some nifty blink patterns. First, copy and paste the four lines in the `loop()` function so that it repeats and you end up with eight lines of code. This gives you two blink sequences and more code to work with. You can create patterns by modifying the delay times to control when the

LED lights. For example, we made a pattern that looks like a heartbeat; our modified Blink sketch is shown in Listing 1-4.

**LISTING 1-4:**

Example code of a heartbeat pattern

```
void setup() {
 pinMode(LED_BUILTIN, OUTPUT);
}

void loop() {
 digitalWrite(LED_BUILTIN, HIGH);
 delay(200);
 digitalWrite(LED_BUILTIN, LOW);
 delay(200);
 digitalWrite(LED_BUILTIN, HIGH);
 delay(200);
 digitalWrite(LED_BUILTIN, LOW);
 delay(800);
}
```

For a real challenge, try programming your Arduino to flash the letters of your name in Morse code with a series of short (dot) and long (dash) blinks. Figure 1-22 shows a Morse code cheat sheet to help you figure out the blink patterns. The classic message that most people start with is S-O-S, or . . . - - - . . . (dot dot dot, dash dash dash, dot dot dot).

**FIGURE 1-22:**

Basic Morse code chart

## Modify

A blinking light is a powerful thing! With your newfound superpower, you can physically add LEDs to a lot of things around the house. A Halloween costume is always a great place for some blinky bling. You could solder the LED legs to some wire to make the connections longer so it's easy to hide the Arduino somewhere more comfortable for the wearer (like in a pocket). We took a Halloween spider we got from the local grocery store and hacked it with some creepy red eyes that blink (see Figure 1-23).

Another good fit for blinking and controlling LEDs is in scale modeling. Adding working LEDs to car headlights, buildings, or streetlights is always a great way to create the illusion of reality in any scale model or scene, as shown in Figure 1-24.

## SAVING YOUR SKETCH

Every project looks more stylish with a few blinking LEDs, so we suggest you keep your remixed Blink sketch handy so you can reuse parts of it in future builds. Save your sketch, and be sure to name it something descriptive that'll remind you what it is. Your filename should not contain any spaces; if it does, Arduino will replace the spaces with underscore (_) characters. By default, when you save your sketches, Arduino will save them to the Arduino sketchbook folder, usually found in the *Documents* folder on your computer. You can choose to save them elsewhere, but it's often a good idea to have all your sketches in one place.

When you're ready to level up your blinking skills, head to Project 2, where we'll show you how to build your very own Arduino-powered stoplight.

# A STOPLIGHT FOR YOUR HOUSE

IN YOUR FIRST BIG STEP TOWARD WORLD DOMINATION THROUGH EMBEDDED ELECTRONICS, YOU SET UP THE ARDUINO IDE AND BLINKED AN LED. THAT'S HUGE, BUT WITH AN ARDUINO, NO PROJECT NEEDS TO STOP AT JUST ONE LED. THIS PROJECT WILL SHOW YOU HOW TO EXPAND YOUR FIRST LED SKETCH TO DISPLAY

a blinking pattern on *three* LEDs. Your mission, should you choose to accept it, is to build and program a stoplight for a busy hallway in your house (see Figure 2-1).

**FIGURE 2-1:**

The completed
Stoplight project

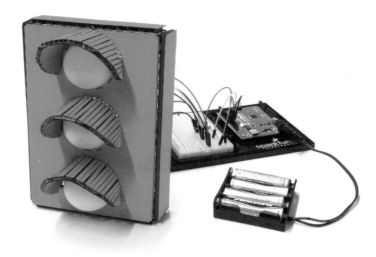

## MATERIALS TO GATHER

The materials in this project are all pretty simple. All of the electronic parts are standard in the SparkFun Inventor's Kit, except for the ones marked with an asterisk (*). If you're using your own kit or piecing together parts yourself, see the following parts list. Figure 2-2 shows all of the parts used in this project.

### Electronic Parts

- One SparkFun RedBoard (DEV-13975), Arduino Uno (DEV-11021), or any other Arduino-compatible board

- One USB Mini-B cable (CAB-11301 or your board's USB cable; not shown)

- One solderless breadboard (PRT-12002)

- One red LED, one yellow LED, and one green LED (COM-12062)

- Three 330 Ω resistors (COM-08377, or COM-11507 for a pack of 20)

- Male-to-male jumper wires (PRT-11026)

- Male-to-female jumper wires (PRT-09140*)

- (Optional) One 4 AA battery holder (PRT-09835*; not shown)

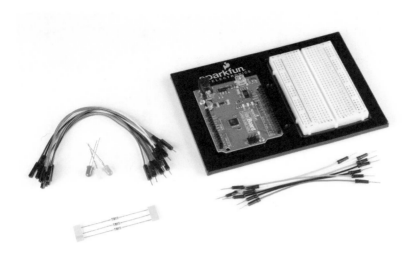

**FIGURE 2-2:**

Components for the
Stoplight

## Other Materials and Tools

If you want to build an enclosure like the one in Figure 2-1 or follow
the suggestions in "Going Further" on page 64, you'll also need the
following supplies, shown in Figures 2-3 and 2-4:

- Pencil
- Craft knife
- Metal ruler
- Pliers
- Wire stripper
- Glue (hot glue gun or craft glue)
- (Optional) Drill and a 3/16-inch drill bit
- (Optional) Soldering iron
- (Optional) Solder
- (Optional) Helping hands (not shown)
- Cardboard (about 12 inches square) or a cardboard box
- Two ping-pong balls
- Enclosure template (see Figure 2-15 on page 55)

**NOTE**

*Good, clean cardboard will
be worth its weight in gold
in these projects. We sug-
gest picking up cardboard
sheets from a craft or art
supply store.*

**FIGURE 2-3:**

Recommended tools

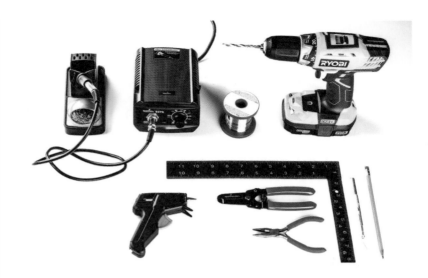

**FIGURE 2-4:**

Recommended building
materials

## NEW COMPONENT: THE RESISTOR

Although you used an LED on its own in Project 1, in most cases it's best to use a *resistor* to protect the LED from too much current. Resistors like the ones in Figure 2-5 are everywhere. They are indispensable when you're building circuits, and you'll need them to complete this project, too.

**FIGURE 2-5:**
Resistors up close and
personal

If you think of electricity like the flow of water through a pipe, a resistor is analogous to a point where the pipe size narrows, reducing the water flow. (If you're curious, see "Visualizing Electricity as Water in a Pipe" on page 4, which describes this metaphor in detail.) Resistors control or limit the flow of current.

Resistance is measured in *ohms* (typically shortened to Ω, the Greek symbol omega), and the colored bands on resistors represent their resistance. You'll find a resistor color band decoder in "Resistors and Bands" on page 308; however, in this book, you only need to be able to identify two different values of resistors: 330 Ω and 10 kΩ. The bands on a 330 Ω resistor are orange, orange, and brown (see Figure 2-5), while on a 10 kΩ resistor they're brown, black, and orange. There is also a fourth band on a resistor, and its color indicates the resistor's *tolerance*. A resistor's value will be accurate within a certain tolerance: silver means the resistor has a 5 percent tolerance, while gold indicates a 10 percent tolerance. The projects in this book aren't sensitive enough for the tolerance level to make a difference, though, so we'll just refer to the resistors by their assumed value, which will work for either tolerance band.

Some components, like LEDs, can be damaged if the current flowing to them is too high, and resistors can protect those components by reducing the current. Having a resistor in line with an LED to limit the current to a safe level is a good precaution so your LED doesn't burn out—or, in the worst case, pop! (Yes, they can literally pop.) From here on, we'll use current-limiting resistors in all projects.

## WHY THE STOPLIGHT USES 330 Ω RESISTORS

An average red LED has a maximum current rating of about 20 mA, as listed on its datasheet. In order to protect it, you need to add a resistor to keep the current below this limit. But how do you know to use a 330 Ω resistor?

The output pins on the Arduino provide 5 V when they are turned on. Depending on the color, each LED needs a slightly different amount of voltage to turn on, typically in the range of 2.0 to 3.5 V. A red LED turns on at about 2 V, and that leaves 3 V remaining. The 3 V will be dissipated across a resistor or anything else that is in line in the circuit. It's generally good practice to limit the current going through an LED to about half the maximum, so for the red LED with a maximum current rating of 20 mA, you get 10 mA. You can calculate the resistor needed for 3 V and 10 mA with *Ohm's law* (remember 10 mA = 0.01 A):

$$V = I \times R$$

$$R = \frac{V}{I} = \frac{3\,V}{0.01\,A} = 300\,\Omega$$

But 300 Ω isn't a standard resistor value. The closest standard resistor value is 330 Ω, and usually the nearest standard resistor is good enough. This should ensure that the LED lasts for a very, very long time. Since the resistor will be dictating the current, this is a *current-limiting resistor*.

If you have different resistors available, you could use a different value resistor and see what happens. Bigger resistors will make the current smaller, and smaller resistors will make the current bigger. What happens if you use the 10 kΩ resistor instead?

## BUILD THE STOPLIGHT PROTOTYPE

Now it's time to build the circuit. First, take a look at the schematic shown in Figure 2-6. You'll build this on a breadboard, as shown in Figure 2-7.

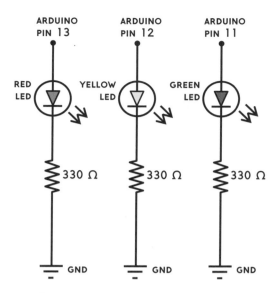

**FIGURE 2-6:**

Schematic diagram for the Stoplight project

The schematic illustrates how each component is connected electrically. Pin 13, pin 12, and pin 11 on the Arduino will each be used to control an individual LED on the Stoplight circuit. As you can see in the schematic, each LED is connected to an individual resistor, and each resistor is connected to GND (ground). Next, let's look at the wiring.

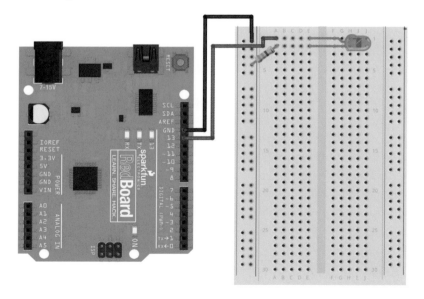

**FIGURE 2-7:**

Connecting a red LED to a breadboard with a current-limiting resistor

## Connect the Red LED to the Breadboard

Now you'll start to translate the schematic into an actual circuit. In the first project, you blinked an LED built into the Arduino board. This LED was internally wired to pin 13 on the Arduino. Because you'll be using three discrete LEDs, you need to wire these up yourself. Take out your breadboard, and, following the schematic in Figure 2-6 or the illustrated diagram in Figure 2-7, connect pin 13 to the positive (long) leg of the LED.

**NOTE**

*For a refresher on how breadboards work, see "Prototyping Circuits" on page 6.*

To wire this on the breadboard, we suggest that you first position your Arduino and breadboard as shown in Figure 2-7. (This will be the standard layout throughout the book.) Then, find a red LED and a 330 Ω resistor. Bend the resistor legs as shown in Figure 2-8 so that the resistor is easier to insert into the breadboard. We suggest using wire cutters to trim both resistor legs by about half their length to make the resistor easier to work with. Resistors aren't polarized like LEDs, so you don't have to keep track of which leg is positive or negative.

**FIGURE 2-8:**

Bending a resistor

Figure 2-9 shows a diagram of a typical breadboard. Most breadboards have labeled columns and numbered rows as references. Using these reference points, insert the LED into your breadboard as shown in Figure 2-7. The long, positive leg (anode) should be in column E, row 1 (E1) on the breadboard, and the short, negative leg (cathode) should be in column E, row 2 (E2). Now, find a 330 Ω (orange-orange-brown) resistor. Insert one leg of the resistor into any hole in row 2 of the breadboard to connect the resistor to the short leg of the LED. In our diagram, we insert this leg of the resistor into A2 on the breadboard. On all standard breadboards, for each row, columns A–E are connected, and columns F–J are connected. Now, insert the other leg of the resistor into the breadboard's *negative power rail*, which is the column marked with a blue or black line and a – (minus) symbol.

**FIGURE 2-9:**

A breadboard has numbered rows and columns labeled with letters.

## Add Power to the Breadboard

Grab two male-to-male jumper wires. We suggest using black for ground (GND) and red for power, and that's the convention we'll follow throughout this book.

Connect the black wire from the GND pin on the Arduino to the negative power rail on the breadboard. There are three pins labeled GND on the Arduino. You can use any of these. The power for each LED will actually come from the digital pins. Since pin 13 will power the red LED, connect a wire from pin 13 on the Arduino to A1 on the breadboard.

Plug your Arduino board into your computer using a USB cable, and the "Hello, world!" sketch from Project 1 should run, causing your LED to blink. In fact, both the LED on the breadboard and the LED on the Arduino should be blinking, because they're both wired into pin 13.

If the breadboard LED doesn't blink but the Arduino one does, double-check your wiring and the orientation of the LED. Make sure that the shorter leg is in the second row of the breadboard, connected to the resistor, and that the resistor is connected to GND through the negative power rail. After you get the red LED blinking, disconnect the Arduino from the computer so that you can safely build the rest of the circuit. It's best practice to disconnect the board while building your circuit.

## Add the Yellow and Green LEDs

Now, connect the yellow LED to pin 12 on the Arduino and the green LED to pin 11; you can follow the same basic instructions you followed for the red LED, but use different pairs of rows for each new LED, as in the final wiring diagram in Figure 2-10.

**FIGURE 2-10:**

The final Stoplight circuit, using pins 11, 12, and 13

Each LED should have its own resistor wired to the ground rail, just like the schematic from Figure 2-6. Notice, too, that we gave each LED a little space on the breadboard so that we could have room to plug in wires without messing up other parts of the circuit. Although we suggested a specific way to plug in this circuit, remember that you can use any part of the breadboard—so long as the two wires you're trying to connect are in the same row. Once you're done, your circuit should resemble Figure 2-11.

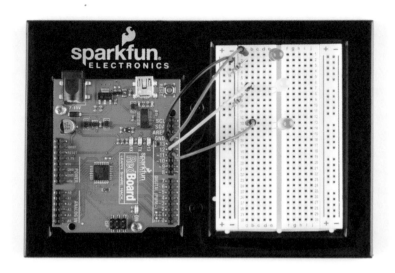

**FIGURE 2-11:**
The completed Stoplight circuit, including the Arduino, LEDs, and resistors

To mimic a real stoplight, this project needs a way to turn on each light for a certain amount of time and then switch to the next one. Fortunately, an Arduino sketch can use all kinds of instructions, including timing commands, to control a circuit.

## PROGRAM THE STOPLIGHT

Now, plug your Arduino back into your computer. It's time to get programming! Open the Arduino IDE to start a new sketch.

### Confirm Your IDE Settings

When writing any sketch, you should always start with a little house-keeping. First, check that the Board type and Port are properly set. Click **Tools ▸ Board** now. If you're using the SparkFun RedBoard or a standard Arduino Uno, select **Arduino/Genuino Uno**. Then, click **Tools ▸ Port**. In Windows, your Arduino should be set to the highest numbered COM port. On OS X or Linux, the port should be listed as */dev/cu.usbserial-A<xxxx>*, where *<xxxx>* is a string of random characters unique to your Arduino.

### Create Placeholders for Pin Numbers

With your IDE settings confirmed, you're ready to create the sketch. As discussed in "Anatomy of an Arduino Sketch" on page 27, a basic Arduino sketch consists of two parts: the setup() function and the loop() function. That simplified description is true for most simple sketches, but more complex sketches have many different parts. One new part that the Stoplight sketch uses is the *global*

*namespace*, which is the part of your sketch above the `setup()` function and completely outside of any function. In this space, you can define certain names (*variables*) as placeholders for values, and these values will then be available for all parts of your sketch to use. Arduino sketches can work with several types of values.

### Data That Sketches Understand

The Arduino language includes a number of possible *data types* for values, and there are a few you'll run into often when writing sketches. The following list isn't exhaustive, but it touches on the big ones and shows how their names appear in code:

**Integer (`int`)**   A whole number that ranges from –32,768 to 32,767

**Float (`float`)**   A number that has a decimal point and ranges from –3.4028235E+38 to 3.4028235E+38

**Byte (`byte`)**   A number that ranges from 0 to 255

**Character (`char`)**   A single letter, denoted by a set of single quotes, such as `'a'`

**String (`String`)**   A series of characters, denoted by a set of double quotes, such as `"hello"`

**Boolean (`Boolean`)**   A value of either `true` or `false`, which maps to `1` or `0` in the sketch and `HIGH` or `LOW` in terms of pin output

Arduino sketches require you to specify the data type of a variable when you define it. Let's look at how that works.

### Values That Can Change

Most values you'll create to use in your sketches will be variables. Think of a variable as a placeholder for a piece of data. That data can be a number, a letter, or even a whole sentence.

Before you can use a variable, you have to *define* it, which includes giving it a name, declaring its data type, and initializing it with a value. It's a good habit to give a variable a value at the moment you define it, which looks something like this:

```
❶int ❷val = ❸10;
```

This variable definition has three parts: the data type ❶, the name of the variable ❷, and the variable's value ❸. At the end of this line, notice that there is a semicolon—this denotes the end of a statement or instruction. The semicolon is very important, and forgetting it is often the root cause of many compiler errors or bugs in code, so be careful to remember it!

When choosing a variable name, you can use any unbroken set of characters, including letters and numbers. There is one caveat here: variables cannot start with a number or consist of any special characters. We suggest making variable names as descriptive as possible, while keeping them short. It's a chance for you to be a little creative with abbreviating words and descriptions. In this example, we chose to name the variable val (short for *value*), and 10 is the variable's *initialized value*, or the value assigned to a variable to start with. You don't need to initialize a variable when you define it, but doing both at the same time is helpful and a good practice.

For this project, you'll create three variables to store pin numbers for the three LEDs the Arduino will control. It's a lot easier to work with a variable that describes an LED color than it is to try to remember which LED is connected to which pin!

Start a new sketch, and add the code in Listing 2-1 to the global namespace of your sketch.

```
byte redPin = 13;
byte ylwPin = 12;
byte grnPin = 11;
```

**LISTING 2-1:**
Variables that represent pin numbers

Again, these three variables store the pin numbers for the three LEDs. On the Arduino, pin numbers are limited to whole numbers between 0 and 13, so we use the byte data type. We can use byte because we know that the pin number will be less than 255. Notice that each variable's name describes what it contains: redPin is for the red LED pin, ylwPin is the yellow LED pin, and grnPin is the green LED pin. And, just as Figure 2-10 shows, the red pin is pin 13, yellow is pin 12, and green is pin 11. Now, anytime you use a pin number in your sketch, you can use the descriptive variable name instead.

**NOTE**

*For legibility, we camel-cased the variable names by capitalizing the p in pin. Camel-casing is a coding convention that allows you to separate words in a variable without using spaces.*

## Write the setup() Function

To continue writing the Stoplight sketch, add the setup() function in Listing 2-2.

```
void setup()
{
 //red LED
 pinMode(redPin❶, OUTPUT❷);
 //yellow LED
 pinMode(ylwPin, OUTPUT);
```

**LISTING 2-2:**
setup() code for the Stoplight

```
//green LED
pinMode(grnPin, OUTPUT);
}
```

Just like the "Hello, world!" sketch in Project 1 (see "The setup() Function" on page 30), this sketch configures the digital pins of the Arduino in setup() with the pinMode() function.

This project uses three different digital pins, so the sketch has three separate pinMode() functions. Each function call includes a pin number as its variable ❶ (redPin, ylwPin, and grnPin) and the constant OUTPUT ❷. It uses OUTPUT because this sketch controls LEDs, which are output devices. We'll introduce INPUT devices in Project 4.

### Write the loop() Function

Next comes the loop() function. Normal stoplights cycle from red to green to yellow and then back to red, so this project does, too. Copy the code from Listing 2-3 into the loop() portion of your sketch.

**LISTING 2-3:**

loop() code for the Stoplight

```
void loop()
{
 //red on
 digitalWrite(redPin, HIGH);
 digitalWrite(ylwPin, LOW);
 digitalWrite(grnPin, LOW);
 delay(2000);

 //green on
 digitalWrite(redPin, LOW);
 digitalWrite(ylwPin, LOW);
 digitalWrite(grnPin, HIGH);
 delay(1500);

 //yellow on
 digitalWrite(redPin, LOW);
 digitalWrite(ylwPin, HIGH);
 digitalWrite(grnPin, LOW);
 delay(500);
}
```

The Stoplight will have only one light on at a time, to avoid confusing your hallway traffic and causing chaos. To maintain order, each time an LED is turned on, the other LEDs should be turned off. For example, if you wanted the red light to be on, you'd call the function digitalWrite(redPin, HIGH), followed by digitalWrite(ylwPin, LOW) and digitalWrite(grnPin, LOW). The first call writes HIGH to

turn on the red LED on `redPin` (pin 13), and the other two calls write `LOW` to `ylwPin` and `grnPin` (pins 12 and 11) to turn off the yellow and green LEDs. Because the Arduino runs at 16 MHz (roughly one instruction per 16 millionth of a second), the time between these commands is on the order of a few microseconds. These three commands run so fast that you can assume they all happen at the same time. Finally, notice the function `delay(2000)`. This function pauses the sketch and keeps the red light on for 2,000 ms, or 2 seconds, before executing the next set of instructions.

The code for the yellow and green LEDs repeats the same concept, setting the corresponding pin to `HIGH` and the others to `LOW` and delaying for different lengths of time. For your own Stoplight, try changing the delay times to something a little more realistic for your hallway's traffic. Remember that the value you pass to the `delay()` function is the amount of time you want the LED to stay on in milliseconds.

## Upload the Sketch

After you've typed in all of the code, double-check that it looks like the code in Listing 2-4, save your sketch, and upload it to your Arduino by clicking **Sketch ▸ Upload** or pressing CTRL-U. If the IDE gives you any errors, double-check your code to make sure that it matches the example code exactly. Your instructions should have the same spelling, capitalization, and punctuation, and don't forget the semicolon at the end of each instruction.

When everything works, your LEDs should turn on and off in a cycle that is similar to a real stoplight—starting with a red light, followed by a green light, and then a short yellow light before returning to the top of the `loop()` function and going back to red. Your sketch should continue to run this way indefinitely while the Arduino is powered.

```
byte redPin = 13;
byte ylwPin = 12;
byte grnPin = 11;

void setup()
{
 pinMode(redPin, OUTPUT);
 pinMode(ylwPin, OUTPUT);
 pinMode(grnPin, OUTPUT);
}
```

**LISTING 2-4:**

Complete code for the Stoplight

```
void loop()
{
 //red on
 digitalWrite(redPin, HIGH);
 digitalWrite(ylwPin, LOW);
 digitalWrite(grnPin, LOW);
 delay(2000);

 //green on
 digitalWrite(redPin, LOW);
 digitalWrite(ylwPin, LOW);
 digitalWrite(grnPin, HIGH);
 delay(1500);

 //yellow on
 digitalWrite(redPin, LOW);
 digitalWrite(ylwPin, HIGH);
 digitalWrite(grnPin, LOW);
 delay(500);
}
```

## Make the Stoplight Portable

When your Arduino is connected to your computer, it's receiving power through the USB port. But what if you want to move your project or show it around? You'll need to add a portable power source—namely, a battery pack. The Arduino board has a barrel jack power port for plugging battery packs into, as well as an on-board voltage regulator that will accept any voltages from about 6 V to 18 V. There are many different battery adapters available, but we like using a 4 AA battery adapter for a lot of our projects, as shown in Figure 2-12.

**FIGURE 2-12:**

A 4 AA battery pack with a barrel jack adapter

Unplug the USB cable from your computer, insert four AA batteries into your battery pack, and plug your portable battery pack into your Arduino, as shown in Figure 2-13. If your batteries are charged, you can move your project around or embed it directly into a model stoplight!

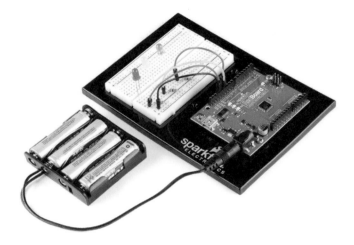

**FIGURE 2-13:**
Making the Stoplight portable by adding a battery pack

Now you'll level up this project. In the next section, we'll show you how to turn these LEDs into a model stoplight that you can mount in high-traffic areas of your house.

## BUILD THE STOPLIGHT ENCLOSURE

Once your Arduino isn't tethered to a computer, you can build any electronics project into a more permanent enclosure. The circuit on your breadboard is great, but you probably have to use your imagination to picture it as a stoplight. For maximum effect, the Stoplight just needs a good housing and lenses that will make the lights visible from a distance. The enclosure is optional if all you want to do is prototype, but we hope you'll try it out.

For this project, we'll show you how to build a more realistic-looking stoplight with some cardboard or cardstock, but you can use any material that you happen to have lying around. Be creative! Our example, shown in Figure 2-14, is made from some cardboard, ping-pong balls, and a bit of crafting skill.

You can either build a stoplight on your own using this project only as an inspiration or, if you want to reproduce this project exactly as you see it here, download the ZIP file of templates and sketches at *https://www.nostarch.com/arduinoinventor/*. Each project in this book includes templates that you can print, trace, and hand-cut the old-fashioned way with a craft knife and a metal ruler.

Extract the Project 2 files from the ZIP file, and print the Stoplight template PDF at full size if you'd like a cutting guide. With your templates in hand, collect the other items listed in "Other Materials and Tools" on page 39 and start building.

## Cardboard Construction

First, cut out the templates, shown in Figure 2-15. In our template, the housing body is a single piece of cardboard that is meant to be cut out, scored, and folded.

Trace the template onto your cardboard, and make careful note of the dashed lines, perhaps by drawing them on your cardboard in a different color. You'll score the cardboard along those lines to bend it, so whatever you do, don't cut along them yet.

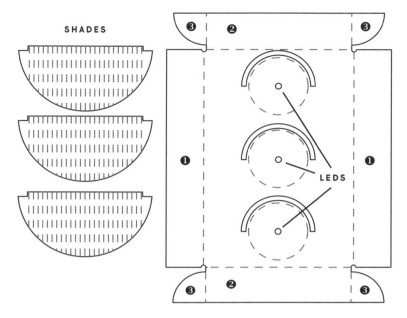

SHADES

LEDS

**FIGURE 2-15:**

Enclosure template for the Stoplight (not full size)

Once you have everything traced, cut out the stoplight pieces along the solid lines using a craft knife and a metal ruler, as shown in Figure 2-16. If you've never used a craft knife before, be sure to read "Using Craft Knives Safely" on page 56. Score the cardboard for the housing along each dotted line, on the exterior side of the cardboard. When scoring cardboard, you take a couple of shallow passes with the craft knife (don't cut all the way through). Don't score the shades yet.

**FIGURE 2-16:**

Scoring along the template with a craft knife and metal ruler

## USING CRAFT KNIVES SAFELY

You'll use craft knives a lot in this book, so it's important to know how to safely use them. Just like any tool, when used incorrectly, craft knives like the one here can cause injury.

Here are a few tips for using craft knives safely:

- Always pull the blade when slicing through sheet materials. Pushing or forcing the blade in any other direction raises the potential for slipping or breaking the blade.

- Be patient. Don't try to cut through the entire thickness of the material in a single pass. Make multiple passes with medium pressure. This will save your blade and also produce a cleaner finished product in the end.

- Use a straightedge made of metal, such as a metal ruler. If you use a wooden or plastic ruler as a straightedge, you run a higher chance of your blade catching the straightedge, rebounding off the material, and ultimately moving toward your hand.

- Keep your fingers out of the way. This may seem obvious, but accidents happen.

- If your knife starts to roll off your desk, let it fall, and just pick it up off the floor. If you reach for it and catch it before it falls, you run the risk of stabbing yourself in the hand. Ouch!

- Finally, use sharp, new, and intact blades. If a blade breaks, replace it. If a blade is dull, replace it. Cutting through paper and cardboard dulls blades very quickly. Keep a supply of extra blades around, and if it's starting to get hard to cut, replace the blade.

Once you have cut out your cardboard enclosure, add the mounting holes for the three LEDs; these should be at the little solid-lined circles inside the big dashed circles. One easy option is to carefully press a sharp pencil through the cardboard to make the holes. For cleaner holes, however, we suggest using a 3/16-inch drill bit and power drill to make holes in the cardboard, as in Figure 2-17. The LEDs are about 5 mm (about 0.197 inches) in diameter. You want the hole to be a nice, tight fit. So, a 3/16-inch hole (0.1875 inches) is perfect for making the fit snug for the LED.

Be careful when completing this step, and make sure to watch where your fingers and hands are relative to the drill bit. You don't want to drill into yourself! You can also use the drill bit without the drill and manually spin it through the cardboard if you don't have a drill or aren't comfortable using one.

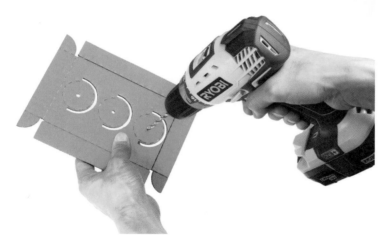

**FIGURE 2-17:**
Drilling holes for the LEDs

Once you have the holes drilled, remove the three LEDs from your breadboard and insert them through the back side of the cardboard, as shown in Figure 2-18. Remember that standard traffic lights are usually ordered red, yellow, and green from the top to the bottom. Pay attention to where the LEDs connect on the board, because we're going to reconnect them at the end.

**FIGURE 2-18:**

All three LEDs pressed
into the cardboard

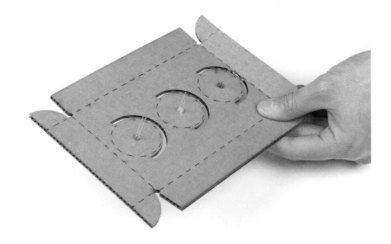

Next, bend the cardboard along the scored lines, as shown in
Figure 2-19. Bend the vertical sides ❶ toward the interior, and then
do the same with the top and bottom sides ❷ and the tabs ❸. (The
sides and tabs are labeled in Figure 2-15.)

**FIGURE 2-19:**

Prefolding the scored
cardboard to form
an enclosure for the
Stoplight

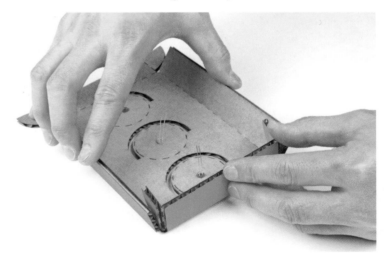

Position the tabs ❸ inside the vertical sides ❶, and glue them
in place as shown in Figure 2-20. You can use hot glue, tape, or
craft glue—we prefer hot glue because it's easy to work with, sets
quickly, and has a pretty strong bond.

Repeat this for the top and bottom corners. You should end up
with a shallow rectangular box with an open back.

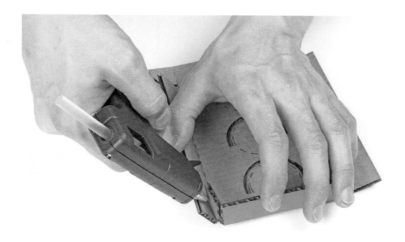

**FIGURE 2-20:**
Folding and gluing the
cardboard housing

## Make the Stoplight Lenses

The Stoplight's lenses are made from ping-pong balls cut in half, but
you can use anything that's moderately translucent.

If you're using ping-pong balls or something similar, carefully
cut two balls in half. When doing this, place the ball against a cut-
ting mat or thick piece of cardboard and hold it firmly at the sides
with your fingertips. Carefully push the knife blade down toward
the mat and into the ping-pong ball (making sure the blade isn't
pointing at you or your hand) to make an incision as shown in
Figure 2-21. Rotate the ping-pong ball and repeat until you've cut
all the way through. Make sure to keep your fingers away from the
blade, and always cut on a cutting mat or a piece of cardboard.

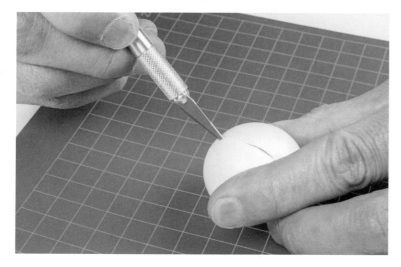

**FIGURE 2-21:**
Safely cutting a
ping-pong ball

Once you have three ping-pong ball halves (you'll have four; one's an extra to use in future projects or as a small hat for your favorite stuffed animal), secure them with a dab of hot glue as shown in Figure 2-22.

**FIGURE 2-22:**

The enclosure with ping-pong balls as lenses

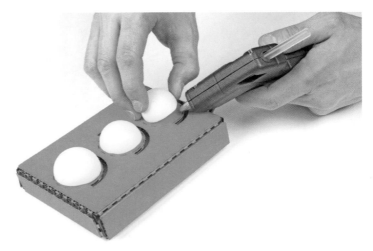

## Make the Shades

Finally, add the shades to the Stoplight. For a nice curve, make a number of parallel scores, about 1/8 inch apart, as shown in Figure 2-23. There are example score lines in the template, so you can follow those. After making all of your scores, bend each shade into a curve, as shown in Figure 2-24.

**FIGURE 2-23:**

Scoring a shade

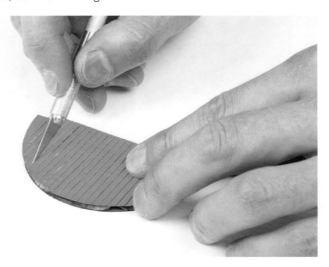

**FIGURE 2-24:**
Bending the shade into a curve

Once you have the shades bent and shaped to your liking, fit them into the housing just above each lens, as shown in Figure 2-25, and then glue them in place. If you're going for a more finished or realistic look, you can spray paint the housing black. Make sure you either remove the lenses or cover them with masking tape first so that they don't get coated in spray paint.

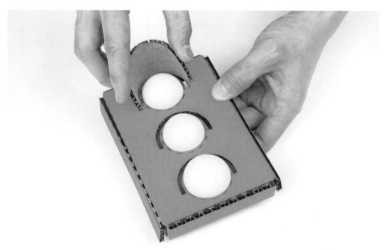

**FIGURE 2-25:**
Fitting a shade into the housing

## Mount the LEDs and Arduino

All you have left to do is to connect the LEDs from the new enclosure to your Arduino. First, use two male-to-female jumper wires (SparkFun PRT-09385) to extend each of the LEDs. You'll need a total of six of these jumper wires. Simply plug each LED leg into the

female end of the jumper wire. To keep things organized, we like to use black wires for the negative (shorter) leg and colored wires for the positive (longer) leg, as shown in Figure 2-26.

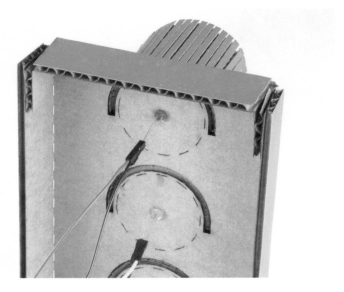

With the jumper wires connected to the LEDs, plug the male end into the breadboard in the same place where the LED came out, as shown in Figure 2-27. Again, pay attention to which LED goes where. If you don't remember, consult the original diagram in Figure 2-10.

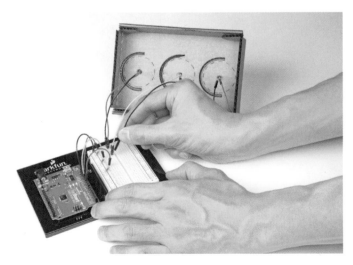

Check to make sure your connections work by plugging in the Arduino to your computer or to a battery pack. If one of the lights isn't working, try jiggling the connections or double-checking that the wires are plugged into the correct row on the breadboard.

You can either leave the Arduino and breadboard outside the Stoplight housing or tack them inside the housing with glue or double-sided tape. Whatever you decide, when you're done, power up your Stoplight, and go find a busy hallway intersection in need of traffic safety.

Figure 2-28 shows the finished Stoplight in all its glory.

**FIGURE 2-28:**
Finished Stoplight project

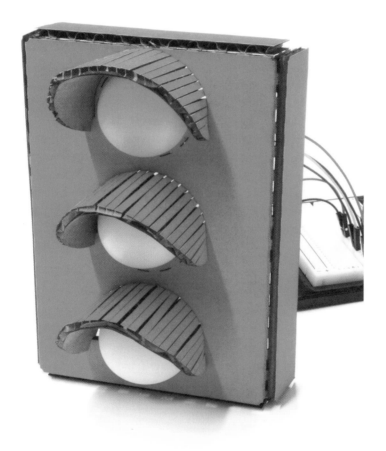

## GOING FURTHER

The concepts you saw while building the Stoplight, such as timing the control of output (LEDs), can be applied to a number of different uses in your house and life. Here are a couple of suggestions for adapting the Stoplight.

### Hack

The basic concept of a stoplight is all about timing. When else would a timer be useful? What about changing the code to help you time frying an egg? You could rework the Stoplight so that the red LED is lit while the egg is still in a state of "iffy" or "rare" doneness, the yellow LED lights when it's almost cooked the way you like it, and then the green LED lights when the egg is done.

We can't give you the timing, as we probably have different preferences for how we like our eggs cooked. There are also a number of variables that will affect the timing, like the temperature, the type of pan, and the size of the egg. You'll have to figure that all out on your own.

In the code, you'd need to work with pretty big numbers for the delay, since it's measured in milliseconds. To set a delay in minutes, all you need is a little multiplication. Remember that 1,000 ms equals 1 second; multiply by 60, and you'll find that 60,000 ms equals 60 seconds, or 1 minute. For a delay of 3 minutes, you can multiply 3 by 60,000 directly in the delay() function, like this:

```
delay(60,000 * 3);
```

You may be wondering how long you can set the delay() function for. The data type that delay() receives is an *unsigned long*, which is any number that falls in the range of 0 to 4,294,967,295. So the maximum delay is 1,193 hours or so. Pretty cool! Knowing this, is there anything else you'd want to time with the delay() function?

## Modify

If you're looking to make this project more permanent and sturdy, you can solder wires to the LEDs instead of using the male-to-female jumpers. If you've never soldered before, turn to "How to Solder" on page 302 for some soldering instructions before you start. You'll need to snip the end off of a male-to-male jumper wire, strip the insulation back about 1/2 inch using wire strippers, and then solder the stripped end to each leg of a trimmed LED, as shown in Figure 2-29. Notice that we twisted the wire around the leg of the LED to hold it securely while soldering. After soldering, the connection will be more durable, and you'll be able to use the LEDs for other projects since the other end is still a male jumper.

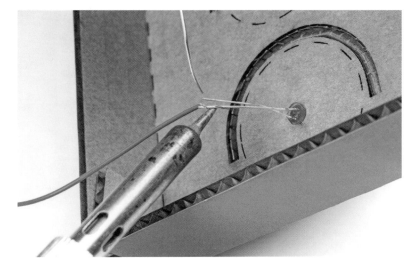

**FIGURE 2-29:**
Soldering a cut jumper wire to an LED

Though this project looks impressive, the programming and hardware are pretty simple. As you read about sensors and logic over the next few chapters, we encourage you to think back to this project and brainstorm ways you can elaborate on it with what you learn.

# THE NINE-PIXEL ANIMATION MACHINE

WE USE MONITORS EVERY DAY, ON OUR PHONES, COMPUTERS, TABLETS, AND TVS. THE DISPLAYS ON MOST PRESENT-DAY MONITORS ARE COMPOSED OF MILLIONS OF <u>PIXELS</u>, SHORT FOR <u>PICTURE ELEMENTS</u>. PIXELS ARE TINY POINTS THAT THE COMPUTER CAN LIGHT UP IN DIFFERENT COLORS; ALL THE PIXELS TOGETHER MAKE UP THE TEXT, IMAGES, AND VIDEOS ON THE SCREEN.

In this project, you're going to build a simple monitor using LEDs. You'll expand on your work with blinking LEDs and learn to use custom functions in Arduino. Finally, you'll learn how to display secret characters on your very own Nine-Pixel Animation Machine. You can see ours in Figure 3-1.

**FIGURE 3-1:**

A completed Nine-Pixel Animation Machine

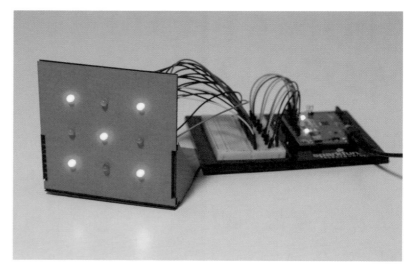

You can use the Nine-Pixel Animation Machine to show letters and numbers, draw basic geometric shapes, and make plenty of other fun pixel art.

## MATERIALS TO GATHER

For this project, you'll need a few more electronic components than you used in Project 2, specifically more LEDs. This project is simpler in terms of enclosure construction, however. The materials you'll need are shown in Figures 3-2 and 3-3.

### Electronic Parts

- One SparkFun RedBoard (DEV-13975), Arduino Uno (DEV-11021), or any other Arduino-compatible board
- One USB Mini-B cable (CAB-11301 or your board's USB cable; not shown)
- One solderless breadboard (PRT-12002)

**NOTE**

*In our project all the LEDs are the same color so the patterns are easier to see, but if you don't have nine LEDs of the same color, you can mix them up.*

- Nine LEDs, preferably of the same color (COM-10049 for a pack of 20 red and yellow LEDs)
- Nine 330 Ω resistors (COM-11507 for a pack of 20)
- Male-to-male jumper wires (PRT-11026)
- Male-to-female jumper wires (PRT-09140*)
- (Optional) One 4 AA battery holder (PRT-09835*; not shown)

**NOTE**

*The parts marked with an asterisk (*) do not come with the standard SparkFun Inventor's Kit but are available in the separate add-on kit.*

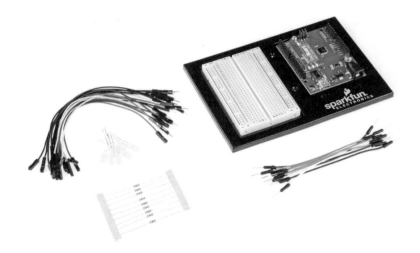

**FIGURE 3-2:**

Components for the Nine-Pixel Animation Machine

## Other Materials and Tools

- Pencil
- Craft knife
- Metal ruler
- Wire cutters
- Glue (hot glue gun or craft glue)
- Graph paper (not shown)
- (Optional) Drill and a 3/16-inch drill bit
- (Optional) Soldering iron
- (Optional) Solder
- (Optional) Helping hands (not shown)
- Cardboard sheet (roughly 8 × 11 inches, or 20.5 × 30 cm; not shown)
- Enclosure template (see Figure 3-13 on page 83)

**FIGURE 3-3:**

Recommended tools

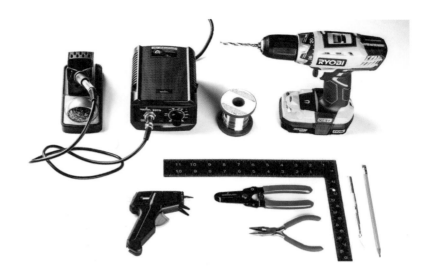

## BUILD THE NINE-PIXEL ANIMATION MACHINE PROTOTYPE

This simple pixel art display will teach you to manage lots of wires in one circuit, which is important as your circuits grow larger. First, you'll use the breadboard to make sure the circuit works, test a sketch, and get comfortable with all of the jumper wires. (We'll show you how to transfer the LEDs to a display housing in "Cardboard Construction" on page 83.) Notice that the circuit diagram in Figure 3-4 looks a lot like Figure 2-6 on page 43. That's because this project uses the same LED circuit, but instead of just three LEDs, it uses nine LEDs, each of which is independently controlled by a pin on the Arduino.

**FIGURE 3-4:**

Schematic diagram for the Nine-Pixel Animation Machine

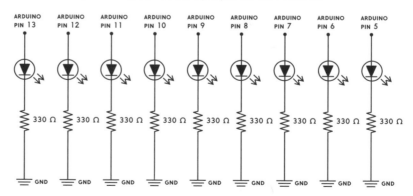

In this section, you'll use the breadboard to connect all nine LEDs to pins on the Arduino. With your components and jumper wires in hand, build the circuit in Figure 3-5 on your breadboard. If you want to practice building smaller LED circuits first, flip back to "Connect the Red LED to the Breadboard" on page 44 for a refresher.

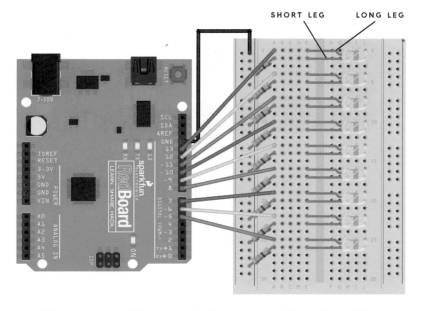

SHORT LEG     LONG LEG

**FIGURE 3-5:**

Nine LEDs connected to the Arduino, with the pin 13 LED at the top and the pin 5 LED at the bottom

Wiring up nine LEDs can make for a cluttered breadboard. To keep your breadboard organized, connect the ground rail (–) on the left side of your breadboard to the GND pin on the Arduino first. That's the black wire in Figure 3-5. Then, connect your first LED's negative leg (the shorter one) to this ground rail through a 330 Ω resistor. In Figure 3-5, the long leg of the LED is in row 1, and the shorter leg is in row 2. Finally, connect the long leg of the LED to pin 13 with a jumper wire from pin 13 of the Arduino to row 1 of the breadboard. Connect the other eight LEDs to pins 12 through 5 in the same way. And remember: the LED's short leg is its negative leg. As you're building this circuit, make sure that the shorter leg of each LED is connected to the ground rail of the breadboard through a resistor. When you're done, your circuit should resemble the circuit in Figure 3-6.

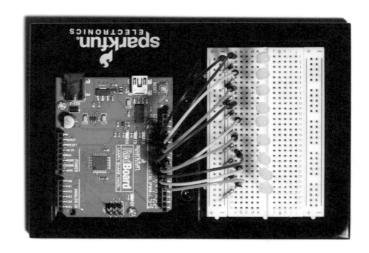

Once you've wired the nine LEDs, open the Arduino IDE and plug the Arduino into your computer with the USB cable. If you uploaded a sketch to the Arduino in a previous project, you might see the LEDs light up as it runs the last sketch you uploaded. Now let's take a look at how you'll code up all nine of these LEDs.

## PROGRAM THE NINE-PIXEL ANIMATION MACHINE

In previous projects, it's been simple enough to use a bunch of `digitalWrite()` functions and `delay()` functions to control LEDs. But with nine LEDs, you'd have a really messy `loop()` function! Instead, you can write your own *custom function* to blink a single LED, and then use this function to control all the LEDs.

### What Are Custom Functions?

The Arduino language has 60 or so *built-in* (or predefined) functions that make it easier for you to interact with hardware using simple, single-line instructions. The `digitalWrite()` and `delay()` functions are two examples. Behind the scenes, the `digitalWrite()` function consists of more than 20 lines of code. Most of that code is complex, but the `digitalWrite()` function is easy to understand.

Even when you understand a big sketch, typing 20 or more lines of code each time you want to turn an LED on or off is tedious and error prone. Arduino's built-in functions cover common tasks, but when you need to do something specific to your sketch, you'll want

to write custom functions. Custom functions allow you to easily reuse code in other sketches, and they'll make your `loop()` functions easier to read.

## Write a Custom Function

You can use custom functions to teach the Arduino new commands. Your first test function will blink an LED on and then off again, using a modified version of the code in Listing 3-1.

```
void setup()
{
 pinMode(13, OUTPUT);
}

void loop()
{
 digitalWrite(13, HIGH);
 delay(1000);
 digitalWrite(13, LOW);
 delay(1000);
}
```

**LISTING 3-1:**

A simple sketch that blinks an LED

This code should look similar to the Blink example from Project 1 (Listing 1-1 on page 28). However, here we are using pin 13 explicitly instead of using the LED_BUILTIN system constant. This code turns the LED on, waits for a second, turns the LED off again, and then waits for another second before repeating. You'll need to do this a lot in later projects, so we'll show you how to put this code in a custom `blink()` function. To make your custom function as useful as possible, you'll write it in a way that allows you to use any pin for any delay time.

First, open a new sketch, copy the code from Listing 3-1 into it, and save it. Then, define the `blink()` function below your `setup()` and `loop()` functions, as shown in Listing 3-2.

```
❶void ❷blink(❸int pinNumber, int delayTime)
{
 //custom function code goes here
}
```

**LISTING 3-2:**

A skeleton for a custom `blink()` function

This is just the skeleton of the function. Function definitions always specify the data type that the function will return first ❶. The `blink()` function asks the Arduino to perform a task without expecting any data back, so, just like the `setup()` and `loop()` functions, its data type is void.

Next comes the function's name ❷, which in this case is blink. You can name Arduino functions almost anything you want, but they can't start with a number or include any spaces or special characters. Also, to make sure the function's purpose is clear when you're reading over your sketch, we recommend using a name that's descriptive and easy to remember.

After naming the function, define any parameters the function needs to work in parentheses ❸. To make blink() as reusable as possible, provide a pin number and a delay time as parameters. These allow you to specify which LED to blink and for how long. Each of the blink() function's parameters is an int. Notice that defining parameters is similar to declaring variables. That's because parameters are basically variables that can only be used inside the function.

Finally, a custom function has its own set of curly brackets, which enclose all of the code you want a call to the function to represent. For the blink() function, this is the set of digitalWrite() and delay() functions from Listing 3-1, as shown in Listing 3-3. Add the code inside the curly brackets to your blink() function now.

**LISTING 3-3:**

Custom blink() function

```
void blink(int pinNumber, int delayTime)
{
 digitalWrite(pinNumber, HIGH);
 delay(delayTime);
 digitalWrite(pinNumber, LOW);
 delay(delayTime);
}
```

Notice that in the digitalWrite() and delay() function calls, the blink() function replaces the pin number 13 and the delay of 1000 ms with the pinNumber and delayTime parameters, respectively.

## Use a Custom Function

Now you can use your custom function in place of the code in your loop() function, as in Listing 3-4.

**LISTING 3-4:**

Complete sketch using the new custom blink() function

```
void setup()
{
 pinMode(13, OUTPUT);
}

void loop()
{
 blink(13, 1000);
}
```

```
void blink(int pinNumber, int delayTime)
{
 digitalWrite(pinNumber, HIGH);
 delay(delayTime);
 digitalWrite(pinNumber, LOW);
 delay(delayTime);
}
```

The modified loop() function calls the blink() function and passes it the pin number of the LED to blink (13) and the amount of time the light should stay on or off, in milliseconds (we suggest using 1000, for 1 second). That's it! Doesn't this code look a lot cleaner and clearer?

Upload this sketch to your Arduino, and the LED on pin 13 should blink. Congratulations! You just "taught" the Arduino what blink() means, and you condensed four lines of code into a single instruction.

But custom functions are just one key to this project. You'll also want to plan some nine-pixel patterns ahead of time to make them easier to program, so let's do that now.

## TRY IT OUT: PLAY WITH PATTERNS

Before you finish the Nine-Pixel Animation Machine, spend some quality time with your more powerful blink() sketch. For example, change your loop() function as follows:

```
void loop()
{
 blink(13, 100); //short 100 ms blink on pin 13
 blink(13, 2000); //longer 2000 ms blink on pin 13
}
```

This makes the LED blink for 100 ms, followed by a longer blink of 2,000 ms. Try blinking the other LEDs to create your own patterns and sequences!

## Design Your Artwork

Grab colored pencils and graph paper, and put on your artist's hat! You're going to make some pixel art to display on the Nine-Pixel Animation Machine.

Start by drawing several 3 × 3 grids, or print out a copy of the template shown in Figure 3-7, which you'll find in this book's resource files. These drawings don't have to be perfect; you're just sketching out a few ideas.

**FIGURE 3-7:**

Blank grid planning template

We numbered the pixels with 13 in the upper-left corner and 5 in the lower-right corner. These numbers correspond to the LED pin numbers on the Arduino; this is how you'll control the LEDs in the Nine-Pixel Animation Machine. When your canvas is ready, get creative: fill in the pixels to make your own patterns. Figure 3-8 shows some examples that we came up with during a department meeting . . . don't tell our boss!

**FIGURE 3-8:**

Some pixel pattern examples

When you show these patterns and shapes in sequence, you can create animations! First, we'll teach you to program two simple shapes, and then we'll tackle a complete animation.

## The Test Sketch

Create a new sketch in the Arduino IDE, and add the setup() and loop() functions in Listing 3-5.

```
//LED array is set up in this arrangement:
// 13 ---- 12 ---- 11
// 10 ---- 9 ----- 8
// 7 ---- 6 ----- 5

void setup()
{
 pinMode(13, OUTPUT);
 pinMode(12, OUTPUT);
 pinMode(11, OUTPUT);
 pinMode(10, OUTPUT);
 pinMode(9, OUTPUT);
 pinMode(8, OUTPUT);
 pinMode(7, OUTPUT);
 pinMode(6, OUTPUT);
 pinMode(5, OUTPUT);
}

void loop()
{
}
```

**LISTING 3-5:**

setup() function for the Nine-Pixel Animation Machine

**NOTE**

*We also suggest adding a comment with a diagram of the LED placement. Describing the circuit you're writing code for in the sketch will help others re-create it and will remind you of the structure you're working with as you develop your code.*

This project uses nine LEDs on nine digital GPIO pins (13 through 5), so this setup() function has nine pinMode() functions. They're all set as OUTPUT since they're controlling LEDs.

## Write a Function to Draw an X

With the pinMode() functions in place, look at the shapes you drew by hand and pay attention to the numbers; they'll help you write your custom function. Figure 3-9 shows an example to test with—a simple X pattern.

**FIGURE 3-9:**

A nine-pixel X

The X pattern in Figure 3-9 translates to the set of digitalWrite() functions in Listing 3-6.

**LISTING 3-6:**

Code for displaying an
*X* on the nine LEDs

```
digitalWrite(13, HIGH);
digitalWrite(12, LOW);
digitalWrite(11, HIGH);

digitalWrite(10, LOW);
digitalWrite(9, HIGH);
digitalWrite(8, LOW);

digitalWrite(7, HIGH);
digitalWrite(6, LOW);
digitalWrite(5, HIGH);
```

These `digitalWrite()` function calls turn on only the LEDs on the grid's diagonals and turn off the rest. But drawing a single *X* takes nine lines of code! Instead of writing all of this out by hand every time, you can create a custom function to execute all of these calls with just one line of code.

Below the curly brackets of the `loop()` function, create a custom function named xChar() with the code in Listing 3-7.

**LISTING 3-7:**

The xChar() custom

function

```
void xChar()
{
 digitalWrite(13, HIGH);
 digitalWrite(12, LOW);
 digitalWrite(11, HIGH);

 digitalWrite(10, LOW);
 digitalWrite(9, HIGH);
 digitalWrite(8, LOW);

 digitalWrite(7, HIGH);
 digitalWrite(6, LOW);
 digitalWrite(5, HIGH);
}
```

We named this custom function xChar() because it displays an *X* character. This function won't return anything, so its data type is void. Since the `digitalWrite()` calls from Listing 3-6 are inside this single custom function, you can keep your `loop()` code simple. Call the function xChar() inside your existing `loop()`, as shown in Listing 3-8.

**LISTING 3-8:**

loop() function with
xChar() function call

```
void loop()
{
 xChar();
}
```

This is a small step, but it's very important. If you forget to actually call your custom function, its code will never run, and you'll never display your *X*.

Upload this sketch to your Arduino now. Your LEDs are still in a vertical line rather than a grid, but your sketch can still help you test that you've got everything wired and coded correctly. Instead of an *X*, you should see every other LED turn on, starting at the top, as shown in Figure 3-10. If the LEDs don't light up as expected, double-check your wiring against the diagram in Figure 3-5 on page 71, and check your digitalWrite() functions to make sure they're all correct as well.

When you can see the right pattern, read on to create a second character.

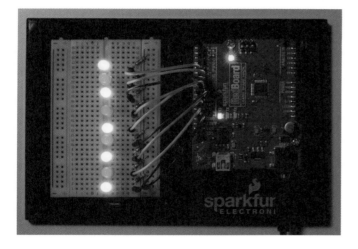

**FIGURE 3-10:**
Prototype and correct sequence for an *X*

## Write a Function to Draw an O

Next, you'll create an *O* like the one in Figure 3-11 to go with the *X*.

**FIGURE 3-11:**
A nine-pixel *O*

Pro tip: you can work smarter rather than harder here. Copy the entire xChar() function, paste the copy after the last curly bracket in xChar(), change its name to oChar(), and tweak it to look like Listing 3-9.

**LISTING 3-9:**

The oChar() custom function

```
void oChar()
{
 digitalWrite(13, HIGH);
 digitalWrite(12, HIGH);
 digitalWrite(11, HIGH);

 digitalWrite(10, HIGH);
 digitalWrite(9, LOW);
 digitalWrite(8, HIGH);

 digitalWrite(7, HIGH);
 digitalWrite(6, HIGH);
 digitalWrite(5, HIGH);
}
```

The only difference between xChar() and oChar() is which LEDs are turned on and which are turned off. Whereas xChar() turns on alternating LEDs, oChar() turns on every LED except the center one.

---

### TRY IT OUT: WRITE A CUSTOM FUNCTION FOR YOUR OWN IMAGE

We showed you how to write functions to draw an *X* and an *O*, but we're sure you have your own lovely pixel art images in mind. Create a function that will blink out the patterns you made, and hang on to it for when you're done building the Nine-Pixel Animation Machine.

---

### Display the X and the O

The goal now is to show an *X* character for a bit, then show an *O* character, and finally go back to the *X*. To show each character for a set time, you can add the oChar() function to your existing loop and slow the loop down with delay() calls. Update your sketch so that it looks like Listing 3-10.

```
//LED array is set up in this arrangement:
// 13 ---- 12 ---- 11
// 10 ---- 9 ----- 8
// 7 ---- 6 ----- 5

void setup()
{
 pinMode(13, OUTPUT);
 pinMode(12, OUTPUT);
 pinMode(11, OUTPUT);
 pinMode(10, OUTPUT);
 pinMode(9, OUTPUT);
 pinMode(8, OUTPUT);
 pinMode(7, OUTPUT);
 pinMode(6, OUTPUT);
 pinMode(5, OUTPUT);
}

void loop()
{
 //blink between x and o characters
 xChar();
 delay(500);
 oChar();
 delay(500);
}

void xChar()
{
 digitalWrite(13, HIGH);
 digitalWrite(12, LOW);
 digitalWrite(11, HIGH);

 digitalWrite(10, LOW);
 digitalWrite(9, HIGH);
 digitalWrite(8, LOW);

 digitalWrite(7, HIGH);
 digitalWrite(6, LOW);
 digitalWrite(5, HIGH);
}

void oChar()
{
 digitalWrite(13, HIGH);
 digitalWrite(12, HIGH);
 digitalWrite(11, HIGH);
```

**LISTING 3-10:**

The loop() looks similar to the one in the Blink sketch but uses xChar() and oChar() instead of digitalWrite().

```
digitalWrite(10, HIGH);
digitalWrite(9, LOW);
digitalWrite(8, HIGH);

digitalWrite(7, HIGH);
digitalWrite(6, HIGH);
digitalWrite(5, HIGH);
}
```

This loop displays an *X* for 500 ms and then switches to an *O* for 500 ms. Upload the updated sketch to your Arduino, and run it to see how it works. Every LED except the middle one lights up when oChar() is called. Figure 3-12 shows what you'll see as the LEDs blink.

**FIGURE 3-12:**

Switching between two patterns

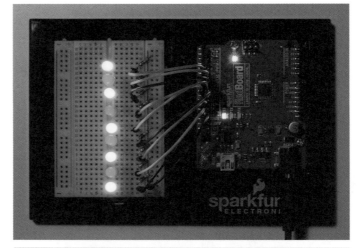

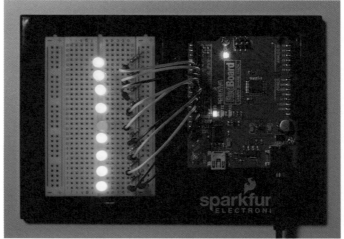

Save your sketch now, because you'll build on it later. But as long as the LEDs in this circuit are on the breadboard, they won't display any recognizable picture. So next, we'll show you how to make the display to see the Nine-Pixel Animation Machine in all its tiny glory.

## BUILD THE NINE-PIXEL ANIMATION MACHINE ENCLOSURE

The enclosure for this project is simply a cardboard display with holes for LEDs. There's wiring to do as well, but once that's done, you'll be able to make all kinds of pixel art.

### Cardboard Construction

Find a sheet of cardboard that is clean and free of creases and bends. Our designs are based around cardboard about 1/8 inch thick, but you can use any similar board or panel materials. Some materials will be easier to cut than others, so pick yours based on the tools you have.

#### Cut Out the Parts

Open the template shown in Figure 3-13 in this book's resource files (*https://www.nostarch.com/arduinoinventor/*) and trace it onto your cardboard. Try to line your templates up with the edge of the cardboard to make cutting easier.

**FIGURE 3-13:**
Enclosure template for the Nine-Pixel Animation Machine (not full size)

Once you've traced your pieces, cut them out. We highly recommend using a sharp craft knife and a metal ruler to get clean edges for your project. Remember craft knife safety: always pull (don't push) the blade, and make multiple passes rather than digging in deeply on your first go.

After cutting your cardboard parts, make the LED holes in the front piece. You can drill them as shown in Figure 3-14, punch them

with a hole punch, or even poke them out with a pencil. Just be sure to have a free LED on hand to test the size of each hole for a snug fit. If the holes are a little too large and you don't mind making the LEDs a permanent feature of the project, you can hot glue them in.

**FIGURE 3-14:**
Drilling holes for LEDs. Use caution when drilling or ask an adult for help.

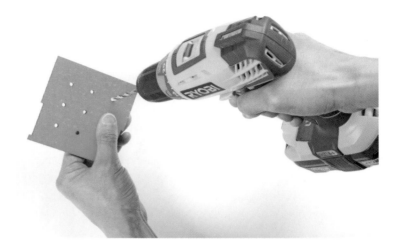

You should have four pieces cut out, as shown in Figure 3-15. The base has the big hole in the middle; use its center piece to cut out two triangles to use as support braces. These triangles have tabs that fit into slots connecting the bottom piece to the front. Before assembling the parts, however, add labels so that you can keep your LEDs straight when you wire up your circuit.

**FIGURE 3-15:**
Cardboard pieces for the enclosure

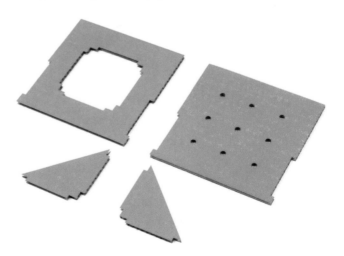

## Label the LED Holes

Flip the front cardboard piece over, and number the LEDs so you have a connection guide. Start with pin 13 in the top right and count down as you go left, as shown in Figure 3-16. You should finish with 5 in the lower-left corner.

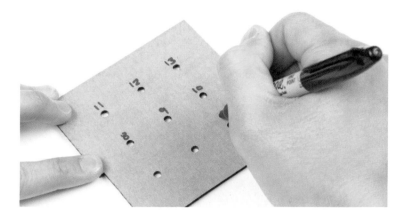

**FIGURE 3-16:**
Labeling the back side of the LED grid

## Add the LEDs

With the cardboard flat, insert the nine LEDs through from the back side. You can reuse the LEDs from your breadboard prototype or grab new ones. As you insert the LEDs, keep them aligned with the long leg on the right side to make things easier when you start wiring them to the Arduino again. You want the LEDs to fit snugly, as shown in Figure 3-17. If the hole is too big, you can add a dab of hot glue to secure it (but, again, keep in mind that you won't be able to reuse the LEDs afterward).

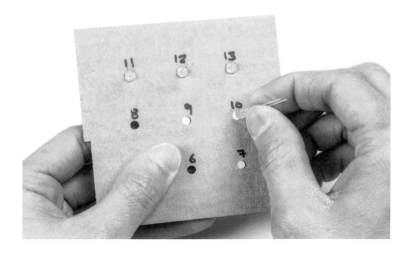

**FIGURE 3-17:**
Inserting the LEDs

## Assemble the Parts

Now, gather the four pieces of cardboard to be assembled. You'll probably need craft glue or a hot glue gun to secure all of the pieces together.

First, glue one of the triangles to the base to support the front plate, as shown in Figure 3-18. See Figure 3-19 for the orientation of the support triangles. Repeat this process for the other triangle piece. Give the glue some time to dry before moving on.

**FIGURE 3-18:**

Adding support triangles to the base

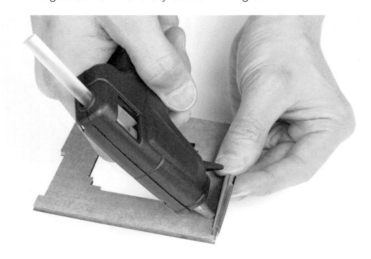

With the support triangles in place, glue the front to the base. The front should fit snugly onto the tabs of the support triangles and sit on top of the base cardboard, as shown in Figure 3-19. For extra strength, you may also want to add hot glue along the inside edges where the front plate connects to the base and support triangles.

**FIGURE 3-19:**

Adding the final piece of the project—the front

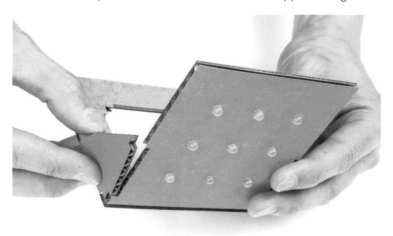

With the cardboard construction part of this project done, it's time to wire the circuit.

## Connect the Electronics

There are a lot of wires in this project, so we'll take it one step at a time. You'll reuse the breadboard prototype circuit you built earlier in this chapter and simply use jumper wires to connect the nine LEDs to the Arduino.

There are two ways to approach this part of the project: the nonpermanent way, which uses male-to-female jumper wires, and the permanent way, which involves soldering. We'll cover the nonpermanent approach, but if you do want to solder the LEDs to jumper wires, refer to "How to Solder" on page 302 for a brief lesson before you attempt that.

If the LED legs are too long, you can snip them before attaching the jumper wires, but pay attention to which leg is positive (the long leg) and which is negative. Leave the positive leg a little longer so that you can still tell which leg is which; you could also draw a dot on the back of the box. Be sure to wear eye protection, too—when you're trimming the legs, the little wire pieces can fly up in the air and toward your eyes!

Connect the female end of each jumper wire to one of the nine LEDs on the front plate. To keep things organized, use black wires to designate the negative side, and connect these to the shorter leg of the LED, as shown in Figure 3-20. You can use any color for the positive side of each LED.

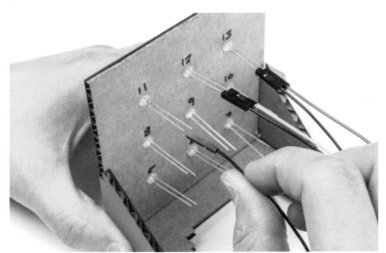

**FIGURE 3-20:**
Connecting the LEDs with male-to-female jumper wires

Once all nine LEDs are connected to male-to-female wires, connect the other end of each jumper wire to the breadboard, following the pin labels on the back side of your project. If you left the LEDs in the breadboard, remove those first, and simply plug the jumper wires into them as shown in Figure 3-21.

**FIGURE 3-21:**

Nine LEDs connected to the breadboard with male-to-female jumper wires

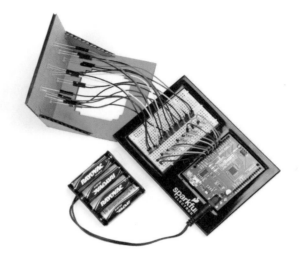

Each wire connected to the negative leg of an LED (each black wire) connects to a resistor that is connected to the ground rail. Each positive wire connects to the Arduino pin written on the back of your LED array.

Once you've added all nine LEDs to the front of your display and completed your wiring, plug your Arduino into your computer with a USB cable. If everything is wired correctly, your display will show an alternating X and O pattern. If you have a battery pack, you can connect it as shown in Figure 3-22.

If the test images don't show properly, double-check that the LEDs are plugged into the correct Arduino pins. When you see the correct patterns, take a moment to bask in the glory of your new pixel art display, but don't stop here! When you're ready, try making a more complicated animation.

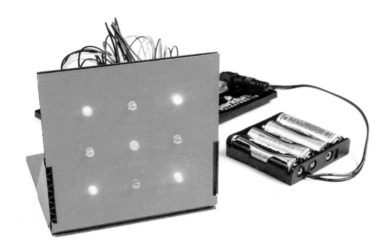

**FIGURE 3-22:**

The final display with cycling *X* and *O* characters

# CREATE AN LED ANIMATION

Your monitor can display any image you can draw on a 3×3 grid. An animation is just a series of images shown sequentially, so if you show a bunch of 3×3 images in a row, you'll have a pixel art animation. We'll show you how to design and display a spinning line.

## Plan the Animation Sequence

Let's begin by translating a spinning line into a series of images. We started with a vertical line and rotated it around the display in four separate images, as shown in Figure 3-23.

**FIGURE 3-23:**

Image progression of a spinning line

Save your program from Listing 3-10, and then create a new sketch. Add the setup() and loop() functions in Listing 3-11.

```
void setup()
{
 pinMode(13, OUTPUT);
 pinMode(12, OUTPUT);
 pinMode(11, OUTPUT);
 pinMode(10, OUTPUT);
```

**LISTING 3-11:**

The setup() code for all nine LEDs

```
 pinMode(9, OUTPUT);
 pinMode(8, OUTPUT);
 pinMode(7, OUTPUT);
 pinMode(6, OUTPUT);
 pinMode(5, OUTPUT);
}

void loop()
{
 //animation function call will go here
}

//custom functions to show frames will go here
```

Since you're using the same LEDs you were in the *X* and *O* sketch, you can just copy the code from there into your new sketch.

## Write Custom Functions

Now, create a custom function for each image of your animation. This animation has four frames, so you'll need four functions. Add the functions in Listing 3-12 to your sketch, after the closing bracket in the loop() function.

**LISTING 3-12:**

Custom functions to draw a spinning line

```
❶ void verticalLine()
{
 digitalWrite(13, LOW);
 digitalWrite(12, HIGH);
 digitalWrite(11, LOW);

 digitalWrite(10, LOW);
 digitalWrite(9, HIGH);
 digitalWrite(8, LOW);

 digitalWrite(7, LOW);
 digitalWrite(6, HIGH);
 digitalWrite(5, LOW);
}

❷ void topLeftDiagonal()
{
 digitalWrite(13, HIGH);
 digitalWrite(12, LOW);
 digitalWrite(11, LOW);

 digitalWrite(10, LOW);
 digitalWrite(9, HIGH);
 digitalWrite(8, LOW);
```

```
 digitalWrite(7, LOW);
 digitalWrite(6, LOW);
 digitalWrite(5, HIGH);
}
```

❸ void horizontalLine()
```
{
 digitalWrite(13, LOW);
 digitalWrite(12, LOW);
 digitalWrite(11, LOW);

 digitalWrite(10, HIGH);
 digitalWrite(9, HIGH);
 digitalWrite(8, HIGH);

 digitalWrite(7, LOW);
 digitalWrite(6, LOW);
 digitalWrite(5, LOW);
}
```

❹ void topRightDiagonal()
```
{
 digitalWrite(13, LOW);
 digitalWrite(12, LOW);
 digitalWrite(11, HIGH);

 digitalWrite(10, LOW);
 digitalWrite(9, HIGH);
 digitalWrite(8, LOW);

 digitalWrite(7, HIGH);
 digitalWrite(6, LOW);
 digitalWrite(5, LOW);
}
```

The verticalLine() function ❶ shows the first image in
Figure 3-23, the topLeftDiagonal() function ❷ shows the second
image, the horizontalLine() function ❸ shows the third, and the
topRightDiagonal() function ❹ shows the last. As with your previ-
ous custom function, these custom functions have the void data
type, since they won't return a value.

Custom functions can call other custom functions, too, so let's
call the four line functions inside a single spinningLine() function.
Add the following code to your sketch, after the closing bracket in the
topRightDiagonal() function.

```
void spinningLine(int delayTime)
{
 verticalLine();
 delay(delayTime);

 topLeftDiagonal();
 delay(delayTime);

 horizontalLine();
 delay(delayTime);

 topRightDiagonal();
 delay(delayTime);
}
```

**NOTE**

*You'll find a complete listing of this code in the resource files at https://nostarch .com/arduinoinventor/.*

This code shows a vertical line, a diagonal line, a horizontal line, and another diagonal line, with a delay after each line. Now, all you have to do is call `spinningLine()` inside the `loop()` function.

## Tweak Your loop() Function

Add a call to your custom function inside your `loop()` function, as in Listing 3-13. Remember that you still need to have all of those `pinMode()` commands in your `setup()` function.

**LISTING 3-13:**

Completed `loop()` function with the new custom function call `spinningLine(200);`

```
void loop()
{
 spinningLine(200);
}
```

Once you add the function and pass it a delay time parameter (the code uses 200), upload your sketch to your Arduino. You'll see a rotating line on your display. With this knowledge of sequencing LEDs and custom functions, you can make your own nine-pixel animation!

## GOING FURTHER

Custom functions will be useful when you want to reuse code later or organize your code. To take this project further, try designing more elaborate animations; you could even come up with your own alphabet and use your monitor to display a secret message.

## Hack

To take this project further, start by creating more elaborate animations. As you work through the next few projects, look for ways to incorporate your monitor—for example, maybe you could use a sensor to control an animation speed or display a sensor value in some interesting ways. Download a blank design template at *https://www.nostarch.com/arduinoinventor/*.

## Modify

You've learned how to control a number of electronic components by using digital pins and custom functions. Try replacing your individual LEDs with different components. We suggest a *seven-segment display*, as shown in Figure 3-24.

**FIGURE 3-24:**
A single seven-segment display

Each segment is an LED that you can control. There are seven individual segments (plus the decimal points), as shown in Figure 3-25, and by turning specific segments on and off, you can make numbers and most letters of the English language.

**FIGURE 3-25:**
Illustration of the seven individual segments and the decimal point with a corresponding wiring diagram

You can control one of these displays the same way you control the Nine-Pixel Animation Machine: just create custom functions for each number. For a challenge, create a single function that lets you pass a number to display to it.

# REACTION TIMER

AN AVERAGE HUMAN REACTS TO A VISUAL <u>STIMULUS</u>, LIKE A LIGHT TURNING ON, IN ABOUT 215 MILLISECONDS. THIS IS THE TIME IT TAKES FOR A SIGNAL YOU SEE WITH YOUR EYES TO TRAVEL TO YOUR BRAIN AND OUT TO YOUR LIMBS TO RESPOND. THE REACTION TIMER IS A GREAT PROJECT TO DEMONSTRATE THIS TIME DELAY, AND IT ALSO MAKES FOR A FUN GAME! HOW FAST ARE YOU AND YOUR FRIENDS?

In this chapter, you'll learn how to build your own reaction timer using Arduino. The full project is shown in Figure 4-1. The concept behind it is simple: the Arduino will turn on an LED, start a timer, and wait until you press a button. When you see the LED turn on, you press the button as quickly as you can, and the Arduino will report back to your computer the time between the light coming on and you pressing the button. The Arduino has a 16 MHz clock, which means that it can process 16 million instructions per second! That's *fast*, and it makes the Arduino perfect for this project.

**FIGURE 4-1:**

The completed
Reaction Timer project

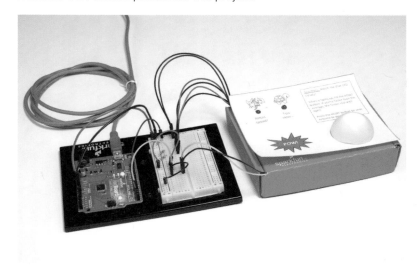

## MATERIALS TO GATHER

Like the previous projects in this book, the Reaction Timer uses LEDs, resistors, wires, and an Arduino. Unlike other projects, this one also includes a button to make the game interactive, and to make it look spiffy we suggest a custom cardboard enclosure. Figures 4-2 and 4-3 show the parts and materials you'll need for this project.

### Electronic Parts

- One SparkFun RedBoard (DEV-13975), Arduino Uno (DEV-11021), or any other Arduino-compatible board

- One USB Mini-B cable (CAB-11301 or your board's USB cable)

- One solderless breadboard (PRT-12002)

- One red LED, one blue LED, and one green LED (COM-12062)

- Three 330 Ω resistors (COM-08377, or COM-11507 for a pack of 20)

- One 10 kΩ resistor (COM-08374, or COM-11508 for a pack of 20)

- One push button (COM-10302)

- Male-to-male jumper wires (PRT-11026)

- Male-to-female jumper wires (PRT-09140*)

**NOTE**

*The parts marked with an asterisk (*) do not come with the standard SparkFun Inventor's Kit but are available in the separate add-on kit.*

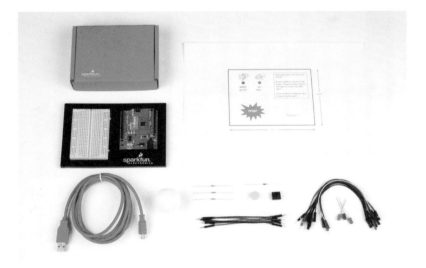

**FIGURE 4-2:**
Components and materials for the Reaction Timer

## Other Materials and Tools

- Pencil

- Craft knife

- Metal ruler

- Glue (hot glue gun or craft glue)

- (Optional) Drill and 3/16-inch and 5/16-inch drill bits

- (Optional) Wire cutters (not shown)

- Cardboard (about 12 inches square) or a cardboard box

- Enclosure template (see Figure 4-16 on page 115)

- (Optional) Ping-pong ball

**FIGURE 4-3:**

Recommended tools

## NEW COMPONENT: THE PUSH BUTTON

This project revolves around two components: an LED and a button. The button switch is an *input* to an Arduino pin, which means that the sketch can react to a change in the voltage on that pin. Inputs like buttons let you create circuits that people can interact with.

### How Push Buttons Work

There are many different kinds of push buttons, but they all work in a similar manner. A *push button* is really an electrical switch. Push buttons like the ones in Figure 4-4 are small, spring-loaded devices that connect two sides together electrically for as long as you apply pressure, like the keys on your keyboard. And they're everywhere—in remote controls, garage door openers, coffee makers, radios, game controllers, and so much more!

**FIGURE 4-4:**

A variety of push buttons

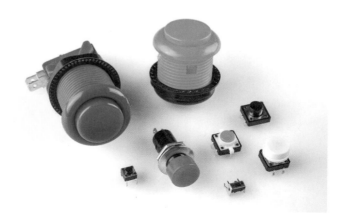

These nifty input devices are really simple on the inside. Figure 4-5 shows the schematics for both a push button and a switch.

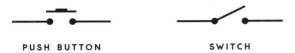

**PUSH BUTTON**          **SWITCH**

**FIGURE 4-5:**
Schematic drawings for a push button and a switch

When you flip a switch on, a piece of metal inside closes the gap between two contacts, like a gate. When you press a push button, metal pushes straight down to bridge that gap. Find a push button in your supplies for this project and examine it. Even though the schematic symbol in Figure 4-5 shows only two contacts, most standard push buttons for breadboards have four legs. Figure 4-6 shows a more accurate illustration of the contacts inside, along with how a button like that might look on the breadboard. When you plug one in, the legs should straddle the ditch in the middle of the breadboard.

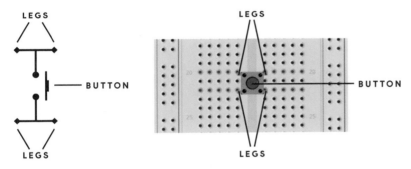

**FIGURE 4-6:**
Push button schematic and button correctly placed on a breadboard with legs straddling the ditch

Push buttons are fantastic inputs in projects, because everyone knows how they work. Push buttons are also pretty simple to connect in a circuit with an Arduino. Let's look at how that works.

## Using Resistors with Push Buttons

To use any button as an input to an Arduino, you'll need to use a *pull-up resistor circuit* like the one in Figure 4-7. A pull-up resistor connects to a power source on one side and to an input component (like a button) on the other. The part of a circuit that needs to detect input is connected at the intersection of the resistor and the button.

In the configuration shown in Figure 4-7, the resistor to 5 V *pulls* the Arduino pin's default voltage *up* to 5 V, which is considered HIGH. When the button is pushed, a path is created between the Arduino pin and ground, and the Arduino pin reads a LOW voltage. This works because current always flows along the path of least

resistance: when the button isn't pressed, the Arduino pin 10 kΩ resistor is the only path the current can access, but when the button *is* pressed, it offers a path with effectively zero resistance.

**FIGURE 4-7:**

Pull-up resistor and push button circuit

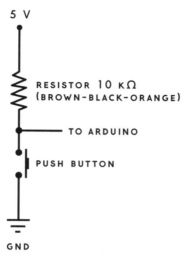

## BUILD THE REACTION TIMER PROTOTYPE

The Reaction Timer combines an LED circuit similar to the ones in previous projects with the button circuit from Figure 4-7 to make the supercircuit in Figure 4-8, which lights an LED and detects button presses.

**FIGURE 4-8:**

Schematic diagram for the Reaction Timer prototype

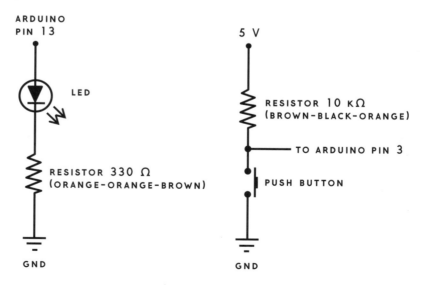

Take out your breadboard and wire up a single LED and a button, as shown in Figures 4-9 and 4-10. You'll use this prototype to test your code before building the final Reaction Timer.

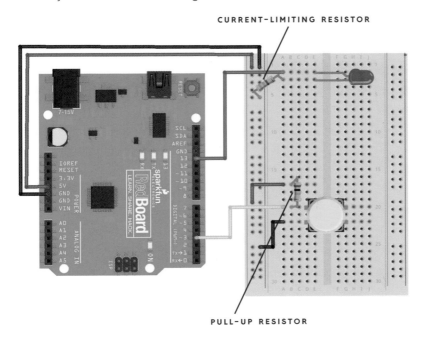

CURRENT-LIMITING RESISTOR

PULL-UP RESISTOR

**FIGURE 4-9:**

Wiring diagram for the Reaction Timer circuit

**FIGURE 4-10:**

Final prototype circuit of the Reaction Timer with a single button and a single LED

As you connect this circuit, note the two different resistance values: 330 Ω for the LED and 10 kΩ for the push button. (See "Resistors and Bands" on page 308 for details on how to determine the value of a resistor from its color bands.) The resistor on the LED

is a current-limiting resistor and should be tied to ground, while the resistor on the push button is a pull-up resistor connecting pin 3 to 5 V. But your circuit can't do anything without the code, so let's look at that now.

## PROGRAM THE REACTION TIMER

As your sketches and circuits become more complex, you'll find it helpful to organize your thoughts by listing each action you want the Arduino to take, in the order you want it to happen. Some programmers refer to a list like this as *pseudocode*. Here's our pseudocode for the Reaction Timer:

1. Wait a random amount of time before turning on the LED (to prevent predicting/gaming the Reaction Timer).

2. Turn on the LED.

3. Record the starting time.

4. Start a timer and wait for a button press.

5. When the button is pressed, calculate the reaction time as the timer value minus the starting time.

6. Report the time back.

   Pretty simple, right? Let's open up Arduino and look at the sketch.

### Write the setup() Function

Open a new sketch and type the initialization and the setup() code shown in Listing 4-1.

**LISTING 4-1:**
setup() and initialization code for the Reaction Timer

```
❶ unsigned int waitTime; //random wait time before
 //turning on LED
 unsigned int startTime; //zero reference time
 unsigned int reactTime; //calculated reaction time

 void setup()
 {
❷ Serial.begin(9600); //sets up serial
 //communication
 pinMode(13, OUTPUT); //sets pin 13 as an OUTPUT for the
 //stimulus LED
❸ pinMode(3, INPUT); //sets pin 3 as an INPUT for the
 //button
 }
```

**NOTE**

*The unsigned int data type can hold values from 0 to 65,535 ($2^{16} - 1$).*

First, the namespace defines three unsigned int variables ❶ to store the waitTime, startTime, and reactTime values.

Next comes the setup() function, which has a new instruction: Serial.begin(9600) ❷. Make sure to capitalize Serial and leave no spaces between Serial, the period, and begin. This instruction is a little different from previous commands because it has a period that divides the *object* and the *method*. An *object* is a concept used in computer programming that is similar to a special type of variable that can have different functions or actions. Here Serial is the name of the object we're using. The functions that an object can perform are called *methods*. The begin() method initializes or begins *serial communication* between your Arduino and your computer, which allows the Arduino to send and receive data through the USB cable. For this command, the number in the parentheses, 9600, sets the communication rate to 9,600 bits per second (or *baud*). The Arduino will use serial communication to report your reaction time back to your computer. The Serial object has many other methods, which we'll introduce throughout this book, to handle data between the computer and the Arduino.

Finally, you'll set up your pins. This project uses a single LED on pin 13 to indicate when to press the button, so you once again use pin 13 as an OUTPUT using the pinMode() function. Then set pin 3 with the pinMode() function ❸ using the INPUT keyword. You use INPUT here because Arduino needs to be able to detect button presses, not output to the button.

## Write the loop() Function

Now let's write the loop() part of the sketch. Enter the code in Listing 4-2 after your setup() function.

```
void loop()
{
//prints the challenge instructions
❶ Serial.println("When the LED turns on, push the button!");
 Serial.println("Now, watch the LED. Ready?");
❷ waitTime = random(2000, 4000); //random wait time
 //from 2000 to 4000 ms
❸ delay(waitTime); //delay random wait time

 //turn on the LED!
 digitalWrite(13, HIGH);

 startTime = ❹millis(); //set zero time reference
```

**LISTING 4-2:**

The loop() function for the Reaction Timer

```
 //loop to wait until button is pressed
 ❺ while(digitalRead(3) == HIGH)
 {
 }

 ❻ reactTime = millis() - startTime; //calculation of
 //reaction time

 digitalWrite(13, LOW); //turn off LED!

 //display information to Serial Monitor
 ❼ Serial.print("Nice job! Your reaction time was ");
 ❽ Serial.print(reactTime);
 ❾ Serial.println(" milliseconds");
 delay(1000); //short delay before starting again
 }
```

First, this code uses the Serial.println() method ❶ to show a message prompt explaining how to play the game. The println() method sends text to the computer and adds a newline character to move the cursor down one line. When this method is called, any text between quotation marks (" ") is displayed on the Arduino IDE's Serial Monitor. The Serial Monitor is like a simple chat window, or *terminal*, that allows you to send and receive data between the Arduino and your computer. You can open the Serial Monitor by clicking the magnifying glass button in the top-right corner of the Arduino IDE (shown in Figure 4-11), by clicking Tools ▸ Serial Monitor, or by using the hotkey CTRL-SHIFT-M.

**FIGURE 4-11:**

Opening the Serial Monitor through the Arduino IDE

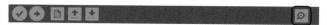

We'll look at the Serial Monitor in just a moment.

### Generate the Delay Time

To make the Reaction Timer less predictable, the sketch calls the random() function ❷ to generate a random waitTime. The random() function takes a minimum value and a maximum value as arguments and returns a *pseudorandom number* (a number that appears to be random but isn't; this is explained in more detail in "Try It Out: Make waitTime More Random" on page 109). In this example, the waitTime variable is set to a "random" number between 2,000 and 4,000 and is passed to delay() ❸ before the LED turns on. This prevents you and your friends from predicting when to press the button.

When the LED turns on, a call to the `millis()` function ❹ captures the starting time. The `millis()` function checks the Arduino's internal timer and returns the number of milliseconds since the Arduino was turned on or reset. The `millis()` function is handy for any Arduino project that involves timing.

## Check the Button with a while() Loop

After fetching the start time, the sketch uses a `while()` loop ❺ to wait for a button press. In Arduino, as in many other programming languages, a `while()` loop runs the code inside its curly brackets as long as the expression between its parentheses is `true`. In this case, the expression is

```
digitalRead(3) == HIGH
```

The `digitalRead()` command reads the voltage on the pin specified between the parentheses and returns a value of `HIGH` or `LOW` depending on if it sees 5 V or GND. This call checks the voltage on pin 3. Remember that pull-up resistor on the push button? The button's normal state is open, and the pin defaults to `HIGH` until you press the button to close the circuit. When you press the button, pin 3 connects to ground, and the state becomes `LOW`. The double equal sign (`==`) checks equality. (See "Logical Comparison Operators" on page 106.)

As long as the button isn't pressed, the expression is `true`, and the `while()` loop should repeat, preventing the sketch from executing any code after. Notice, however, that there's no actual code inside the loop. This is referred to as a *holding* or *blocking loop*, and rather than executing any code itself, it just prevents other code from executing. When the button is pressed, the expression becomes `false`, and the sketch proceeds.

## Calculate and Display the Reaction Time

Next, the sketch computes the reaction time ❻ by subtracting the `startTime` from the current timer value, which is fetched with the `millis()` command.

As a final step, the LEDs are turned off, and the `reactTime` value is printed to the serial communication line. To make the information more readable, the sketch prints the string `"Nice job! Your reaction time was "` to the Serial Monitor using the `print()` method ❼ of the `Serial` object. This method sends the text between

## LOGICAL COMPARISON OPERATORS

*Logical comparison operators* perform operations that test one value against another value. For example, the double equal sign (==) compares two values to see whether they are equal. A logical operation can return only one of two values: `true`, meaning the comparison evaluates correctly, or `false`, meaning it doesn't evaluate correctly. In Arduino, there are many ways to compare two values, and all of the operators are listed in the following table:

| OPERATOR | COMPARISON |
|:--------:|:----------:|
| == | Equal to |
| != | Not equal to |
| > | Greater than |
| >= | Greater than or equal to |
| < | Less than |
| <= | Less than or equal to |

For example, if you enter `2 == 4` in the Arduino IDE, it will return `false`, because two is not equal to four. However, if you enter `2 <= 4` in the Arduino IDE, it will return `true`, because two is less than or equal to four. In sketches, comparison operators are often used with `if()` or `while()` statements to run a certain block of code based on a certain condition. For example, the `while()` loop in Listing 4-2 says, "while `digitalRead(3) == HIGH` is `true`, repeat the holding loop; otherwise, skip to the next bit of code."

A common bug is to mistakenly use a single equal sign when working with comparisons. Remember: a single equal sign sets a variable, whereas the double equal sign compares the two values.

You'll use comparison operators more and more as you start to evaluate data your Arduino gathers from various sensors and inputs, and we'll use some of them later in this chapter, too.

the quotation marks and doesn't move the cursor to a new line. In fact, it keeps the cursor on the same line so that you can append more information, like the actual reaction time, which is added at ❽ with `Serial.print(reactTime);`. The sentence is finished with a call to the `println()` method ❾, which prints the string `" milliseconds"` and then moves the cursor to a new line.

Notice that every character must be explicitly printed, including any spaces you want between numbers or characters. You can use the `print()` and `println()` methods, as in this example, to combine, format, or organize text that you display in the Serial Monitor.

The final line of code in the `loop()` function is a short `delay()` function to pause the sketch before it loops back and starts the Reaction Timer again.

## SPECIAL COMMAND CHARACTERS

When printing data or text, you must represent every individual character, including spaces, and every formatting command in your code. There's a set of reserved characters, called *escape sequences*, to indicate special formatting. For example, \n moves the cursor to a new line; so, `Serial.print("Hello Arduino!\n");` is equivalent to `Serial.println("Hello Arduino!");`.

You can use escape sequences in your `print` statements to add formatting or other special characters to your text. The following table lists a handful of useful escape sequences.

| ESCAPE SEQUENCE | RESULT |
|:---:|:---:|
| \t | Tab |
| \n | New line |
| \' | Single quotation mark |
| \" | Double quotation mark |
| \x*hh* | ASCII character, where *hh* is a hexadecimal number |

## Test the Reaction Timer Sketch

That's all the code you need to test your Reaction Timer game circuit! Save your sketch, compile it, and upload it to your Arduino now. To see the data that your sketch sends on the serial communication line, open the Serial Monitor window by clicking **Tools ▸ Serial Monitor** or the magnifying glass button in the upper-right corner of the IDE.

Notice that the bottom-right corner of the Serial Monitor has a pull-down menu to control the serial data rate in *baud* (bits per second), which defaults to 9,600 baud (see Figure 4-12). This is the same value this sketch uses to initialize the `Serial` object, using the `Serial.begin(9600)` instruction. Always check that the Serial Monitor speed is the same as the rate set in the sketch with `Serial.begin()`—otherwise, you may just get gibberish!

**FIGURE 4-12:**

The Arduino IDE's Serial Monitor window testing the Reaction Timer

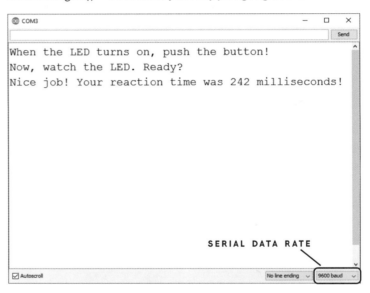

You can set the serial data rate to any standard rate from 300 to 250,000 baud, but 9,600 baud is the most common speed. Generally speaking, slower speeds are more reliable and use less power and fewer resources on the Arduino, but they also introduce a delay that slows down the `loop()`. If you need a really fast response and don't care much about power usage, you can use a faster baud rate.

Now, let's play! Run the sketch and watch your LED closely. When it lights up, push the button. Your code will print your reaction time, in milliseconds, to the Serial Monitor, like in Figure 4-12. How fast are you? Go challenge one of your friends! The average is about 215 ms. How do *you* measure up?

**NOTE**

*Some components, such as GPS or a serial-enabled LCD screen, will communicate with the Arduino at different baud rates, so when using a new part, it's a good idea to check what rate it uses and set that in the sketch.*

## TRY IT OUT: MAKE WAITTIME MORE RANDOM

In most digital devices like an Arduino, it's hard to get a *truly* random number because the random number is generated through a mathematical calculation. On an Arduino, each time the `random()` function is called, the function bases its calculation on the previous result from `random()`. Because the next "random" number is calculated from the previous result, the sequence of numbers will always be the same.

For example, on our Arduino (and probably yours), the first call to `random(2000, 4000)` will always set `waitTime` to 2807. The second number generated will always be 3249, the third will be 2073, and so on.

You can make the `waitTime` value appear more random by calling the function `randomSeed()` in your `setup()` function. This generates a *seed* value that tells `random()` where the pseudorandom sequence should start. When your Arduino starts running a sketch, the seed defaults to 1, which is why 2807 is always the first number generated by the `random(2000, 4000)` call.

To make your Reaction Timer behave more randomly, add this line of code to your `setup()` routine, just before the closing curly bracket:

```
randomSeed(analogRead(A5));
```

This seeds the random-number generator with the current voltage value on the Arduino's analog pin A5. We'll cover `analogRead()` in more detail in Chapter 5, but for now, just know that it reads the voltage level on the analog pin passed to it. Because pin A5 isn't connected to anything in the Reaction Timer, the voltage *floats*, or bounces around somewhat unpredictably.

If you choose to add this line of code, then each time you run your sketch, the first call to `random(2000, 4000)` should return a different number. To confirm, add these two lines of code after the `delay(waitTime)` call in your sketch:

```
Serial.print("waitTime = ");
Serial.println(waitTime);
```

*(continued)*

Now, comment out the `randomSeed()` call by adding `//` at the beginning of the line, run your sketch a few times, and note the initial `waitTime` values printed. Uncomment the `randomSeed()` call and repeat the process. Over time and a lot of data points, there will still be a pattern, but that's a topic for another book—or perhaps for a degree in computer science!

## Play Again?

To play again, simply press the Arduino's reset button—the brass-colored button near the corner of the board, shown in Figure 4-13. This will restart your code and let you play again. Watch the LED closely. Are you any faster?

**FIGURE 4-13:**

Press the reset button to play again.

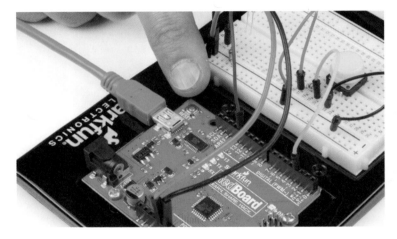

## Add a Game Element

To add a little carnival-game style to this project, you can add a visual speed indicator to show if you're faster than a given reaction time. We suggest starting with the average, 215 ms, as the time to beat. To do this, you'll need to add two more LEDs: a green one to indicate that you were faster than the time set in the code and a red one to say you were slower. Since you already used pin 13 for the stimulus LED, you'll connect these two LEDs to pins 11 and 12. Add these to your breadboard as shown in Figures 4-14 and 4-15.

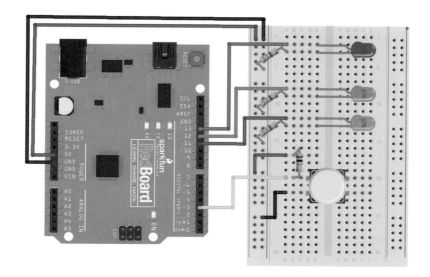

**FIGURE 4-14:**
Circuit diagram with two
extra LEDs

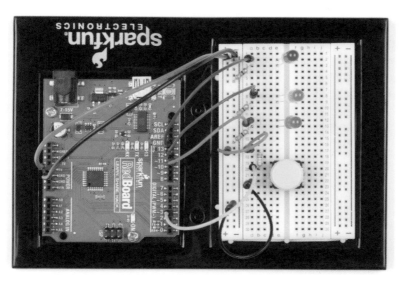

**FIGURE 4-15:**
Completed wiring of
the new circuit with two
extra LEDs

## Update the Code for Extra LEDs

Now that you have these two indicator LEDs, you'll add a few extra
lines of code to your project to turn on the green LED if you're faster
than the time to beat and the red LED if you're not.

You'll need to add a `pinMode()` command for pins 12 and 11
and set these up as OUTPUTs to control your new LEDs. The changes
to the `setup()` function are shown in Listing 4-3 (the existing code is
shown in light gray).

**LISTING 4-3:**

The modified setup()
function for the
Reaction Timer with
the extra speed-
indicator LEDs

```
void setup()
{
 Serial.begin(9600); //sets up serial
 //communication
 pinMode(13, OUTPUT); //sets pin 13 as an OUTPUT for the
 //stimulus LED
 pinMode(12, OUTPUT); //sets pin 12 as an OUTPUT for the
 //green LED
 pinMode(11, OUTPUT); //sets pin 11 as an OUTPUT for the
 //red LED
 pinMode(3, INPUT); //sets pin 3 as an INPUT for the
 //button
}
```

You simply inserted two extra `pinMode()` instructions for the two extra LEDs that you're going to add.

### Control the Flow with if() and else()

Now you'll need to add a little bit of decision logic into your sketch. In Arduino programming, an `if()` statement allows you to control the direction and flow of a sketch. It tells the code "if this is true, run the code in the following curly brackets." The general syntax for the `if()` statement is shown in Listing 4-4.

**LISTING 4-4:**

Generic if() statement
in Arduino

```
if(❶expression) //if expression is true, run the code in
 //the following loop
 {
 ❷
 }
❸ else //otherwise, run the code in this loop instead
 {
 ❹
 }
```

The *expression* ❶ is a Boolean expression that is either `true` or `false`, like the ones we discussed earlier in "Logical Comparison Operators" on page 106. If the expression is `true`, the sketch will start executing any code between the curly brackets ❷. If it's not `true`, the sketch skips over the curly brackets and goes to the next statement. Oftentimes, the `if()` statement is paired with an `else` ❸. If the expression is not `true`, the sketch skips over the first set of curly brackets ❷ and continues on to the code that is part of the `else` statement ❹.

For the Reaction Timer game, you'll use an `if()` statement to turn on the green LED if the reaction time is less than or equal to

215 ms and the red LED if the reaction time is greater than 215 ms. You'll be able to change this value to make it harder or easier, but this is a good middling value for now. Listing 4-5 shows the code to do this.

```
❶ if (❷reactTime <= 215)
 {
❸ digitalWrite(12, HIGH); //green LED ON
❹ digitalWrite(11, LOW); //red LED OFF
 }
❺ else
 {
 digitalWrite(12, LOW); //green LED OFF
 digitalWrite(11, HIGH); //red LED ON
 }
```

You can see at ❶ that the sketch uses the if() statement to perform this logic. The Boolean expression, reactTime <= 215 ❷, checks whether the value from reactTime is less than or equal to 215, and if it is, the green LED turns on ❸. When the green LED turns on, the red LED needs to be off, so you add one extra instruction ❹ to do that. Finally, you add the else statement ❺ to turn the red LED on if the if() statement evaluates to false.

## Upload the Complete Code for the Reaction Timer

The new if() statement should be placed within the loop(), after the code to turn off the red LED, as shown in Listing 4-6. (The *snip* indicates where existing code has been omitted on the page for length.)

```
--snip--

 //loop to wait until button is pressed
 while(digitalRead(3) == HIGH)
 {
 }

 reactTime = millis() - startTime; //calculation of reaction
 //time

 digitalWrite(13, LOW); //turn off LED!

 if (reactTime <= 215)
 {
 digitalWrite(12, HIGH); //green LED ON
 digitalWrite(11, LOW); //red LED OFF
 }
```

```
 else
 {
 digitalWrite(12, LOW); //green LED OFF
 digitalWrite(11, HIGH); //red LED ON
 }

//display information to Serial Monitor
--snip--
```

After you've added the new code, upload the whole sketch to your Arduino. Open the Serial Monitor and play a game to make sure it all works as expected. Can you get the green light to turn on? You have to be fast!

---

### GAMING THE GAME: CONTROL THE DIFFICULTY

As with all games, with the Reaction Timer, sometimes you'll need to adjust the difficulty level. Since you're the programmer, you get to control the game. If 215 ms is too fast or too slow, you can adjust your game *threshold* by changing the number in the line `if (reactTime <= 215)`.

Want to make it impossible to beat? Change this value to a low number like 100 ms. Want to be nice and make it easier? Change it to a number like 500 ms. You're writing the code, so you get to decide the rules of the game!

---

## BUILD THE REACTION TIMER ENCLOSURE

When your prototype works, it's time to build a more permanent enclosure. To keep this project as simple as possible, our version of the Reaction Timer is designed to fit into a small SparkFun box. The top of the box measures 3 7/8 inches × 5 inches, but you can put your game in anything you have lying around the house—an old cereal box, oatmeal container, or anything else made of a sturdy cardboard.

We made our Reaction Timer look like an old-school carnival game with a few fun clip-art drawings we found, but you can make yours look however you want. Figure 4-16 shows a template for the outside of our box. For this design, we have a hole for the button, a

hole for the stimulus LED, and two holes for indicator LEDs—one to show that you're faster than a ninja and the other to show that you're as slow as a turtle. You can download the template with this book's resources via *https://www.nostarch.com/arduinoinventor/* or just cut holes for the LEDs and buttons anywhere you like on your box.

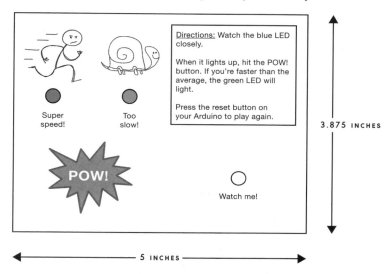

**FIGURE 4-16:**

Template for the Reaction Timer carnival game cover art (not full size)

## Cut Out the Cardboard

If you use our template, print it and then glue or tape it to the front of your box. Whether you use the template or not, you'll need to make a total of four holes in the cardboard for the three LEDs and the button. You can use a craft knife or a drill to *carefully* cut out the holes, as shown in Figure 4-17. The LEDs are 5 mm in diameter, so a 3/16-inch drill bit is a pretty close fit. For the button hole, we recommend using a 5/16-inch drill bit, if you're drilling, or a sharp pencil.

**FIGURE 4-17:**

Cutting out the holes from a cardboard box

## Assemble the Electronics

Now that you have the holes cut out of your Reaction Timer box, you need to add the electronic components. You're going to move the three LEDs and the button from the breadboard to the exterior of your new cardboard box so that players can see them.

### Attach the LEDs and Button to the Cardboard

First, press the LEDs through their three holes from the back side of the cardboard, making sure that each sits snugly. If the holes you cut are too big and the LEDs are a little loose, simply add a small dab of glue to keep them in, as in Figure 4-18.

**FIGURE 4-18:**

Moving the LEDs to your project box/ cardboard

Next, add the button. The push buttons that come in the SparkFun Inventor's Kit have a cap that pops off. Remove the button cap, insert the button from the inside of the box, and glue the button onto the cardboard, as in Figure 4-19. Reattach the button cap on the top side of the cardboard. Players are going to mash this button as they try to get the best score possible, so use a lot of glue to make sure it's secure! When the glue is dry, try the button out. You need to be able to press the button in all the way, so make sure the cap doesn't get caught on any cardboard when you press it down.

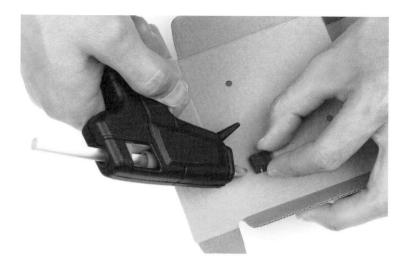

**FIGURE 4-19:**
Secure the button in place with a lot of glue.

**NOTE**

*If using hot glue, be cautious when gluing the button to the cardboard. Hot glue is hot!*

## Reconnect the Components to the Arduino

Now, use male-to-female jumper wires to connect the LEDs to the breadboard. Remember that the shorter leg of the LED needs to connect to ground (GND) in the circuit, and each of the longer legs should connect to its respective pin on the Arduino, through a 330 Ω resistor. Because the LED legs are a bit long, you may need to clip them back with wire cutters. A strategy we often use is to cut the shorter leg just a little shorter so that you can always tell which leg is the negative leg, as shown in Figure 4-20.

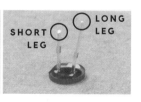

**FIGURE 4-20:**
Cutting back the LED legs. Keep the short leg short!

If you can't tell which leg is longer, you can also look at the shape of the plastic lens on the LED. There is typically a flat edge on the side nearest to the negative leg of the LED. The flat edge is subtle, but if you look closely, you should be able to see it.

Press the female ends of the male-to-female jumper wires onto the ends of the LEDs so that they fit snugly, like in Figure 4-21. To keep things organized and easy to follow, we recommend using a black wire for the negative (short leg) of the LED.

Once the jumper wires are connected to all three LEDs, connect the male ends to the breadboard circuit. The wires for the stimulus LED should go to E2 and E3, for the green LED to E8 and E9, and for the red LED to E12 and E13.

Next, reconnect the button to the circuit. The button has four legs, but you only need to connect to two legs on one side of the button. Connect one male-to-female wire to one leg and another to the other leg, as in Figure 4-22. Then, plug one wire into the same breadboard row that connects the 10 kΩ resistor and Arduino pin 3, and plug the other into GND on the breadboard. (If you wired up your breadboard prototype just like the diagram in Figure 4-14, then connect these wires to E20 and E22 on the breadboard.) Because the button is just a switch, it doesn't matter which wire you plug into GND.

With your components in place, plug your Arduino into the computer and open the Serial Monitor to make sure your circuit still works. You should see your instruction messages on the Serial Monitor. When the blue LED lights, press the button as fast as you can. The Serial Monitor should show your reaction time, and either the red or green LED should turn on, based on how fast you were.

If your circuit doesn't seem to be working, check that all of your connections are secure, and compare your circuit to Figures 4-14 and 4-15 to make sure the connections are correct.

## Spice Up Your Game Enclosure

To finish up, add some bling to your new game. Use your imagination! You might want to cover your Reaction Timer with your favorite stickers or paint the box. We love using ping-pong balls in our projects, and since we had a half left over from Project 2, we decided to glue it on top of the blue LED, as in Figure 4-23.

**FIGURE 4-23:**
Carnival-themed Reaction Timer game

## GOING FURTHER

Next, try combining what you learned in the first three projects with what you know from this project to make it more interesting—add even more LEDs, or maybe make the game suitable for two players.

## Hack

Add two more LEDs to make a four-LED scale that will show your speed more accurately. Faster reaction times will light up more LEDs. To do this, you'll need the help of a nested if()–else if() control

statement. You can stack your condition statements to tell the code what to do in different conditions, so if the first logical expression is `false`, the next one is tested; if that's also `false`, the next is tested; and so on until the final `else()` statement, which runs if none of the previous conditions were `true`. Listing 4-7 shows an example of this conditional logic. It assumes you've added two extra LEDs connected to pins 10 and 9. Don't forget the `pinMode()` commands you'll have to add to the `setup()`!

**LISTING 4-7:**

Snippet of nested

if()–else if()

statement

```
❶ if (reactTime <= 215)
 {
 //turn all LEDs on
 digitalWrite(12, HIGH);
 digitalWrite(11, HIGH);
 digitalWrite(10, HIGH);
 digitalWrite(9, HIGH);
 }
❷ else if (reactTime <= 250)
 {
 //turn three LEDs on
 digitalWrite(12, LOW);
 digitalWrite(11, HIGH);
 digitalWrite(10, HIGH);
 digitalWrite(9, HIGH);
 }
❸ else if (reactTime <= 300)
 {
 //turn two LEDs on
 digitalWrite(12, LOW);
 digitalWrite(11, LOW);
 digitalWrite(10, HIGH);
 digitalWrite(9, HIGH);
 }
❹ else
 {
 //turn one LED on
 digitalWrite(12, LOW);
 digitalWrite(11, LOW);
 digitalWrite(10, LOW);
 digitalWrite(9, HIGH);
 }
```

The `if()` statement at ❶ checks whether the reaction time is less than or equal to 215 ms and lights up all four LEDs. Then two `else if()` statements catch times between 215 ms and 250 ms ❷,

lighting up three LEDs, and between 250 ms and 300 ms ❸, lighting up two LEDs. Finally, an else statement ❹ catches all times slower than 300 ms and lights up a single LED.

If you need a little more help with the code, check out our example sketch in the resources at *https://www.nostarch.com/arduinoinventor/*.

## Modify

One fun way to modify this project would be to make it a two-player game. You could add a second button and repurpose your LEDs to indicate which player is faster. In this modification, the green LED will light up if Player 1 is faster, and the red LED will light up if Player 2 is faster.

First, add a second button. Figure 4-24 shows the additional button at the bottom of the breadboard. Notice that it's just a duplication of the pull-up resistor/button combination circuit that you built for the first button.

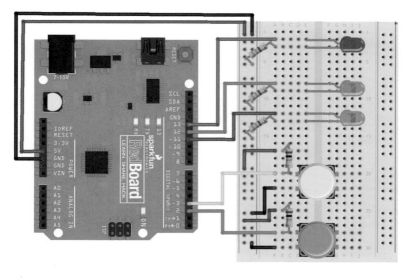

The complete code for the two-player modification is available, along with the wiring diagram for the modification, at *https://www.nostarch.com/arduinoinventor/*.

Now, go and take your new game out on the town. Are you faster than your family? Are you faster than your friends? Who is the fastest person you know?

# 5

# A COLOR-MIXING NIGHT-LIGHT

THE WONDERFUL THING ABOUT DIGITAL ELECTRONICS AND MICROCONTROLLERS IS THAT THEY ARE SMART. THEY CAN READ SENSORS AND MAKE DECISIONS BASED ON WHAT THOSE SENSORS TELL THEM. SENSORS ARE COMPONENTS THAT COLLECT INFORMATION ABOUT THE ENVIRONMENT AROUND THEM AND CONVERT THAT INTO SOMETHING A MICROCONTROLLER CAN UNDERSTAND.

You can use sensors to make projects that react to all sorts of stimuli (like temperature, sound, and the proximity of an object), but in this project, we'll start small with a night-light that reacts to changes in light level, shown in Figure 5-1.

**FIGURE 5-1:**

Finished Night-Light project

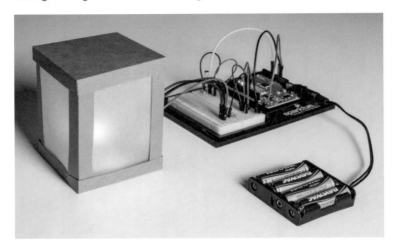

## MATERIALS TO GATHER

This project uses a new kind of LED and a *photoresistor*, a sensor that changes resistance based on how much light it detects. We encourage you to be creative and design a custom shade, too, but if you don't feel up to that challenge yet, fear not! This book's resource files include a shade design you can start with. Figures 5-2 and 5-3 show the parts and equipment you'll need for this project.

### Electronic Parts

**NOTE**

*The parts marked with an asterisk (\*) do not come with the standard SparkFun Inventor's Kit but are available in the separate add-on kit.*

- One SparkFun RedBoard (DEV-13975), Arduino Uno (DEV-11021), or another Arduino-compatible board
- One USB Mini-B cable (CAB-11301 or your board's USB cable; not shown)
- One solderless breadboard (PRT-12002)
- One mini breadboard (PRT-12043*; not shown)
- One RGB LED, common cathode (COM-09264)
- Three 330 Ω resistors (COM-08377, or COM-11507 for a pack of 20)
- One 10 kΩ resistor (COM-08374, or COM-11508 for a pack of 20)
- One photoresistor (SEN-09088)
- Male-to-male jumper wires (PRT-11026)

- Short 4-inch male-to-male jumper wires (PRT-13870*)

- (Optional) Male-to-female jumper wires (PRT-09140*)

- (Optional) One 4 AA battery holder (PRT-09835*; not shown)

**FIGURE 5-2:**

Components for the
Night-Light

## Other Materials and Tools

- Craft knife

- Metal ruler

- Glue (hot glue gun or craft glue)

- One sheet of cardstock (not cardboard), about 8.5 × 11 inches

- One sheet of white or translucent vellum, or standard copy paper, about 8.5 × 11 inches

- Enclosure template (see Figure 5-20 on page 144)

**FIGURE 5-3:**

Recommended building
materials for the Night-Light

## NEW COMPONENTS

You'll be using two new components in this project: an LED that has three colors integrated into a single package, and a photoresistor. Let's take a look at how these components work.

### The RGB LED

If you've built any of the other projects in this book, then you already have experience with regular LEDs. The *red, green, blue (RGB)* LED shown in Figure 5-4 works very similarly. This LED is actually three LEDs in one package: one red, one green, and one blue. Each LED has its own positive (or anode) leg, but they all share a single negative (or cathode) leg, called the *common cathode*.

If you look closely at the LED in Figure 5-4, you'll notice that the legs are all different lengths. With regular LEDs, the short leg is the negative leg, but with the RGB LED, the longest leg is the negative leg. The circuit diagram for this component is usually drawn like Figure 5-5. Notice that it shows three separate LEDs connected together, and they each share a single negative connection.

**FIGURE 5-4:**

An RGB LED with a common cathode leg

**FIGURE 5-5:**

Circuit diagram of an RGB LED

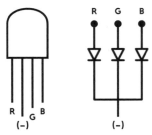

To figure out which positive leg is which color for this particular LED, orient the LED so that it looks like the one shown in Figure 5-5. In this orientation, the leftmost leg is the red positive leg. The next leg (the longest one) is the shared negative leg, and the last two legs are the green and blue positive legs, respectively.

Keeping in mind which positive leg corresponds to which color, you can wire this LED into a circuit just like you would three separate LEDs. Just connect the positive leg(s) you want to use to power or to an Arduino output pin through a current-limiting resistor, and connect the common cathode to ground.

RGB LEDs are cool because you can use them to create a slew of colors. Red, green, and blue are the primary colors in the additive color scheme, and the LED can mix these colors to create light in other colors. (This is different from the *primary pigments*—red, blue, and yellow—which, as you might remember from grade-school art class, mix together in paints to create new colors.) The additive color wheel in Figure 5-6 shows how primary colors can combine to create any color in the rainbow.

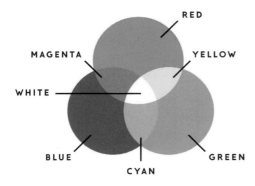

**FIGURE 5-6:**

The additive color wheel

With your RGB LED, if you turn on the blue LED and the red LED together, you get magenta light. Combine the red and green LEDs, and you get yellow. If all the LEDs are on, you get white light. This concept is the foundation for how an LED TV or monitor works: each pixel on your screen is essentially an RGB LED.

## The Photoresistor

This Night-Light will turn on when it is in a dark room and turn off when the room is bright. That means the Night-Light needs to determine whether the room is dark. To do so, it uses a light sensor to monitor the light level of its surroundings. There are a number of different light sensors available, but we used the simple photoresistor

shown in Figure 5-7. This component is sometimes also called a
*light-dependent resistor (LDR)* or a *photocell*. Also, similar to many
other types of sensors, a photoresistor is sometimes referred to as a
*variable resistor sensor*.

The resistance of the photoresistor in this project varies from
about 80 Ω to around 1,000,000 Ω (1 MΩ) depending on how much
light it is exposed to. The photoresistor has a low resistance when
exposed to bright light and a high resistance when it's in the dark.

**FIGURE 5-7:**

A photoresistor

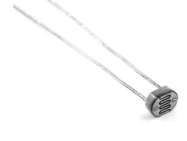

To use the photoresistor to measure brightness, you have to
place it in a *voltage divider* circuit, like the one in Figure 5-8. A voltage
divider uses two resistors wired in *series* (that is, in line with each other)
between a supply voltage (5 V) and ground to obtain a smaller voltage.

**FIGURE 5-8:**

Voltage divider circuit

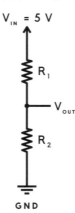

$V_{IN}$ = 5 V

$R_1$

$V_{OUT}$

$R_2$

GND

The total voltage across these two resistors is 5 V, and the
voltages across $R_1$ and $R_2$ depend on the ratio of the two resistors'
resistances. $V_{out}$ will be some voltage between 5 V and 0 V, because
the voltage is divided between the two resistors. The relationship
between $V_{out}$ and the resistor values $R_1$ and $R_2$ can be characterized
by the following equation.

$$V_{out} = \frac{R_2}{R_1 + R_2} \times V_{in}$$

We know what you're thinking: that looks like math! Well, it is, and math is an important part of electronics, but it doesn't have to be complicated. We'll take things slow to make sure everyone understands it as we go along. This little equation is especially helpful when you're dealing with this photoresistor or any other type of resistive sensor. In the voltage divider circuit, if you replace $R_1$ with the photoresistor, you get the circuit shown in Figure 5-9.

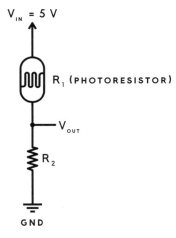

$V_{IN}$ = 5 V

$R_1$ (PHOTORESISTOR)

$V_{OUT}$

$R_2$

GND

**FIGURE 5-9:**

A voltage divider circuit with a photoresistor

The resistance of the photoresistor increases as the light around it gets dim. Now, look at the voltage divider equation. As resistance $R_1$ increases, the denominator of the fraction increases, making the entire fraction smaller. That means $V_{out}$ gets smaller as it gets darker.

With this circuit, you can accurately read the amount of light on the photoresistor by connecting $V_{out}$ to an analog input pin on the left-hand side of the Arduino (the pins marked with an A). *Analog* signals are those that can vary across a range of values. Up to this point, you've only used the *digital* pins on the right-hand side of the Arduino board. Unlike a push button, which has only two states, the photoresistor can have a range of values based on the brightness of light and the voltage divider circuit. This is the difference between a digital and an analog signal.

That's all you really need to know to use this voltage divider circuit, but if you want to practice the calculations, see "Show Me Some Math: Voltage Dividers" on page 130.

## SHOW ME SOME MATH: VOLTAGE DIVIDERS

Using a multimeter, you can measure the resistance of a photo-resistor under different conditions. (For instructions on using a multimeter, see "Measuring Electricity with a Multimeter" on page 298.) When we shined a bright light from a flashlight or cell phone on the photoresistor, we measured a resistance of about 100 Ω. When we covered the photoresistor with our hands, we saw a resistance of about 200 kΩ. With the fixed resistor ($R_2$) set at 10 kΩ, we'd expect to see the following values from the voltage divider in those two situations:

$$V_{out} = \frac{R_2}{R_1 + R_2} \times V_{in}$$

$$V_{out\,(light)} = \frac{10,000}{100 + 10,000} \times 5\text{ V}$$

$$= 0.990 \times 5\text{ V}$$

$$= 4.95\text{ V}$$

$$V_{out\,(dark)} = \frac{10,000}{200,000 + 10,000} \times 5\text{ V}$$

$$= 0.048 \times 5\text{ V}$$

$$= 0.24\text{ V}$$

With an input voltage of 5 V, the voltage across the photoresistor varies from 0.24 V to 4.95 V through a range of light levels. We'll show you how to use the Arduino to read these voltages in this chapter. Pretty cool, right? Math works!

## BUILD THE NIGHT-LIGHT PROTOTYPE

Let's put the RGB LED and the voltage divider together to build the Night-Light circuit. You'll start by building the voltage divider circuit with the photoresistor and then add the RGB LED. When you're done, your breadboard should look like Figure 5-10. We've also included a circuit diagram in Figure 5-11 for your reference.

RGB LED

**FIGURE 5-10:**

Completed prototype
circuit

PHOTORESISTOR

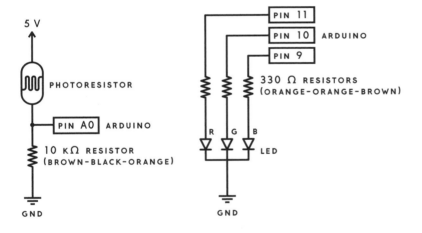

**FIGURE 5-11:**

Circuit diagram of
completed prototype
Night-Light circuit

## Wire the Voltage Divider

Find your photoresistor (it should look like the one in Figure 5-7) and
a 10 kΩ resistor. Recall that a 10 kΩ resistor has brown, black, and
orange color bands, as shown in Figure 5-12. See "Resistors and
Bands" on page 308 for details on how to determine the value of a
resistor from its color bands.

**FIGURE 5-12:**

10 kΩ resistor (brown-
black-orange)

With your parts in hand, build the voltage divider circuit as shown in Figure 5-13. It's good practice to connect both power (5 V) and ground when setting up the breadboard for building circuits, so do that first. Find the ground rail (–) and the power rail (+) on the left side of your breadboard. Connect 5 V on the Arduino to the power rail, and connect GND on the Arduino to the ground rail.

**FIGURE 5-13:**

Completed voltage divider, using the photoresistor

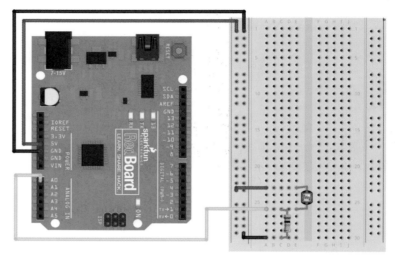

Next, plug the photoresistor in near the bottom of the breadboard, with each leg in its own row. Plug one side of the 10 kΩ resistor into the same row as one of the photoresistor legs (connecting the two together), and plug the other side of the resistor into a row by itself. Add a wire to connect the 5 V power rail (+) to the photoresistor leg that isn't connected to the resistor. Then, add another wire to connect the ground rail (–) to the resistor leg that's in a row by itself.

Finally, connect the photoresistor to the Arduino by running a wire from the breadboard row that's shared with both a leg from the resistor and a leg from the photoresistor to the Arduino analog input pin A0. This wire is often called the output voltage of the photoresistor, or the *signal wire*. The analog input pins, A0–A5, can all be used to measure a range of voltages.

Notice how the breadboard circuit looks a lot like the diagram in Figure 5-9. This is one of the most basic sensor circuits used in Arduino projects. Many other analog sensors, like sensors for flex, temperature, and pressure, are variable resistors, too. To experiment with one of those later, just replace the photoresistor with that sensor.

## Wire the RGB LED

Remember the Stoplight circuit in Project 2? That project had three LEDs. The RGB LED basically squishes those three LEDs together. The RGB LED has four legs, and the longest leg is the common cathode (negative) leg. With your RGB LED oriented as in Figure 5-5, find the red leg. Plug the RGB LED into the breadboard so that the red leg is at the top and the longest leg is the second one down, as shown in Figure 5-14.

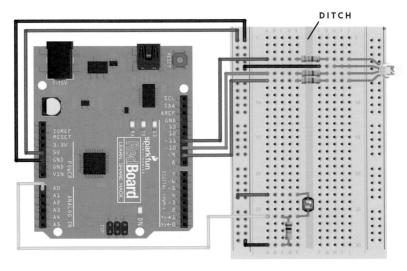

**FIGURE 5-14:**

Adding the RGB LED to the voltage divider circuit

The two halves of the breadboard are divided by a ditch that separates the rows. Plug the RGB LED into the right side, starting with the red pin in row 4.

Next, find three 330 Ω resistors; their color bands are orange-orange-brown. Use the three resistors to bridge the red, green, and blue pins across the ditch to open rows on the other side, as shown in Figure 5-14. The resistors need to straddle the ditch so that the two ends of the resistors aren't shorted together. Run a wire from the common cathode (negative) leg of the LED to the ground rail on the left side of the breadboard. Finally, connect the three pins of the RGB LED to the Arduino by running a wire from pin 11 on the Arduino to the resistor connected to the red pin on the breadboard, pin 10 on the Arduino to the resistor for the green pin on the breadboard, and pin 9 on the Arduino to the resistor for the blue pin on the breadboard. When you're done, it should resemble the diagram in Figure 5-14. Notice that the red, green, and blue wires correspond to the red, green, and blue positive legs on the LED.

With the RGB LED hooked up, you can control each color like a separate LED, using pins 9, 10, and 11. Open up the Arduino IDE, and let's play with this idea!

## TEST THE NIGHT-LIGHT WITH BASIC COLOR MIXING

You'll tackle a few new concepts with this project, starting with how to mix colors using an RGB LED. The RGB LED is really three LEDs in one, and you need to treat it that way in your code. Create a new sketch, and replace the default code with the setup() and loop() functions in Listing 5-1.

**LISTING 5-1:**

A simple code example to display cyan on the RGB LED

```
void setup()
{
❶ pinMode(11, OUTPUT); //red
 pinMode(10, OUTPUT); //green
 pinMode(9, OUTPUT); //blue
}

void loop()
{
❷ digitalWrite(11, LOW); //red
❸ digitalWrite(10, HIGH); //green
❹ digitalWrite(9, HIGH); //blue
}
```

Each pin that controls the RGB LED needs its own pinMode() function to set that pin as an OUTPUT ❶. Previous projects used the digitalWrite() function to turn LEDs on and off with individual pins, and you're going to do the same with the RGB LED. Using the color wheel in Figure 5-6, choose from any of the colors represented. We selected cyan, the combination of green and blue. To create cyan, you need to turn on the green ❸ and blue ❹ LEDs using the digitalWrite() function. To make sure that the red LED is off, the code also needs a third digitalWrite() function ❷.

Upload this sketch to your Arduino, and if the circuit is wired up correctly and the code is correct, your RGB LED should glow with a soft cyan light. If it's a different color or not lighting up at all, check your wiring and the orientation of the RGB LED.

Notice that even though you're using the RGB LED to mix colors, your code is still pretty similar to the code from other LED projects in this book. Each LED is turned on by a separate digital pin using the pinMode() function. You're just controlling the colors by using multiple digitalWrite() functions at the same time.

# PROGRAM THE NIGHT-LIGHT

In the Night-Light circuit, the photoresistor is used as a light sensor. The photoresistor voltage divider is connected to analog input pin A0. Recall that the Arduino can be used to measure voltage on any of the analog input pins. You can have the Arduino read the sensor value from that pin using the `analogRead()` function. The `analogRead()` function reads the voltage applied to an analog input pin and returns a value between 0 and 1,023, scaled from a voltage range of 0 V to 5 V. For example, if you applied 2.5 V to A0, the `analogRead(A0)` function would return a value of about 512, or roughly half of 1,023.

As the amount of light hitting the photoresistor changes, its resistance changes, and because of the voltage divider circuit, the voltage on the analog input pin changes, too. Let's see how to code this on the Arduino. To determine whether the Night-Light should be on or off, you want to read the voltage from the photoresistor and compare it against a value that indicates whether the room is dark or bright. You should already have the circuit wired up, with the RGB LED and the photoresistor hooked up to pin A0. Listing 5-2 shows the Arduino sketch in its entirety. You can either modify the sketch you made for Listing 5-1 to match it or just add this code to a brand-new sketch.

```
int calibrationValue;
int lightValue;

void setup()
{
 pinMode(9, OUTPUT);
 pinMode(10, OUTPUT);
 pinMode(11, OUTPUT);
❶ calibrationValue = analogRead(A0);
}
```

**LISTING 5-2:**
Complete Night-Light code

```
 void loop()
 {
❷ lightValue = analogRead(A0);
 if(lightValue < calibrationValue - 50)
 {
 digitalWrite(11, LOW); //red
 digitalWrite(10, HIGH); //green
 digitalWrite(9, HIGH); //blue
 }
❸ else
 {
 digitalWrite(11, LOW); //red
 digitalWrite(10, LOW); //green
 digitalWrite(9, LOW); //blue
 }
 }
```

Upload this to your Arduino board, and make sure the room you're in is brightly lit. When you shade the photoresistor enough with your hand, the RGB LED should turn on with a cyan color. If it doesn't work, try cupping your hands around the photoresistor or covering it with a book or magazine to make sure that it doesn't sense any light. Now, if you remove your hand and expose the photoresistor to light, the RGB LED should return to being off. Pretty cool! Let's look at how this works.

## Prepare to Check the Light Level

First, the sketch creates the calibrationValue and lightValue global variables without assigning values to them. Like the code in Listing 5-1, the setup() function calls pinMode() once for each pin of the RGB LED, setting pins 9, 10, and 11 to OUTPUT. Next, the sketch takes a single initial calibration reading from the photo-resistor ❶ and places it in the calibrationValue variable. This is the value the sketch will compare future measured light levels against to decide whether to turn the LED on or not.

Now, jump into the loop() function. The loop() function repeat-edly reads the current light level and stores it in the lightValue ❷ variable. The value of lightValue will be updated every time the loop() function repeats.

## Control the Night-Light Based on the Light Level

With the initial light level stored in the calibrationValue variable and the current light level stored in the lightValue variable, the Arduino can compare the two and decide whether to turn the Night-Light on

or off. You can tell the Arduino to do this by using an if() statement, a structure that controls the flow of code execution in a sketch. It allows the Arduino to make a decision based on the truth of an *expression*, a mathematical statement that has one of only two outcomes: true or false. You can see the basic flow of an if() statement in Figure 5-15.

**FIGURE 5-15:**

The structural flow of an if() statement

This sketch's if() statement checks the expression lightValue < calibrationValue - 50. The < symbol means "less than," so this statement reads, "Is lightValue less than calibrationValue minus 50?" If that expression is true, the sketch enacts the code inside the set of curly brackets just underneath the if() statement.

As the room gets darker, the voltage coming from the sensor circuit decreases. This expression checks if lightValue is significantly smaller than calibrationValue, which is true if the room has gotten darker. If it has, the sketch sets pins 9 and 10 HIGH and sets pin 11 LOW to turn the Night-Light on with a cyan color.

When the if() statement is false, the Arduino skips to the code that follows. This sketch includes an else ❸ statement, which gets executed only after an if() statement's expression evaluates to false. Inside the else statement, the sketch turns off all three pins.

## Prevent False Alarms

If the sketch just needs to check whether the light level has changed, why subtract 50 from the calibrationValue variable in the expression? Checking lightValue against a number smaller than calibrationValue increases the tolerance on the sketch. If you

were to use the `lightValue < calibrationValue` expression, your Night-Light would flicker on and off at the smallest changes in light (flip back to "Logical Comparison Operators" on page 106 for more on the < symbol). Subtracting 50 from the calibration value makes sure that the Night-Light turns on when the light level is more than 50 below the calibration (initial) measurement.

### Recalibrate the Night-Light

One last piece of useful information before you prettify your Night-Light is how to reset the calibration value to recalibrate for different light levels. The value of `calibrationValue` is set in the `setup()` function, so it runs only once. When your Arduino is powered, there are two different ways to restart your sketch. First, you can turn the Arduino off and on again, but that's kind of annoying and unsophisticated. The second way is a little more elegant. As with Project 4, you can simply press the reset button shown in Figure 5-16 to restart your sketch. It works the same way as the reset button on a computer or game console. Every time you press that button, the calibration value for the Night-Light is reset.

**FIGURE 5-16:**

The reset button in all of its clicky glory

Each time you move your project into a new room or lighting situation, recalibrate your photoresistor by pressing the reset button. When you recalibrate your photoresistor, make sure that it's reading the actual lighting conditions of your room and that you're not accidentally shadowing it in any way.

## CREATE MORE COLORS WITH ANALOGWRITE()

You're not restricted to just the colors you've seen so far with the RGB LED. By mixing gradations of those colors, you can make cerulean, orange, powder pink, or any of the other thousands of combinations.

But you can't create these colors by just turning the different standard colors on an RGB LED on and off, so you need a way to turn red on just a bit and add a hint of blue and green to create, for example, pink.

## Create Analog Signals with PWM

To use the LED in this way, you need to use analog values rather than digital values. In the Electronics Primer, we talked about the difference between analog and digital (page 10). A digital value can only be on or off, like a normal light switch. An analog signal has an infinite number of values, so it works on a scale, like a dimmer switch.

The problem is that the Arduino is a digital device, which means that it can only turn things on and off. To get it to output a value somewhere between on and off, you use a technique called *pulse width modulation (PWM)* to emulate an analog signal with digital values. The Arduino does this by turning a digital pin on and off extremely fast and then varying the relative amount of time the signal is HIGH (on) compared to the amount of time the signal is LOW (off) to create a signal that appears to be analog. The longer a pin is at a high value, the greater the analog value of the signal. This is sometimes also called varying the *duty cycle*. Figure 5-17 shows some duty cycles with varying pulse widths; the analog value of the pulse at 75 percent is higher than the value of the 25 percent duty cycle.

**25% DUTY CYCLE**

**50% DUTY CYCLE**

**75% DUTY CYCLE**

**FIGURE 5-17:**
Duty cycle signals showing different widths of the pulse

That's great, but not all Arduino pins have the ability to use PWM. On a standard Arduino, only certain GPIO pins—that is, pins 3, 5, 6, 9, 10, and 11—are PWM compatible. These pins are noted with a tilde (~) on the board, highlighted in Figure 5-18.

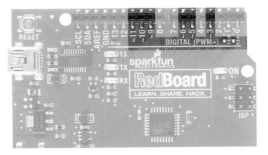

**FIGURE 5-18:**

PWM pins on the
standard RedBoard

Anytime you want to control something with varying values, like the brightness of an LED, the speed of a motor, or the tone of a buzzer, you'll need to use a PWM pin to fake an analog signal. Here, we'll use it to control the brightness of each color of the RGB LED in order to mix the colors. For this project, you have the RGB LED red, green, and blue pins already hooked up to PWM pins 11, 10, and 9, respectively, so you don't have to change any of your wiring, only your code.

## Mix Colors with analogWrite()

To utilize these PWM powers, you need to use the analogWrite() function, which writes a PWM value to a pin. The analogWrite() function accepts two parameters: the pin number that you want to control and a PWM value to write, which is always a range from 0 to 255. The value of 0 is completely off, and 255 is completely on. Let's write a simple sketch that demonstrates the analogWrite() function.

```
void setup()
{
❶ pinMode(9, OUTPUT);
}

void loop()
{
❷ analogWrite(9, 2);
}
```

First, as with any other pin, you need to specify how you're going to use the GPIO pin using the pinMode() function. You pass the pin number, and, since the LED is an output, you pass OUTPUT as you have in past projects ❶. To set a PWM value, you use the analogWrite() function to set an analog value between 0 and 255. In the example,

pin 9 (the blue anode of the RGB LED) is set to an analog value of 2 ❷. Upload this sketch to your Arduino, and you should have a dim blue colored RGB LED. The analogWrite() value of 2 uses PWM to turn on this LED for about 0.7 percent or 2/255 of the time. Before moving on, try changing the PWM value and reuploading a few times to get a feel for the different values and their intensity.

Now that you have the hang of the analogWrite() function, try using it to mix colors. Listing 5-3 creates a blink pattern with different, more interesting colors than those used so far.

```
void setup()
{
❶ pinMode(11, OUTPUT); //red
 pinMode(10, OUTPUT); //green
 pinMode(9, OUTPUT); //blue
}

void loop()
{
❷ analogWrite(11, 153); //dark orchid purple
 analogWrite(10, 50);
 analogWrite(9, 204);
 delay(1000);
❸ analogWrite(11, 155); //pale cerulean
 analogWrite(10, 196);
 analogWrite(9, 226);
 delay(1000);
❹ analogWrite(11, 255); //cadmium yellow
 analogWrite(10, 246);
 analogWrite(9, 0);
 delay(1000);
}
```

First, add the other two color pins using the pinMode() function ❶. Then, cycle through three different colors by setting different analog values to the three pins. This sets the brightness level of each specific color, changing how much of that color is added to the final mix.

The first color set creates a bluish purple ❷, the second creates a dusty pale blue ❸, and the final set creates a bright yellow ❹. Play around with analogWrite() to create different colors.

## Find RGB Values with Color Picker

You created some pretty specific colors before, but it can be hard to predict which RGB values will give you certain colors. An easy way of

finding out is to use a color-picker tool on the web. There are plenty of them out there, but we recommend *https://www.colorpicker.com/*. This tool gives you the RGB values for colors you pick from a palette, as shown in Figure 5-19.

**FIGURE 5-19:**

The color-selector tool from *https://www .colorpicker.com/*.

The three numbers you want to use are labeled R, G, B for the three colors Red, Green, and Blue. Ignore the top three H, S, B boxes; they refer to another common method for specifying colors called *HSB (hue, saturation, and brightness)*. This is a useful technique for many color mixing and graphic design applications, but it's not as useful when you have direct control over the three colors red, green, and blue.

## The Custom-Color Night-Light Code

With the RGB knowledge in hand, now you can easily modify your Night-Light code to include your custom color by replacing your `digitalWrite()` function with `analogWrite()`. Listing 5-4 shows changes to the Night-Light code, with the color values set to the teal color we selected in Figure 5-19.

**LISTING 5-4:**

Final Night-Light code with `analogWrite()` instead of `digitalWrite()` commands

```
int calibrationValue;
int lightValue;

void setup()
{
 pinMode(9, OUTPUT);
 pinMode(10, OUTPUT);
 pinMode(11, OUTPUT);
 calibrationValue = analogRead(A0);
}
```

```
void loop()
{
 lightValue = analogRead(A0);
 if(lightValue < calibrationValue - 50)
 {
 analogWrite(11, 66); //red
 analogWrite(10, 166); //green
 analogWrite(9, 199); //blue
 }
 else
 {
 analogWrite(11, 0); //red off
 analogWrite(10, 0); //green off
 analogWrite(9, 0); //blue off
 }
}
```

With that, your Night-Light prototype is done! If you don't like the teal we selected, use the color-selector tool to find a color you prefer, update your analogWrite() functions with its RGB value, and then re-upload your sketch before moving on. Visit *http://99colors .net/color-names/* if you want to browse through some fun color suggestions.

Now that you have the code working, it's time to get creative and build the enclosure and lampshade.

## BUILD THE NIGHT-LIGHT ENCLOSURE

We suggest cardstock for this project's enclosure rather than card-board (as it produces cleaner edges and is easier to work with) and a vellum material or translucent paper for the shade. Let's get building.

### Cardstock Construction

We'll show you a basic Night-Light design to get you started, but we encourage you to get creative by customizing the design later. Or, if you're feeling confident, you can design your own Night-Light enclo-sure from scratch without using our templates at all.

### Cut Out the Parts

This project has two templates: one for the structure of the Night-Light and one for the shade. The shade can be made from any material similar to printer paper in thickness, but we've found that a fully translucent material like vellum works best. If you have a printer, you can open the templates in Figure 5-20 from this book's resource files and print them directly to your material to cut out.

**FIGURE 5-20:**

Enclosure templates
for the Night-Light
(not full size)

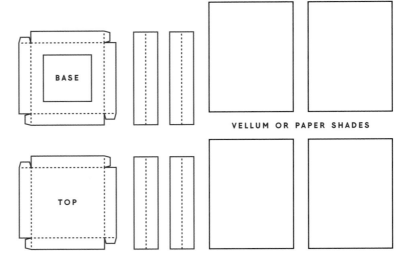

Note that the base of the Night-Light enclosure has a square cut out for access to wires. We also found it convenient to leave one of the four side panels off so that we could run the wires back to the larger breadboard more easily. We'll leave it up to you whether to include that fourth panel.

Once your template pieces are copied onto your cardstock and translucent material, cut them out. We highly recommend a sharp craft knife and a metal ruler to get clean edges for your project, as shown in Figure 5-21. Remember craft-knife safety: always pull the blade (don't push), and make multiple passes.

**FIGURE 5-21:**

Cutting out templates
from cardstock

## Assemble the Parts

Arrange all of your pieces in front of you. You should have six pieces for the structure and four pieces for the shade material, as shown in Figure 5-22.

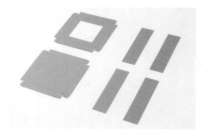

First, pick up the base (the piece with the center cut out). Hold it flat in front of you and fold the left and top edges toward you to form a right angle. Fold the tab on the left edge inward and secure it to the top edge with a small amount of glue, as shown in Figure 5-23. Repeat this for the other four corners of the base piece, and then use the same technique to assemble the top piece.

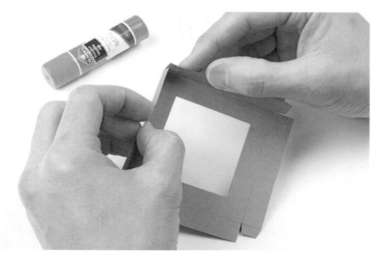

Next, fold each of the four side pieces down the middle lengthwise to form a nice 90-degree angle. There is a dotted line in the template to guide you. Once you have the top and base assembled and the sides folded, the six pieces should look like the ones in Figure 5-24.

**FIGURE 5-22:**
Individual parts cut out and ready for assembly

**NOTE**
*Depending on your card-stock thickness, you may want to lightly score the fold lines with your craft knife. This will result in sharper, cleaner corners.*

**FIGURE 5-23:**
Assembling the base and top pieces

**FIGURE 5-24:**

Assembled pieces
for the Night-Light
enclosure

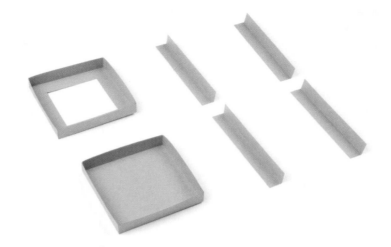

Finally, take each corner piece and glue it to the base, as shown in Figure 5-25.

**FIGURE 5-25:**

Glue each corner piece
to the base

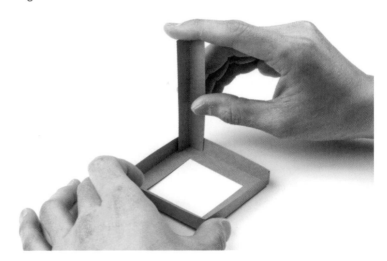

When you're finished gluing corners, you should have four standing corner support structures. We found it easier to glue the shades in place before gluing the top piece, so just add a small dab of glue on the inside edge of each support structure, and press the shades into place, as shown in Figure 5-26. You may want to use only three shades, to allow access for wires.

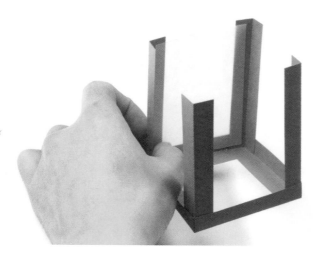

**FIGURE 5-26:**
Before adding the top piece, glue the shades into place.

When you've added all the panels you want, add the top piece. Simply add a small dab of glue on each corner to secure the top piece in place, as shown in Figure 5-27.

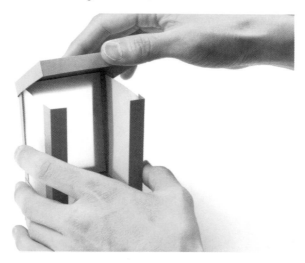

**FIGURE 5-27:**
Adding the final top piece

Now you should have a completed Night-Light enclosure like the one in Figure 5-28!

**FIGURE 5-28:**

Final Night-Light
enclosure

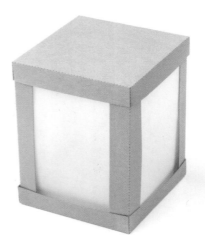

## Put the Electronics Inside

You have a couple of options for transferring the electronics into your new project: put the breadboard and the Arduino baseplate under the Night-Light, or move just the LED inside the Night-Light. We took the second approach.

First, unplug your Arduino from the computer, and then move the RGB LED onto a mini breadboard. The mini breadboard works the same way as its bigger cousin does; it just lacks power rails and is shorter. Add jumper wires to the mini breadboard to make the connection from the LED back to your original circuit, as shown in Figure 5-29. Notice that each of the four legs of the RGB LED is in a separate row: one for the red leg, one for the ground leg (the longest), one for green, and one for blue.

**FIGURE 5-29:**

Using the mini
breadboard to move
the RGB LED inside the
Night-Light

Now, connect the other end of each jumper wire to the breadboard row where the corresponding RGB LED leg used to be, as in Figure 5-30.

**FIGURE 5-30:**
Connecting the mini breadboard back to the main circuit

If you left one of the sides open, simply run the wires out the back of the lamp enclosure, like we did in Figure 5-31. Otherwise, carefully place your shade over the mini breadboard, and either tape your jumper wires to the table so the shade stays flat or make a couple of notches in the cardboard at the bottom of the enclosure for the wires to fit through.

**FIGURE 5-31:**
Placing the shade on top of the mini breadboard

## Let It Glow!

If you have the external battery pack, you can now put four AA batteries in, and plug the barrel jack into the Arduino. The board should still be programmed and running, so just turn off the lights. You should get a nice, softly glowing night-light, like ours in Figure 5-32.

**FIGURE 5-32:**

Lights out! Our final glowing Night-Light project.

## GOING FURTHER

This project used a lot of new skills and knowledge, but it still has a load of potential for further hacking. There are plenty of things you can do in terms of both the design and the code as you build your skills with Arduino.

### Hack

One great sketch hack would be to have the colors change periodically when the Night-Light is on. For some hints, look back at your Stoplight project code. One method would be to add some simple blink code within the `if()` statement rather than just `digitalWrite()` functions and build a color animation.

You could also try adding different colors for different light readings using the `else if()` command rather than just `if()` or `else` on its own. The base structure of this method might look something like Listing 5-5.

**LISTING 5-5:**

Three-stage Night-Light code example

```
if (lightValue < calibrationValue - 200)
{
 //do if it is completely dark
 digitalWrite(11, HIGH);
 digitalWrite(10, LOW);
}
```

```
else if (lightValue < calibrationValue - 50)
{
 //do if it is a little dim
 digitalWrite(11, LOW);
 digitalWrite(10, HIGH);
}
else
{
 //do if it is bright
 digitalWrite(11, LOW);
 digitalWrite(10, LOW);
}
```

You can see the sketch uses `else if()` to set categories of light value. You would then need to set the color for each category.

## Modify

The design of your Night-Light is totally up to you, so you can create a whole new design if you want. There are a number of tools you can use to design an enclosure and then produce it through automated means, such as laser cutting with balsa wood, 3D printing with materials like ABS or HIPS plastics, or even CNC milling, routing, or machining. Computer-controlled manufacturing will produce super-clean and accurate parts that will amount to a more refined product. We encourage you to explore these possibilities to create something more permanent and polished. If you don't have access to these kinds of tools, try looking into local hacker or maker spaces in your city. Often they'll have facilities and tools that you can work with.

We have included a few example templates and ideas of projects that you can build and adapt at *https://www.nostarch .com/arduinoinventor/*. Figure 5-33 shows an example of how you can break up the lampshade design with some fun patterns.

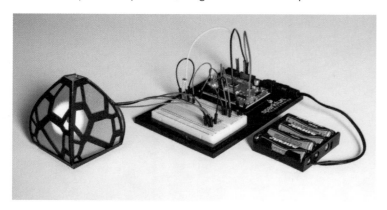

**FIGURE 5-33:**
A fun design from our design templates.

# BALANCE BEAM

IN THIS PROJECT, YOU'LL BUILD A DESKTOP BALANCE BEAM GAME USING A TURN KNOB AND A <u>SERVO MOTOR</u> (A SMALL MOTOR CAPABLE OF MAKING PRECISE MOVEMENTS). THE AIM OF THE GAME IS TO ROLL A BALL BACK AND FORTH ALONG THE BEAM WITHOUT IT FALLING OFF. YOU'LL DO THIS BY USING THE TURN KNOB TO CONTROL THE POSITION OF THE SERVO. AS THE SERVO MOVES, SO WILL THE BEAM! READY TO GET STARTED?

Figure 6-1 shows the finished project. This is a simple mechanism that is made entirely of cardboard and a few household materials.

**FIGURE 6-1:**

The finished Balance Beam project

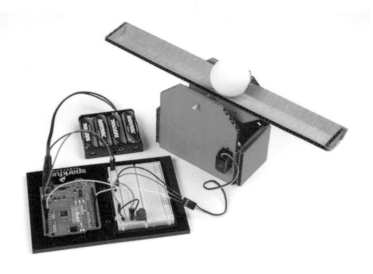

## MATERIALS TO GATHER

The circuit for this project uses relatively few parts, though we will introduce two new pieces of hardware: the servo motor and the potentiometer. Take a look at the electronic parts and other materials you'll need, shown in Figures 6-2 through 6-4.

### Electronic Parts

**NOTE**

*All of the parts used in this project are standard in the SparkFun Inventor's Kit.*

- One SparkFun RedBoard (DEV-13975), Arduino Uno (DEV-11021), or any other Arduino-compatible board

- One USB Mini-B cable (CAB-11301 or your board's USB cable; not shown)

- One solderless breadboard (PRT-12002)

- One 10 kΩ potentiometer (COM-09806)

- One submicro size servo motor (ROB-09065)

- Male-to-male jumper wires (PRT-11026)

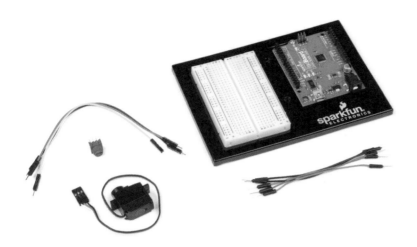

**FIGURE 6-2:**

Components for the
Balance Beam

## Other Materials and Tools

- Pencil or marker
- Craft knife
- Metal ruler
- Needle-nose pliers
- Wire cutters
- Glue (hot glue gun or craft glue)
- Mini screwdriver
- Scissors (not shown)
- (Optional) Drill and 1/4-inch, 1/8-inch, and 1/16-inch bits
- Two sheets of cardboard (roughly 8.5 × 11 inches in size)
- Balance Beam template (see Figure 6-16 on page 167)
- One bamboo skewer
- One small drinking straw (the bamboo skewer should fit into the straw loosely)
- One ping-pong ball
- One medium-size paper clip

**FIGURE 6-3:**

Recommended building
materials

**FIGURE 6-4:**

Recommended tools

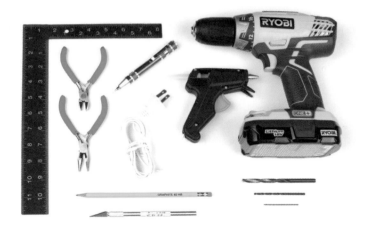

## NEW COMPONENTS

In the previous projects, you've mostly used your Arduino to control
LEDs, but now it's time to branch out and explore other components.
This project introduces a new sensor, called a *potentiometer*, and
motors, specifically the *servo motor*.

### The Potentiometer

In this project, you'll use a potentiometer to control the movement of
the Balance Beam. A potentiometer is a kind of sensor known as a
*variable resistor*, which just means it's a resistor whose value can vary.

A potentiometer generally has three legs or connection points
and is represented by the symbol shown in Figure 6-5.

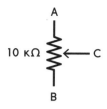

A

10 KΩ ← C

B

**FIGURE 6-5:**
Schematic diagram for a potentiometer

Potentiometers come in many shapes and sizes, a few of which are shown in Figure 6-6. Some look like turn knobs, some are sliders, and others require a small screwdriver to manipulate. Regardless of their appearance, they all work in the same way. And they are all around you—at home, you might find them in the dimmer switch of your dining room light, in the volume knob on your stereo, or inside . devices like DVD players.

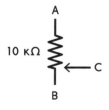

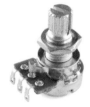

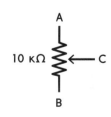

**FIGURE 6-6:**
Various shapes and sizes of potentiometers. We'll be using the one on the left.

A potentiometer has a fixed resistance between the two opposite legs marked A and B in Figure 6-7. Potentiometers can come in all sorts of resistance values, but for this project you'll use a 10 kΩ potentiometer. As you turn the knob or move the slider, the third leg of the potentiometer (marked C), called the *wiper*, moves up or down the resistor, and the resistance between B and C changes. It's this resistance value that's applied to the circuit.

If you turn the knob clockwise, the wiper moves toward A and the resistance between C and B increases; if you turn the knob counterclockwise, the wiper moves toward B and the resistance decreases. Figure 6-7 shows how moving the wiper affects the resistance.

A

10 KΩ ← C

B

$R_{B-C} \approx 0 \text{ K}\Omega$

A

10 KΩ ← C

B

$R_{B-C} \approx 5 \text{ K}\Omega$

A

10 KΩ ← C

B

$R_{B-C} \approx 10 \text{ K}\Omega$

**FIGURE 6-7:**
Various positions on a potentiometer

If you connect A to 5 V, B to GND, and C to an analog input pin on your Arduino, this circuit starts to resemble the voltage divider you used in Project 5. As you turn the knob, you can vary the voltage on C between 0 V and 5 V. This setup is also sometimes called an *adjustable voltage divider.*

### The Servo Motor

A servo motor (or just *servo* for short) is a special type of motor designed to rotate an arm (or *horn*) to a particular angle, which you will determine in your sketch. Most servo motors have a given range of 180 degrees, though some can rotate a full 360 degrees; these are called *continuous rotation servos*. In this project, you'll be using a standard 180-degree hobby servo, shown in Figure 6-8.

**FIGURE 6-8:**

A standard hobby servo

Servo motors are used in thousands of different products, from model cars and airplanes to the speedometer in your car and the robotic arms that built it.

What's inside that black box? We opened one up so you don't have to—see Figure 6-9.

**FIGURE 6-9:**

The inside of a servo motor

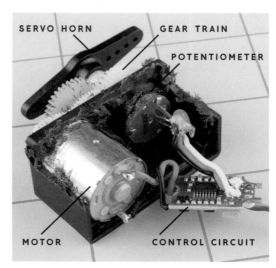

Inside a servo are three main parts: the motor, gear train, and control circuit. When voltage is applied to the motor, it turns the gear train, which turns the hub of the servo motor. The rotational position of the hub is controlled by the control circuit. Part of the gear train is a potentiometer that rotates as the motor rotates. Remember that a potentiometer is a simple sensor that changes resistance based on how much it rotates, and when it's connected up as an adjustable voltage divider, the voltage varies as the potentiometer rotates. The control circuit reads both the value in the input signal coming into the servo (from the Arduino, in this case) and the potentiometer value and compares them. When the two values are equal, the motor stops and holds its position.

A servo motor relies on PWM, a concept we introduced in "Create More Colors with `analogWrite()`" on page 138. To control the position of a servo, the Arduino sends out a PWM signal that pulses every 20 ms. The width of the pulse corresponds to a specific rotational position for the servo motor. Figure 6-10 illustrates this by showing the minimum PWM pulse widths for 0 degrees of a servo, the midpoint of 90 degrees, and the maximum of 180 degrees. Similar to blinking an LED, you can use the Arduino to create a very short pulse that is on for 1 ms and off for 19 ms to move the servo to an angle of 0 degrees.

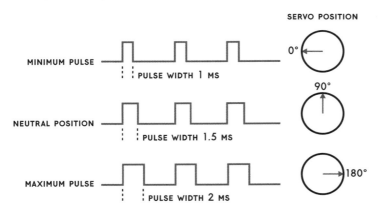

**FIGURE 6-10:**

The PWM duty cycles for the standard range of a servo

To set the angle of a servo motor to 0 degrees, you could use code like the following:

```
void setup()
{
 pinMode(9, OUTPUT);
}
```

```
void loop()
{
 digitalWrite(9, HIGH);
 delay(1);
 digitalWrite(9, LOW)
 delay(19);
}
```

This code drives pin 9 HIGH for 1 ms, and then immediately sets the pin LOW for 19 ms. As soon as the 19 ms are over, it has to drive the pin HIGH again for 1 ms to maintain the timing cycle. If your code is busy managing timing like this, you can't add anything else to it without affecting the timing of the pulses and control of the servo. Thankfully, the Arduino has a trick to simplify the way you control the servo motor: using a *library*. A library is a file containing extra code that you can use with your sketch to perform specific tasks or make it easier to use particular parts. The Servo library handles all of the pulse timing needed to drive the servo motor to a specific angle.

In this project, you'll be using the Arduino to move a balance beam based on the voltage output of a sensor—your potentiometer. The code will use the voltage reading of the sensor to set the appropriate pulse width length for a given rotation for the servo, which will determine the angle of the beam.

The good news is that the Arduino, and more specifically the Servo library, does all of the hard work for you! It is great to understand how the pulse width controls the position of the servo, but, in the end, the software takes care of it for you.

## BUILD THE BALANCE BEAM PROTOTYPE

Now that you know the theory, you'll build the circuit for the Balance Beam. You'll start by connecting the servo, and then you'll add a potentiometer; Figure 6-11 shows the full circuit.

Notice that the servo has a single three-pin female header. To connect this to your circuit, you'll need to use male-to-male jumper wires. Take three short male-to-male jumper wires and connect these to the female pins, as shown in Figure 6-12. It's good practice to use the colors that correspond to the servo wires to make it easier to see which is which: black, red, and white represent the ground, power, and signal lines, respectively. Now, hook the servo up to the Arduino.

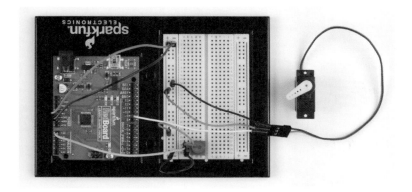

**FIGURE 6-11:**
Balance Beam prototype
circuit

**FIGURE 6-12:**
Adding male-to-male
jumper wire extensions
to the servo motor

The circuit connection is pretty simple: connect 5 V and GND from the Arduino to the power rails on the left side of the breadboard. Connect the servo's ground (black) wire to the ground rail on the breadboard and the power (red) wire to the 5 V rail. Connect the signal wire directly to pin 9 on the Arduino. A complete diagram is shown in Figure 6-13.

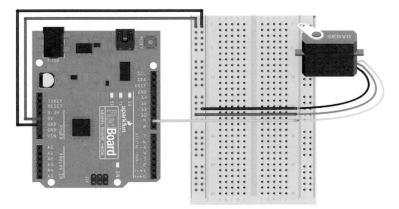

**FIGURE 6-13:**
Servo hooked up to signal,
power, and ground

Finally, add the servo *horn* onto the hub of the servo. Horns are different-shaped arms for a servo that rotate with the hub to make it easier to use and attach things to the servo. At this point, select any one of the horns that come with the servo, and press-fit it onto the hub of the servo, as shown in Figure 6-14. You will add a specific horn later, but for now we just want to make it easier to see rotation.

**FIGURE 6-14:**

Press-fitting a
servo horn from the
included options

If the servo starts moving or acting erratically, simply disconnect its black wire from the ground rail to stop it. It's good safety practice to keep the black wire disconnected until you upload code.

Now, wire up the potentiometer. The breadboard has plenty of room, so place the potentiometer anywhere you like, making sure each leg is in its own row. Connect the two outside pins to the 5 V and ground rails, with the center pin connected to analog input pin A0 directly on the Arduino, as shown in Figure 6-15.

**FIGURE 6-15:**

The full Balance Beam
circuit

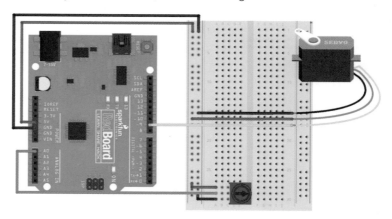

At the moment, you just have a servo connected to a potentiometer. To give the project its balancing powers, you need to program it.

# PROGRAM THE BALANCE BEAM

To use the servo with an Arduino, you need to use the Servo library—which, as mentioned earlier, is a collection of prewritten code that expands the commands and capabilities of the code in your sketch. It gives you more features and functions to work with and simplifies using external hardware with your Arduino. For example, the Servo library includes code that attaches the servo to a specific Arduino pin, moves the servo to specific angles, and even detaches the servo from a pin.

Before you program the full project, you'll upload a quick test sketch to check that your servo is working correctly.

## Test the Servo

Here's a simple example sketch for controlling your servo. Start a new sketch by selecting **File ▸ New**, and then enter the sketch in Listing 6-1:

❶ `#include<Servo.h>`

❷ `Servo myServo;`
`void setup()`
`{`
❸ `  myServo.attach(9);`
`}`

`void loop()`
`{`
❹ `  myServo.write(90);`
`}`

**LISTING 6-1:**

A servo "Hello world"

To use the Servo library, call `#include<Servo.h>` ❶, which tells the Arduino to include the *Servo.h* file containing the Servo library code. This adds the functions and definitions of the library to the sketch. Notice that this is one of the rare instances where there isn't a semicolon at the end of the line. In Arduino programming, the # symbol indicates that the following code is a *preprocessor directive*, a special piece of code that should be executed before the rest of the sketch. When you compile a sketch, the first thing that runs is the *preprocessor*, which searches for any lines that start with a # symbol and don't end with the semicolon and runs those lines first. The `#include` directive tells the preprocessor to include all of the code in the named file before compiling the code in your sketch.

You can also use the drop-down menu to add a library by selecting **Sketch ▸ Include Library...** and then selecting the library you want to use (in this case, **Servo**). This will automatically add the `#include` statement to your sketch. This option is great if you can't remember the precise syntax of the `#include` command or the library name—for example, when you use a library for the first time.

The library allows you to create a type of data structure called an *object*. An object is simply a container for variables and functions that are predefined. Functions that are associated with the object are referred to as *methods*. In this sketch, the line `Servo myServo;` creates a new `Servo` object named `myServo` ❷.

You can give an object any name you like, but we recommend using a descriptive name, like `myServo`, so it's recognizable. Now you can use that name to reference all the servo commands that are available to you in the Servo library. For example, the method `myServo.attach()` tells the Arduino which pin the servo is attached to. If you had multiple servos, each one would get a unique name so that you could control all of them independently.

As an example, think of a robot arm that moves at the shoulder, elbow, and wrist, using a servo for each joint. The code for it would create three `Servo` objects named `shoulderServo`, `elbowServo`, and `wristServo` so that you could position each one accurately and at a different orientation from the others. Each one of those `Servo` objects would have its own set of methods that you could use separately.

For the Balance Beam, you'll use only one servo. The setup of the sketch tells the Arduino that you have a servo attached to pin 9 with the method `myServo.attach(9)` ❸. It then tells the Arduino to move the servo to a position of 90 degrees via the method `myServo.write(90)` ❹. The Servo library converts the angle in degrees of rotation to the appropriate pulse width behind the scenes. This is built into the `write()` method.

Now, plug the black wire of your servo into ground and upload your code to the Arduino, and the servo will rotate to 90 degrees. It's safe for now to leave your servo wired up.

To move the servo again, just pass another number within the bounds of the servo's range of motion (10–170) to the `write()` method and upload the sketch again. Play with your servo for a bit, passing in different values.

Okay, so you know how to get the servo to move just once. Now, here's some code that really gets it moving. Listing 6-2 moves the control of the servo into a loop and repeats a motion.

```
#include<Servo.h>
Servo myServo;
void setup()
{
 myServo.attach(9);
}

void loop()
{
 myServo.write(10);
 delay(1000);
 myServo.write(170);
 delay(1000);
}
```

**LISTING 6-2:**

Servo blink sketch

This piece of code is a servo version of the blink sketch from Project 1. The servo moves to 10 degrees, waits for 1 second, moves to 170 degrees, waits for 1 second, and then repeats. We fondly refer to this as "robot march," because when you have 20+ people doing it at once, it sounds like a robot army marching to take over the world.

Wow! You're on a roll here. But servos really become interesting when you can control the servo yourself, without having to reprogram it each time. It's time to get the potentiometer involved.

## Complete the Balance Beam Sketch

For the final sketch, you'll program the potentiometer to control the rotation of the servo. Modify your sketch as shown in Listing 6-3:

```
#include<Servo.h>
Servo myServo;
❶ int potVal;
int anglePosition;
void setup()
{
 myServo.attach(9);
}

void loop()
{
 potVal = analogRead(A0);
❷ anglePosition = map(potVal, 0, 1023, 10, 170);
 myServo.write(anglePosition);
 delay(20);
}
```

**LISTING 6-3:**

Using the map() function to control a servo with a potentiometer

This sketch reads the value of the potentiometer, translates it into an angle value, and then writes that value to the servo. There are some new commands in here, so we'll go over it step-by-step.

The top portion of this code looks just like the first two example listings. It includes the Servo library and creates a `Servo` object named `myServo`. It also declares two global variables ❶ named `potVal` and `anglePosition`. These variables will be used to store the raw value of the potentiometer and a calculated angle position for the servo, respectively.

In the `loop()` function, the variable `potVal` stores the raw analog-to-digital converter value from the `analogRead(A0)` function. As you turn the knob on the potentiometer, the voltage on the wiper pin will vary between 0 V and 5 V. Remember that `analogRead()` will convert a voltage from 0 V to 5 V to a number between 0 and 1,023. However, the values 0 to 1,023 aren't very useful for controlling the servo. As we mentioned before, the servo needs to stay between 10 and 170 degrees.

Thankfully, Arduino has a built-in `map()` function that allows you to take one range of numbers and find the equivalent value in a different range. The variable `anglePosition` stores an angle position that is calculated from `potVal` using the `map()` function ❷. The `map()` function uses five parameters: `map(input, fromLow, fromHigh, toLow, toHigh)`. In this example, it maps the value of `potVal` from the range of 0 to 1,023 to a new range of 10 to 170. This is a really nifty function in Arduino that makes scaling and translating between value ranges super easy!

The sketch also adds a short delay of 20 ms to give the servo enough time to move before it reads the potentiometer again. A 20 ms delay is the minimum delay that the servo needs. You may also recall that it's the time period of the PWM signal that's used to control the angle.

Once you have this sketch updated, upload it to your Arduino. Now when you turn the potentiometer, the servo moves with it. Pretty sweet! Next you'll take your newfound superpower and build a balancing game out of it.

## BUILD THE BALANCE BEAM

With this cool way to control a servo, we thought it would be fun to create a desktop game. You'll create a balance beam that you control using the potentiometer and servo. A ping-pong ball will roll on the balance beam, and your goal is to get the ball as close as possible to the ends of the beam without it falling off.

### Cut Out the Parts

Download the template provided at *https://www.nostarch.com/ arduinoinventor/* (shown in Figure 6-16), print it out, and then trace it onto your cardboard. We designed this project to fit on as small a piece of cardboard as we could.

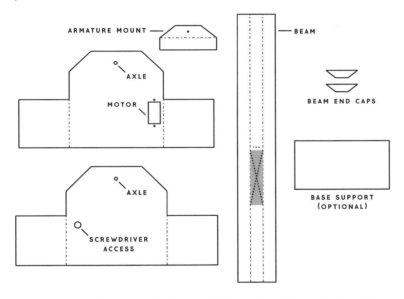

**FIGURE 6-16:**

Balance Beam frame template (not full size)

Using a craft knife, cut all the solid lines along the perimeter of each shape, as well as the cut-out for the motor mount. Don't score any of the pieces just yet; you'll do that as you go along. Remember to exercise safety when cutting. Use a metal ruler and a sharp craft knife, as shown in Figure 6-17, and take your time. Use a drill or a craft knife to make the six different holes in this design. If you're using a drill, you'll need a 1/4-inch drill bit for the screwdriver access hole, a 1/8-inch drill bit for the axle holes, and a 1/16-inch drill bit for the armature mount hole and the two motor mount holes.

**FIGURE 6-17:**

Cutting out the
frame pieces from
the template

Once you've finished cutting, you should have six pieces like those shown in Figure 6-18.

**FIGURE 6-18:**

All cardboard parts
cut out

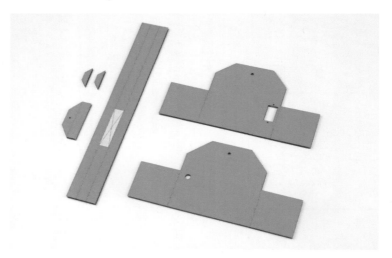

## Build the Beam

Take the longest piece, which will be the actual beam, and carefully score the dotted line that runs along its length. This will allow you to curve the beam so that it cradles the ball. We designed the template so that the beam is 11 inches long, the length of a standard sheet of 8.5 × 11-inch paper.

Next, prepare the armature mount. This is a small trapezoidal piece about 2 1/4 inches wide by 1 inch tall. You will use this piece to connect the servo motor to the beam. Score it and bend it into a right angle, as shown in Figure 6-19.

**FIGURE 6-19:**
Preparing the armature mount

Next, cut down the drinking straw so that it's 1 3/4 inches long, and glue it down along the center line of the beam, as shown in Figure 6-20.

**FIGURE 6-20:**
Gluing down the straw at the midpoint of the beam

Now, glue down the half of the armature mount without the drilled hole. This goes just to the left of the drinking straw, as shown in Figure 6-21; make sure the half with the hole is facing you when the straw is at the right. This is important so that it fits with the servo mounting arm.

**FIGURE 6-21:**

Gluing the armature
mount to the beam

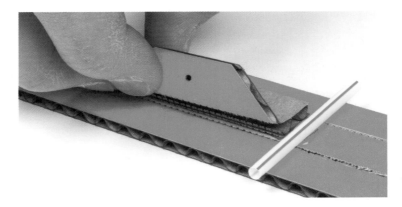

Next, bend the sides of the beam up to form a cradle that will
hold the ball, as shown in Figure 6-22.

**FIGURE 6-22:**

Bending the sides of
the beam to form a
cradle

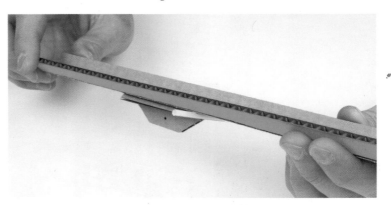

Use the smaller trapezoidal pieces to secure the ends of the
beam and hold the beam together to keep the shape of the cradle.
We suggest using a hot glue gun so that the pieces are secure, like in
Figure 6-23.

**FIGURE 6-23:**

Gluing the end pieces
onto the beam

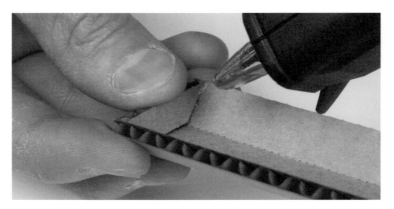

Next, use the wire cutters to cut down the bamboo skewer to about 3 1/4 inches. We suggest using the blunt end of the skewer. Insert the bamboo skewer into the drinking straw to form the axle for the balance beam (Figure 6-24).

**FIGURE 6-24:**

Positioning the cut bamboo skewer so that it sticks out evenly on both sides

## Build the Base and Attach the Servo

Now you'll build the base of the balance beam. Score the sides of the base pieces, as shown in Figure 6-25, so that you can bend them into shape.

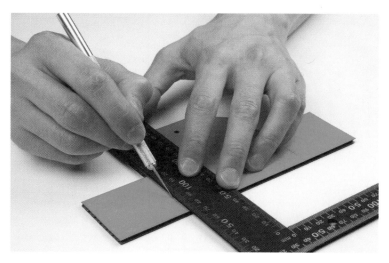

**FIGURE 6-25:**

Scoring the sides of the base pieces

After scoring, bend the sides to form a U shape as shown in Figure 6-26. Repeat this for both pieces.

**FIGURE 6-26:**

Bending the sides

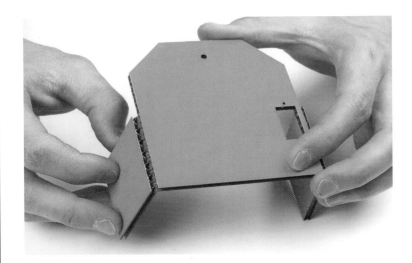

Before gluing together the base, you'll mount the servo motor. Remove the servo motor from the breadboard circuit. There is a small, square cutout in one of the templates that should match the submicro-sized servo perfectly. Insert the servo so that the motor is facing inward, as shown in Figure 6-27.

**FIGURE 6-27:**

Inserting the servo motor

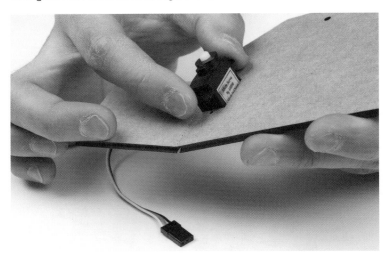

Your servo should have come with three small screws, one short and the other two longer. Use the two longer screws to secure the servo motor in place, like in Figure 6-28. If you don't have screws, you can also use a small amount of hot glue to secure the motor.

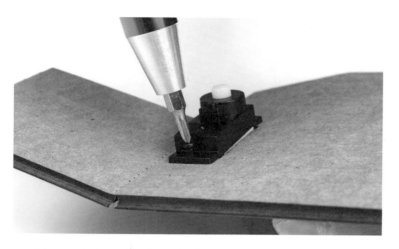

**FIGURE 6-28:**
Securing the servo motor in place using the two longer screws

Now, select a servo horn that's about 0.5 inches long and single sided. Gently push this into place on the end of the servo motor, as shown in Figure 6-29. Once you have it securely on the servo, orient the servo to 0 degrees. Gently rotate the servo counterclockwise with your fingers until it stops. You'll hear the little gears inside the servo turn. Make sure that you move the servo slowly; the gears are often made of plastic and can break.

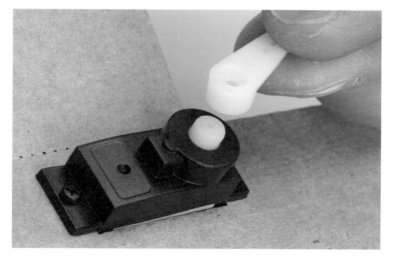

**FIGURE 6-29:**
Attaching the single-sided servo horn

With the servo horn rotated as far as it can go counterclockwise, remove the horn and reposition it so that it is pointed straight up, as shown in Figure 6-30. This will make it easier to connect the linkage to the beam.

**FIGURE 6-30:**

Servo horn aligned at
0 degrees

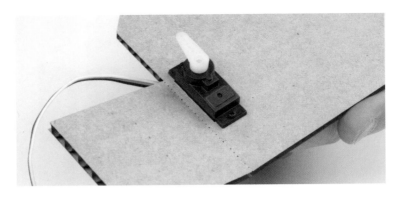

Finally, secure the horn in place using the last small screw that comes with the servo to ensure that the horn does not accidentally pop out. The horn may turn as you tighten the screw. This is okay—it won't damage anything, but you may want to hold the servo horn in place with your fingers when tightening the screw to keep the horn from rotating. If you lost the screw, it's not a big deal; you can leave it out and just reattach the horn if it does slip out. If you have to reposition the servo arm, you'll need to remove this screw, which is why we included a hole on the other side of the base template.

Next, you need a linkage to connect the servo horn to the beam. To make this, you'll shape a medium-size paper clip with a pair of needle-nose pliers. Figure 6-31 shows all the steps of this process.

**FIGURE 6-31:**

The steps to cutting,
bending, and shaping
the servo linkage

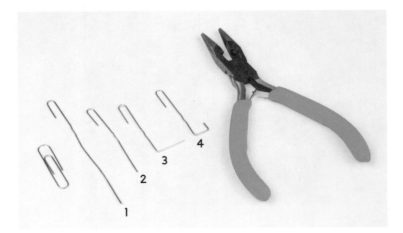

1.  Use the pliers to straighten the paper clip out, leaving all but the small hook on one end.

2.  Trim the paper clip down so that it is about 2 inches long from one end to the other.

3. Bend the straight end of the paper clip away from the hook at about 1 1/2 inches from the hooked end.

4. Add the final bend to create another hook about 3/8 inches deep. When complete, the servo linkage should be about 1 1/2 inches long (Figure 6-32). This length is perfect given the geometry of our template. If you're designing your own enclosure, you might have to play around with this length a bit to get the servo horn connected to the beam properly.

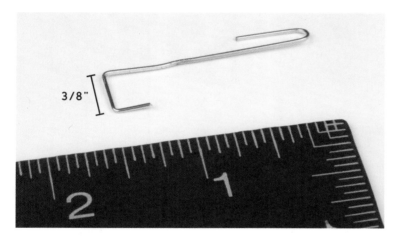

**FIGURE 6-32:**
Final bend in the paper clip linkage

## Final Assembly

Now for the final assembly! First, glue together the two base pieces. Glue two of the square tabs together, starting with the side opposite the servo motor (Figures 6-33 and 6-34). This will give you room to get your hands in there and connect the servo horn linkage.

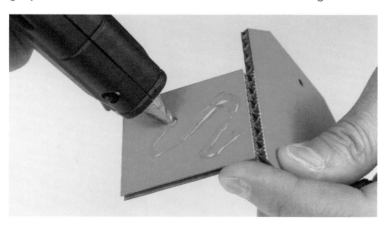

**FIGURE 6-33:**
The best way to adhere two pieces together is to use a snake or S-shaped pattern with the glue.

**FIGURE 6-34:**

Secure the far side of
the base first.

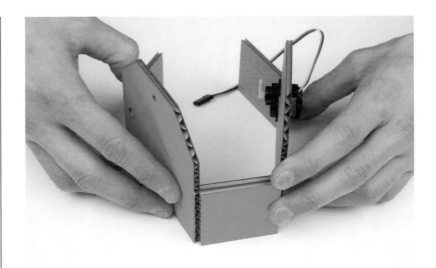

With the servo side open, take the original hooked end of the
bent paper clip linkage and hook it through the last hole on the servo
horn, as shown in Figure 6-35.

**FIGURE 6-35:**

Hooking the paper clip
through the last hole in
the servo horn

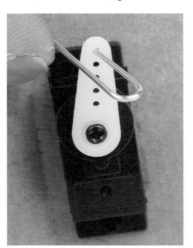

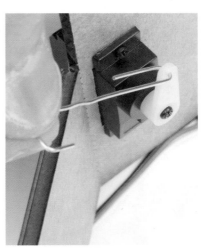

## FOUR-BAR LINKAGES AND CONNECTING
## SERVOS TO DO COOL THINGS

The mechanism used to turn the rotational movement of the servo horn into the up-and-down movement of the balance beam is called a *four-bar linkage*. We designed this template so that the length of the linkage should be about 1 1/2 inches, and it assumes that the servo horn is 1/2 inch long. We used these measurements to calculate the movements of the servo and beam. If you're picturing circles, arcs, pivot points, and a lot of crazy geometry, don't worry: we've done all the hard stuff already. The following figure shows a four-bar linkage in action, with the linkage itself and the pivot of the beam highlighted.

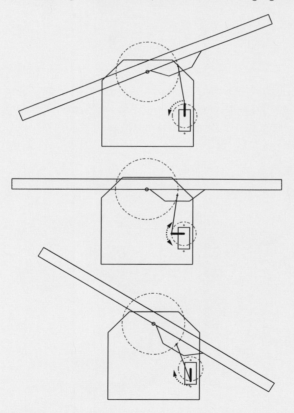

Four-bar linkages are an amazing way of converting the rotation of an object (like the servo) into a different motion (like the up-and-down motion of the beam). Engineers and roboticists use these kinds of mechanisms and linkages all the time to make things move.

Hook the other end of the linkage through the hole in the armature mount, as shown in Figure 6-36.

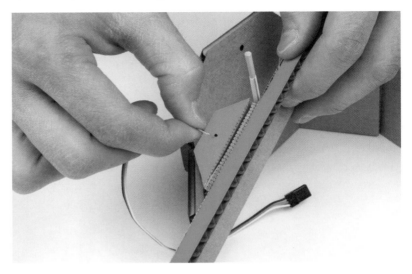

Now, insert the axle through one side of the base, carefully line up the second side, insert the axle through the matching hole, and glue the tabs at the other end of the base together (Figures 6-37 and 6-38).

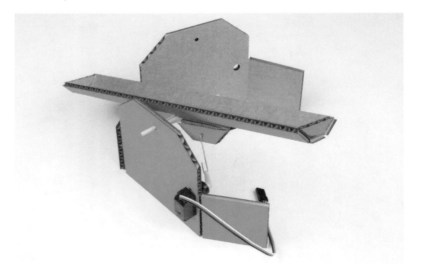

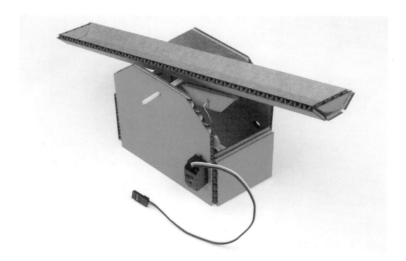

**FIGURE 6-38:**
Completed Balance Beam
project

Finally, connect the servo motor back to the breadboard circuit (Figure 6-39). Power up your Arduino, and the servo motor should move into place. Turn the potentiometer and test to make sure that the linkage and the pivot points all move as expected. If they don't, check that everything is still in place and nothing has fallen out.

As a final step, we suggest an extra rectangular base support piece. The base should measure about 2 × 3.75 inches. Insert this piece at the base of your enclosure to add extra support.

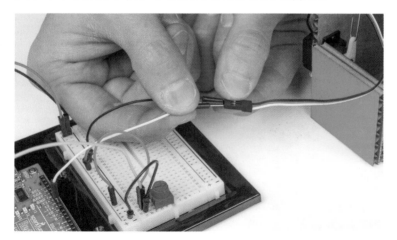

**FIGURE 6-39:**
Reconnecting the
servo motor to the
breadboard circuit

With that, your project is complete! Now, find a ping-pong ball or marble and test your skills of control and precision. You now have a game to play when you should be doing something a little more productive. How many times can you roll the ball back and forth before dropping it? Challenge a friend, and see who's better!

## GOING FURTHER

This project is a great introduction to the world of servos and libraries in Arduino. There's a lot of potential here, so we would like to share some launching points for you to play with servos.

### Hack

Swap out the potentiometer with the light sensor circuit from Project 5. You'll have to include a 10 kΩ resistor and adjust the scaling values you use. Now, move your hand up and down above the light sensor to control the ball. Go challenge a friend! Are you better with the light sensor or the potentiometer?

### Modify

You can add an "autopilot" mode for your Balance Beam that will balance the ball on its own. To do this, you're going to add a switch to your circuit. As you saw in Project 5, a switch is similar to a push button in that it makes or breaks a connection in a circuit, but in a switch the connection stays in place until it is switched again. The switch you'll use is called a *single-pole, double-throw (SPDT)* switch, shown in Figure 6-40. This is a fancy way of saying there's a single common pin and two options that it can be connected to. When the switch is in the leftmost position, it connects the center pin and the left pin. When the switch is in the rightmost position, it connects the center pin and the right pin.

**FIGURE 6-40:**

The single-pole, double-throw switch

This switch, when wired correctly, will act as an on-off switch, allowing you to read whether it is set on 5 V or ground. Place the switch in the breadboard, making sure each leg gets its own row of holes. We placed ours at the top of the breadboard in Figure 6-41. As with the potentiometer, connect the two outer pins of the switch to the 5 V and ground power rails of the breadboard using two shorter jumper wires. Use a third jumper wire to connect the center pin of the switch to pin 12 of the Arduino. A complete diagram of this circuit is shown in Figure 6-41.

**FIGURE 6-41:**
The final circuit with the
mode selection switch

The center pin is the signal pin and will read either HIGH or LOW depending on the position of the switch. You'll use this paired with some basic logic to switch between manual control, which uses the potentiometer, and autopilot, which sets the servo to move back and forth on its own.

From the book's resources at *https://www.nostarch.com/ arduinoinventor/*, upload the *P6_AutoBalanceBeam.ino* sketch to your Arduino. Take a look at the comments in the sketch to see how it works.

Remember that if the beam's not centered when you switch autopilot on, the ball will likely fall off. It may take a few tries, but when you get it, it looks like magic! Take a look at a video of ours running here: *https://www.nostarch.com/arduinoinventor/*.

# TINY DESKTOP GREENHOUSE

GREENHOUSES COME IN ALL SHAPES AND SIZES, FROM TINY INDOOR GREENHOUSES MADE FROM PLASTIC SHEETING TO LARGE INDUSTRIAL GREENHOUSES THAT SPAN THOUSANDS OF SQUARE FEET. NOT EVERYONE WANTS A FULL-SIZE GREENHOUSE, THOUGH, SO IN THIS PROJECT YOU'LL BUILD A SMALLER-SCALE MODEL THAT CAN SIT ON YOUR DESK (FIGURE 7-1).

**FIGURE 7-1:**

The Tiny Desktop
Greenhouse

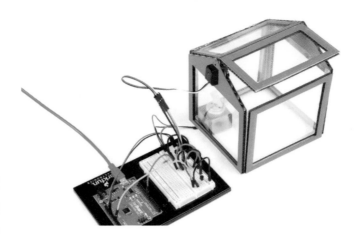

In a traditional greenhouse, the panes of transparent glass or plastic allow light energy in to heat up the interior of the greenhouse, and the greenhouse is sealed to trap that warm air inside, resulting in an overall increase in temperature. The danger, of course, is that a greenhouse might become *too* hot. To regulate temperature, many greenhouses have fans and *autovents* that open windows at the top of the greenhouse to ventilate when it gets too hot.

Your greenhouse will also have an autovent. You'll build a greenhouse controller that will monitor the temperature, and if it gets too warm, a window will open and a fan will turn on.

## THE GREENHOUSE EFFECT

Greenhouses are warm enough to grow veggies year round because they're able to trap and store energy. Earth's atmosphere works similar to a greenhouse. Heat from the sun is radiated by the earth and then reflected and captured by the atmosphere. This unique property is known as the *greenhouse effect*, and it's responsible for keeping the temperature of our planet temperate and livable. Without it, the temperature of our planet would average near 0 degrees Fahrenheit (−18 degrees Celsius)!

Another common example of the greenhouse effect is a car in the middle of the summer. With the windows closed, the temperature inside the car can rise 20 to 30 degrees higher than the outside temperature. This is why you should never leave your pets in the car—especially in the summer!

## MATERIALS TO GATHER

To lift the autovent, this project uses a servo motor similar to the one you used for the Balance Beam in Project 6. We'll also introduce three new parts in this project: a small DC hobby motor for the fan, a *transistor* to control the motor, and a *temperature sensor* to detect the temperature inside the greenhouse.

As you gather your parts, you'll find that the transistor and the temperature sensor look very similar—they're both small, three-legged devices that have a round, black plastic end with a flat edge (see Figure 7-2). To differentiate between them, tilt the flat edge against a light source, and you should see some printing; the temperature sensor should have the letters *TMP* marked on it. Gather your parts, shown in Figures 7-3 and 7-4, and let's get started!

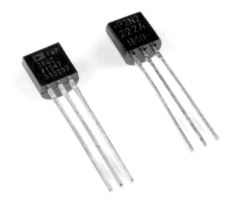

**FIGURE 7-2:**
TMP36 temperature sensor (left) and 2N2222 transistor (right)

## Electronic Parts

- One SparkFun RedBoard (DEV-13975), Arduino Uno (DEV-11021), or any other Arduino-compatible board

- One USB Mini-B cable (CAB-11301 or your board's USB cable)

- One solderless breadboard (PRT-12002)

- One 330 Ω resistor (COM-08377, or COM-11507 for a pack of 20)

- One diode (COM-08588)

- One NPN transistor—2N2222 or BC337 (COM-13689)

- One TMP36 temperature sensor (SEN-10988)

- One hobby motor (ROB-11696)

**NOTE**

*The parts marked with an asterisk (\*) do not come with the standard SparkFun Inventor's Kit but are available in the separate add-on kit.*

- One submicro size servo motor (ROB-09065)
- Male-to-male jumper wires (PRT-11026)
- Male-to-female jumper wires (PRT-09140*)

**FIGURE 7-3:**

Components for
the Tiny Desktop
Greenhouse

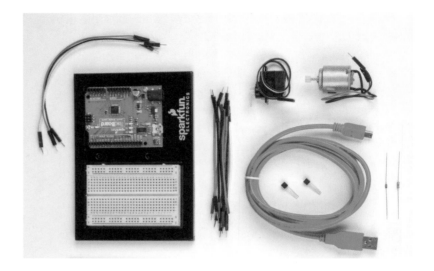

## Other Materials and Tools

- Pencil (not shown)
- Craft knife
- Metal ruler
- Ruler
- Needle-nose pliers
- Wire cutters
- Glue (hot glue gun or craft glue)
- Masking tape (not shown)
- Cardboard (approximately one 11 × 17-inch piece or three 8.5 × 11-inch pieces)
- Enclosure template (see Figure 7-18 on page 208)
- 1 sheet (8.5 × 11 inches) transparency film (not shown)
- 1 medium-size paper clip (not shown)

**FIGURE 7-4:**
Recommended tools and materials

## NEW COMPONENTS

First, let's take a look at the new components, starting with the temperature sensor.

### TMP36 Temperature Sensor

You already know how to measure light levels. With this nifty sensor, you'll be able to measure temperature as well. The TMP36 is one of the easiest temperature sensors to use. The sensor itself is encased in a small plastic shell shaped like a cylinder with a flat edge, and it has just three pins. (Remember to tilt the flat edge against the light to identify the letters *TMP* so you don't mix it up with the transistor. If it says 2N2222 or anything else, it's the wrong part.)

When properly connected to power, the TMP36 sensor will produce a voltage that is directly proportional to the temperature it senses. Similar to how you measured the light level in Project 5 or the position of the potentiometer in Project 6, you can use `analogRead()` to measure the voltage on this sensor. We'll show you how to convert this voltage to a temperature reading in this project.

### Standard Hobby Motor

To move air through the greenhouse, you'll build a fan using a small hobby motor, as shown in Figure 7-5. This is the simplest type of motor available. When you connect its two wires to a power source, the motor spins, and when you reverse the connections, the motor spins in the opposite direction. Unlike the servo motor that you used

in Project 6, the hobby motor spins continuously. The hobby motor works with a voltage between 3V and 6V, so it's perfect for Arduino projects.

## NPN Transistor

The invention of the transistor made it possible to create all kinds of digital devices. For example, the microcontroller on the Arduino is actually made up of millions of transistors. Transistors are part of a family of components called *semiconductors*. A semiconductor is a device that sometimes behaves like a conductor, allowing current to flow, and other times acts like an insulator, preventing current from flowing.

This project uses the transistor like a switch by boosting the Arduino's amp output. The hobby motor uses about 200–300 mA of current, but the Arduino OUTPUT pins are only capable of sourcing about 40 mA of current. Using a simple transistor circuit, we'll show you how to use the low-current Arduino pin to trigger the transistor to open or close, just like a switch.

## TAKING A SYSTEMS APPROACH

For the sake of organization, you'll build this project as three separate parts, or subsystems. This technique, known as a *systems approach*, is used by engineers to separate a complex project into manageable sections that can each be built and tested individually. The main components of the three different parts are the temperature sensor, the servo motor (for the autovent), and the DC motor (for the fan). A schematic of the three parts is shown in Figure 7-6, and a wiring diagram of the compiled project is shown in Figure 7-7.

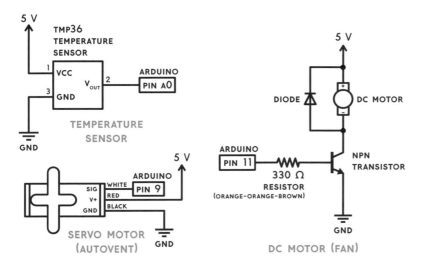

**FIGURE 7-6:**
Schematic diagram of the circuit

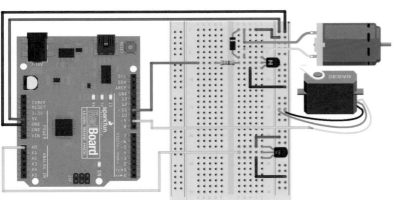

**FIGURE 7-7:**
Wiring diagram of the circuit

# BUILD THE TEMPERATURE MONITOR

First let's take a look at the part of the greenhouse control system that will measure temperature. There are a lot of different temperature sensors out there. A few common types that you might encounter are *thermistors*, which change resistance based on temperature, and *thermocouples*, which output a really small voltage (less than 10 mV) and require an amplifier circuit to use. The TMP36 device is a third type of sensor that simply outputs a voltage calibrated to be 0.75 V at 25 degrees Celsius. The voltage then varies linearly based on the temperature of its surroundings. This means that as the temperature changes the voltage changes accordingly, as shown in Figure 7-8.

FIGURE 7-8:

The linear temperature
versus voltage
response of the
TMP36 sensor

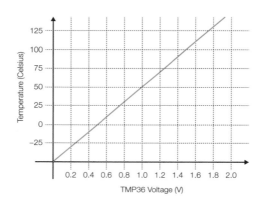

## Measure Temperature with the TMP36

The TMP36 is one of the easiest temperature sensors to use. The sensor is encased in a small plastic shell shaped like a cylinder with a flat edge and has just three pins.

As we mentioned earlier, the TMP36 looks very similar to the transistor, which also comes in the SparkFun Inventor's Kit, so check the flat side of the component by tilting it at an angle under a light source, and look for the letters *TMP*. If it says *2N2222* or anything else, it's the wrong part.

The TMP36 provides a voltage output directly related to the temperature in Celsius of its surroundings. Since you already know how to measure voltages using the `analogRead()` command, this sensor will be easy to use.

The outer pins are for ground and power connections, and the center pin is the voltage signal for the sensor. To use the TMP36, simply connect one pin to 5 V, one pin to ground, and the sensing pin to an Arduino analog pin to read the temperature. Pay attention to how you connect the sensor. With the flat edge facing to the left, the top pin should connect to 5 V and the bottom pin should connect to ground. At 25 degrees Celsius, the sensing pin will have a voltage reading of 0.750 V (750 mV). As the temperature changes, the voltage on this pin will change at a rate of 0.010 V (10 mV) per degree Celsius. Now, this might seem like a lot of math-speak, but we'll show you how to use this information to get an actual temperature reading in your code and convert it to degrees Fahrenheit. But first, let's wire it up.

## Connect the Temperature Sensor

Figure 7-9 shows the temperature monitor circuit wired up on its own. Most of your components will be on the right side of the breadboard,

so connect a jumper wire from 5 V and GND on the Arduino board directly to the power rails on the right side of the breadboard. Next, insert the TMP36 sensor into the lower portion of the breadboard, with the flat side of the sensor facing left, as shown in Figure 7-9.

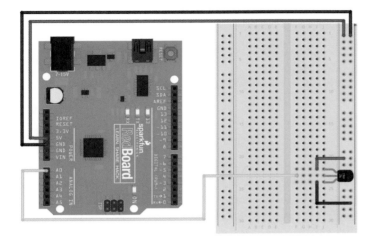

**FIGURE 7-9:**

Simplified wiring diagram showing only the temperature sensor

Next, use two short jumper wires to connect the TMP36 sensor's top pin to 5 V and lower pin to ground, making sure the flat side is facing left. The middle pin is the output voltage of the sensor. Run a jumper wire from this pin to pin A0 on the Arduino board, and that's it!

Now let's take a look at a code example to see how to get temperature readings from this sensor.

## Program the Temperature Sensor

The TMP36 sensor produces a voltage output relative to the ambient temperature. The datasheet for the TMP36 gives a couple of reference points for converting the voltage reading to a temperature: it shows that the voltage changes at a rate of 0.010 V per degree Celsius and that at 25 degrees Celsius, the sensor has a voltage of 0.750 V. Using this information, if you measure the output voltage from the sensor, you can convert this into a temperature reading in the code.

You may recall from Project 5 that the analogRead() function reads voltage as a whole number, with 1023 for an input of 5 V and 0 for 0 V. To make sense of this, you'll need to convert that number to a voltage, then convert that voltage to degrees Celsius, and finally translate that value into Fahrenheit. To keep the code clean, you'll first write a custom function to do the conversion from the raw analogRead() number to volts.

## Create a Custom Conversion Function

Listing 7-1 shows an example of a custom function that will convert the raw analogRead() value and report back an answer that's been converted to volts.

**LISTING 7-1:**

Custom function

volts() to convert from

raw analog value to

voltage

```
❶ float ❷volts(❸int rawValue)
 {
❹ const float AREF = 5.0;
❺ float calculatedVolts;
❻ calculatedVolts = rawValue * AREF / 1023;
❼ return ❽calculatedVolts;
 }
```

In Project 3, we showed you how to write your own custom functions to shorten your code and make the loop() easier to read. In those examples, the data type of the function was always set as void because the function didn't report back a value. In this case, you'll want the function to report back the conversion of analogRead() to volts, so you'll have to specify a data type. Use the data type float ❶, because you'll want this function to return the voltage with as many decimal places as possible for accuracy. Name the function volts ❷, to be as descriptive yet concise as possible, and then define the parameter(s) ❸ that you pass to this function. In this example, it is the raw value from analogRead().

The math needed to convert between raw analogRead() and voltage is pretty straightforward since, as we mentioned earlier, we already know that the analogRead() function returns 1023 for an input of 5 V and 0 for 0 V. This means that an analogRead() value of 1023 would be equal to 5 V. The custom volts() function uses this ratio to convert a raw analogRead() measurement to a voltage.

**NOTE**

It's common practice to
use ALL CAPS to designate
objects or names that are
constants.

First, declare a variable to use as a reference, named AREF ❹, and use this to define the reference voltage, which is 5.0 V. Because you'll want to use it throughout the code, set it as a constant using the keyword const.

Next, you'll define a variable to store the result of the conversion, named calculatedVolts ❺. Notice that the data type for this variable is set as a float as well. You'll want to make sure that any math you perform is accurate beyond whole numbers. To calculate the voltage, simply multiply the rawCount by the ratio of AREF (5.0 V) to 1,023 ❻.

The return instruction ❼ is a command we haven't used in the previous projects. When the sketch gets to the return instruction, it exits the custom volts() function and *returns* to the point in the code

where it was called. When you put a value after the `return` instruc-
tion, the function returns and reports back that value. The `return` data
type must match the data type of the function. For all the functions
we've used to this point, we didn't bother to include `return`, because
those functions were defined as `void` data types and did not report
back a value. Here, the `return` instruction is followed by the vari-
able `calculatedVolts` ❽. This tells the sketch to report the value of
`calculatedVolts` back to the point in the code where it was called.

Note that the `return` instruction can also be used with functions
that have a `void` data type to instruct the sketch to leave the function
and return. In that case, `return` is left blank with no value following it
(see Listing 7-2).

```
void blink()
{
 digitalWrite(13, HIGH);
 delay(500);
 digitalWrite(13, LOW);
 delay(500);
 return;
}
```

LISTING 7-2:

A custom function with
a void data type and a
return instruction

## Test the Function

Let's test the new `volts()` function with an example sketch. Add a
few lines in `setup()` and `loop()` to the code from Listing 7-1 to read
the voltage on pin A0, and print it to the Serial Monitor. The complete
code example is shown in Listing 7-3.

```
//Example sketch - reads analog input from A0 and prints the
//raw analog value and the voltage
int rawSensorValue;
float rawVolts;

void setup()
{
 Serial.begin(9600); //initializes the serial communication
 Serial.print("raw");
 Serial.print("\t"); //tab character
 Serial.print("volts");
 Serial.println(); //new line character
}

void loop()
{
 rawSensorValue = analogRead(A0); //read in sensor value
```

LISTING 7-3:

Testing the analog-to-volts
conversion

```
 rawVolts = volts(rawSensorValue); //convert sensor value
 //to volts
 Serial.print(rawSensorValue); //print raw sensor value
 Serial.print("\t");
 Serial.print(rawVolts); //print raw voltage reading
 Serial.println(); //new line character
}

/**/
float volts(int rawCount)
{
 float AREF = 5.0;
 float calculatedVolts;
 calculatedVolts = rawCount * AREF / 1023;
 return calculatedVolts;
}
```

Connect your Arduino board to your computer with a USB cable, upload this example, and then open up the Serial Monitor. You should see text scroll up the screen like in Figure 7-10. According to this, an analog value of 156 is equal to a voltage of 0.76. You can check the output voltage with this calculation: $156 \times (5.0 / 1,023) = 0.762$ V. It's always good when the math works out!

| COM16 | — □ × |
| --- | --- |
| | Send |

```
156 0.76
156 0.76
156 0.76
156 0.76
156 0.76
156 0.76
156 0.76
156 0.76
156 0.76
156 0.76
156 0.76
156 0.76
156 0.76
156 0.76
156 0.76
156 0.76
156
```

☑ Autoscroll            No line ending ∨    9600 baud ∨

Without an additional delay() command in the loop(), the Arduino takes a sensor reading about 80–90 times per second and sends the information back to the computer. This is why you get a stream of readings rather than a single reading. If you want to slow down the rate at which the sketch prints the readings to the screen,

simply add a `delay(1000);` at the end of the `loop()`, just after the last `Serial.println();`. This will slow the loop to a single reading per second so it's not streaming as fast. You'll do that later in the code.

There's one more step to get the sketch to show the temperature rather than volts.

## Convert Voltage to Temperature

Now you need a formula to convert the volts to temperature. You know that the voltage the TMP36 outputs varies linearly depending on the temperature it senses, meaning that as the temperature changes, the voltage changes proportionately. Therefore, to create a formula, you use the *slope-intercept* equation:

$$y = mx + b$$

This equation describes a line or, more generally, a relationship between two variables $x$ and $y$, where $m$ is the slope of the line describing the rate of change, and $b$ is the y-intercept, showing where the line intercepts the y-axis. In this case, the two variables $x$ and $y$ are the voltage and temperature, respectively, and you'll use the known variable $x$ (volts) to calculate the unknown variable $y$ (temperature).

As mentioned, the datasheet for the temperature sensor states that the voltage changes at a rate of 0.010 V per degree Celsius, or 1 V per 100 degrees Celsius. This rate is the slope of the line and so becomes $m$ in the equation. If you plug in the variables, the equation looks like this:

$$\text{temperature} = \frac{100°C}{1\ V} \times \text{voltage} + b$$

The datasheet for the TMP36 also provides a reference point for mapping voltage to degrees Celsius: at 25 degrees Celsius, the sensor has a voltage of 0.750 V. Substitute these numbers into the equation to solve for the y-intercept $b$:

$$25°C = \frac{100°C}{1\ V} \times 0.750\ V + b$$

$$25°C = 75°C + b$$

$$b = -50°C$$

So now you have values for *m* and *b*. Here's the final equation:

$$\text{temperature} = \frac{100°C}{1\ V} \times \text{voltage} - 50°C$$

This is a technique that you can apply to any number of sensors that have a linear relationship with voltage. It's also a nice reminder that math is important and useful. But, if none of that made any sense, don't worry—all you need to know is that to find the temperature of the sensor, you simply plug the voltage reading into this equation.

Now, use this equation in the code to convert the `rawVolts` reading to a temperature. You'll work from the example code in Listing 7-3 and add the new code in Listing 7-4 to show you the temperature reading from the sensor.

**LISTING 7-4:**

Converting from volts
to temperature

```
//Example sketch – calculates the temperature from the TMP36
//sensor and prints it to the Serial Monitor
int rawSensorValue;
float rawVolts;
❶ float tempC;
float tempF;

void setup()
{
 Serial.begin(9600); //initializes the serial communication
 Serial.print("raw");
 Serial.print("\t"); //tab character
 Serial.print("volts");
❷ Serial.print("\t");
 Serial.print("degC");
 Serial.print("\t");
 Serial.print("degF");
 Serial.println();
}

void loop()
{
 rawSensorValue = analogRead(A0); //read in sensor value
 rawVolts = volts(rawSensorValue); //convert sensor value
 //to volts
❸ tempC = 100 * rawVolts - 50; //convert volts to deg. C
❹ tempF = 1.8 * tempC + 32; //convert deg. C to deg. F

--snip--
 Serial.print(rawVolts); //print raw voltage reading
❺ Serial.print("\t");
```

```
 Serial.print(tempC);
 Serial.print("\t");
 Serial.print(tempF);
 Serial.println(); //new line character
❻ delay(1000);
}

/***/
float volts(int rawCount)
--snip--
```

First, add two lines in the global namespace at the top to declare variables to store the temperature in degrees Celsius (tempC) and in degrees Fahrenheit (tempF) ❶. Next, add a few lines in the setup() to use appropriate column headings for the readings printed to the Serial Monitor, separated by a tab character, which is represented by the control character \t ❷. You can now use the slope-intercept equation to calculate the temperature in degrees Celsius ❸. You'll also add one last line that converts the temperature from Celsius to Fahrenheit ❹.

And, for some additional feedback, add a few extra lines to Serial.print() to make sure you print the new variables ❺ to the Serial Monitor. Notice that the very last Serial.print() line is actually a Serial.println() command that inserts a newline character and moves the cursor to the next line. This will make sure each new reading starts on a new line. Finally, add the 1-second delay ❻ to slow down the loop so that the sensor is sampled only once per second and you have time to read the text.

Upload the updated code to your Arduino, and open the Serial Monitor. You should see four columns of data scroll up the screen, as shown in Figure 7-11. As the new column headings denote, these figures represent raw data, voltage, temperature in degrees Celsius, and temperature in degrees Fahrenheit. If you squeeze the temperature sensor with your fingers, you should notice that the temperature increases. Congratulations, you have a working temperature monitor, the first big part of this project!

**FIGURE 7-11:**
Serial Monitor displaying temperatures from the TMP36

# BUILD THE SERVO MOTOR AUTOVENT

You'll use a servo motor like the one you used in Project 6 to open and close a window on the greenhouse. A servo is a simple motor that uses three wires for the control signal (yellow or white), power (red), and ground (black) connections, as shown in Figure 7-12.

**FIGURE 7-12:**

Adding the servo motor to the circuit

Most standard servos have a three-pin female connector. Connect three male-to-male jumper wires to these three pins to extend these connections, as shown in Figure 7-13. If possible, match the colors of your jumper wires to the leads on the servo connector. Then, connect the yellow (or white) signal wire to pin 9 on the Arduino board. Connect the red wire to 5 V and the black wire to GND on the right side of the breadboard.

**FIGURE 7-13:**

Inserting male-to-male jumper wires to connect the servo to the breadboard

# PROGRAM THE AUTOVENT

Add the servo code shown in Listing 7-5.

**LISTING 7-5:**

Adding in the servo control

```
❶ #include<Servo.h>
❷ Servo myServo;

 //Example sketch - calculates the temperature from the TMP36
 //sensor and prints it to the Serial Monitor
 int rawSensorValue;
 float rawVolts;
 float tempC;
 float tempF;
❸ int setPoint = 85;
 int returnPoint = 83;

 void setup()
 {
 myServo.attach(❹9, 1000, 2000); //initializes myServo object
 Serial.begin(9600); //initializes the serial communication
 --snip--
 }

 void loop()
 {
 --snip--
 Serial.println(); //new line character

❺ if(tempF > setPoint)
 {
 myServo.write(180);
 }
 else if(tempF < returnPoint)
 {
 myServo.write(0);
 }
 delay(1000);
 }

 /***/
 float volts(int rawCount)
 --snip--
```

Remember from Project 6 that to use the servo you need
to include the Servo library ❶ and create a servo object named
myServo ❷. Next, create two variables ❸ to define the *set points*
for the control system. These set points are the temperatures

at which the window will automatically open and close. Notice that `setPoint`, which opens the window, is 2 degrees higher than `returnPoint`, which closes the window, giving you 2 degrees where the window will not be opening or closing. This control technique, referred to as *hysteresis*, is useful for systems where the temperature might fluctuate slightly and keeps the window from constantly opening and closing at the smallest temperature variation.

Finally, you need to initialize the servo by telling the Arduino that the servo is connected to pin 9 ❹. You might notice that this `myServo.attach()` command has two extra numbers, rather than the one number you used in Project 6. To understand why, take a look at "How Servos Really Work" on page 201.

Finally, for the control logic, you'll use a nested `if()`–`else if()` control statement. Add the eight lines of code at ❺ just above the `delay()` to move the servo to a 180-degree position if the temperature is above 85 degrees Fahrenheit (the `setPoint`) and return the servo to the 0-degree position if the temperature drops below 83 degrees Fahrenheit (the `returnPoint`). This will open and close the autovent window.

Upload the updated code from Listing 7-5 to your Arduino, and open the Serial Monitor. Try it out by pinching the sensor between your fingers or cupping your hands around the sensor and blowing deeply to warm it above 85 degrees. Watch the Serial Monitor to see the temperature rise. As soon as it hits 85 degrees, you should hear the servo motor as it moves into position. Now, let the temperature sensor sit and cool down. As soon as it dips below the `returnPoint`, you should hear the servo motor again as it returns to the 0-degree position. Pretty neat, eh?

Now you'll build the final component: the fan.

## BUILD THE FAN MOTOR

The fan, which will move air around in the greenhouse, is going to spin via a small DC hobby motor—a standard cylindrical device with two wires and a center axle that spins when you apply voltage to the leads. The servo motor you've been using so far has gearing inside that allows it to move very precisely in a tightly defined range of motion. Recall that it has only about 180 degrees of motion. You'll use a DC motor here, rather than the servo motor, because you'll need the fan

## HOW SERVOS REALLY WORK

Servos are neat devices that move a motor to a specific position based on a signal from the microcontroller. A standard servo motor has a fixed range of motion of about 180 degrees.

All servo motors have three wires: a white (or sometimes yellow or orange) wire for receiving the signal, a red power wire, and a black ground wire. The signal is a unique pulse sent every 20 ms, or at a rate of 50 Hz. To encode a position, a microcontroller varies the width of the pulse to indicate the angle or position that the motor will turn to (see Project 5 for more details on pulse width modulation). For most standard servo motors, a 1,000-microsecond (1,000 µs) pulse indicates the 0-degree position, and a 2,000 µs pulse indicates the full 180-degree position, so a 1,500 µs pulse indicates the midpoint of the servo, or the 90-degree position.

The Arduino's *Servo.h* library maps the pulse widths to the motor positions, but the library has a slightly different definition for the servo positions and pulse widths, using a 544 µs pulse for the 0-degree position and a 2,400 µs pulse for the 180-degree position. This allows the library to work with *extended-range* servos, but it is outside the limits of most standard servos. So, when you use a command like `myServo.write(0);` the motor receives a 544 µs pulse and will try moving beyond its own physical limits. If that happens, the motor will shake, buzz, and heat up because it's just not able to move to a position that coincides with a 544 µs pulse.

To counteract this, you can set limits for the servo in the code. As in Project 6, use the command `myServo.attach(9);` to initialize the servo on pin 9 of the Arduino. You can also add parameters to set lower and upper pulse width limits for the motor, with `myServo.attach(9, 1000, 2000);`. With this initialization, the command `myServo.write(0);` will move the motor to its 0-degree angle position and it won't shake, buzz, or heat up.

If you want to know more about how servos work, take a look at the tutorial on SparkFun at *https://www.sparkfun.com/tutorials/283/*.

blade to spin continuously the entire time you apply power to it. This makes it perfect for a fan function. The DC motor you'll use is designed to operate between 3 V and 6 V but draws around 200–300 mA when it's spinning. The Arduino OUTPUT pins are capable of driving only about 40 mA of current, so to provide enough amps for the DC motor, you'll build an extra circuit called a *transistor amplifier circuit*—more technically known as a *common-emitter amplifier*.

A transistor has three legs: the collector (C), base (B), and emitter (E). Any current that goes into the base is amplified on the collector pin. The base is like a control for a door that allows current to move from the collector to the emitter. The more you push on the base, the wider the door opens, and more current can pass through from the collector to the emitter. The amazing thing about transistors is that you need apply only a small amount of current at the base to let a large amount of current flow from the collector to the emitter. If you provide too much current to the base, you can burn the transistor out, so in the same way you've used resistors to limit the current flowing through LEDs, you'll use a 330 Ω resistor in this circuit to limit the current flowing to the base.

There are many different applications for transistors, such as amplifiers and other devices, but here you're just going to use it like a controllable switch. Even though the Arduino pin can only supply a small amount of current, when you send a HIGH signal to the base of the transistor, the transistor turns "on." This allows current to flow between the collector and the emitter. It essentially connects these pins together, like closing a switch.

The emitter side of the transistor is connected to the ground rail. Notice that one side of the motor is connected to the 5 V rail, and the other side of the motor is connected to the collector of the transistor. When the transistor is turned "on," this connects the collector to the emitter of the transistor, closing the switch between the motor and ground and making it spin. Engineers call this "operating a transistor between cut-off and saturation mode." Power for the motor is coming directly from the power rails. That means you can use the limited current provided by the Arduino OUTPUT pins to control devices requiring a much larger current flow.

You'll build the transistor circuit on the top part of the breadboard, as shown in Figure 7-14.

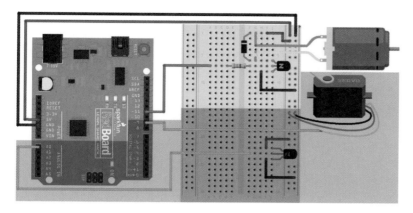

**FIGURE 7-14:**

Adding the fan-motor transistor control circuit

Find the transistor in your kit. As you can see from Figure 7-15, the transistor looks a lot like the temperature sensor, though if you look closely you should see 2N2222 or BC337 on the flat side of the casing. This is an *NPN transistor*, and it will act as the motor's on/off switch that you control with the Arduino board.

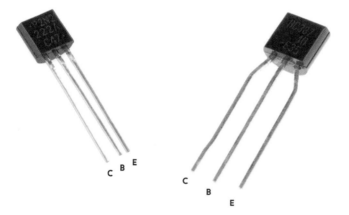

**FIGURE 7-15:**

NPN transistors used in this project—the 2N2222 (left) and the replacement part BC337 (right)

Hold the transistor so that the flat edge is facing to the left, and insert it into the top part of the breadboard with the top pin about six rows down, as shown in Figure 7-14. In this position, the top pin is the collector, the middle is the base, and the bottom is the emitter (Figure 7-15).

Connect a 330 Ω resistor to the base pin and stretch it across the ditch in the breadboard, as shown in Figure 7-14. Then, connect the other side of this resistor to pin 11 on your Arduino so that pin 11 connects to the base pin through the 330 Ω resistor. This is the low-current control signal from the Arduino that will switch the transistor on and off. When the transistor is switched on, current will flow through the motor, and it will spin.

Connect a small jumper wire from the emitter of the transistor (lower pin) to the ground rail. Lastly, connect one of the wires of the motor to the collector (top) pin of the transistor. The motor will spin either clockwise or counterclockwise depending on which wire you use, but in this case it doesn't matter which way it spins, so you can choose either motor wire. Connect the other motor wire to the power rail, and then use a jumper wire to connect the power rail of the breadboard to 5 V on the Arduino. When a small current signal is detected on the base pin, the connection between the collector and the emitter is closed. This connects a path from 5 V through the motor to GND and completes a circuit path that will cause the motor to spin. Figure 7-16 shows the circuit for the motor.

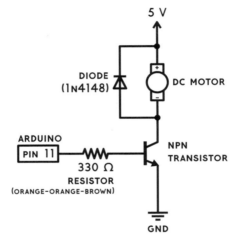

**FIGURE 7-16:**

Transistor circuit to drive the motor from an Arduino pin

The last piece in this circuit is a protection diode, sometimes called a *fly-back diode*, and it protects the transistor from damage that may be caused by the motor. Inside a motor are a bunch of coils that create an electromagnet that pushes and pulls against permanent magnets in the motor—this is what causes the axle to spin. Coils are a really interesting component used in electronics. The magnetic field that they create is actually a form of stored energy, and when the circuit is turned off, this stored energy can rebound and cause large voltage spikes that will damage the transistor. The fly-back diode creates a path for this voltage spike to dissipate without going through the transistor. It's sometimes also called a *snubber circuit*.

In order to wire this component in correctly, it is important to note that diodes are *polarized*, and the orientation makes a difference. The body of the diode has a line or band at one end of the body, as shown in Figure 7-17. Make sure that the side with the band is connected to the positive (5 V) side of the motor.

LINE OR BAND

Add the diode to the motor, making sure that the side of the diode with the line is connected to the 5 V motor wire, as shown in the circuit diagram in Figure 7-16. Connect the other leg of the diode to the other wire of the DC motor—the one connected to the collector pin of the transistor. This means that the two legs of the diode share the same connections as the two wires of the motor. When two devices are wired up like this, we say they're wired *in parallel*.

You should now have a complete circuit that has each of the three subcircuits in Figure 7-6. You'll add a few more lines of code to control the motor.

## Program the Fan Motor

The code for controlling the motor is very simple, just like the code you used to turn an LED on and off. Add the code in Listing 7-6 to your current sketch.

```
#include<Servo.h>
Servo myServo;
--snip--

void setup()
{
❶ pinMode(11, OUTPUT);
 myServo.attach(9, 1000, 2000);
 Serial.begin(9600); //initializes the serial communication
 --snip--
}
```

**LISTING 7-6:**
Complete Tiny Desktop Greenhouse control code

```
void loop()
{
 --snip--
 Serial.println(); //new line character

 if(tempF > setPoint)
 {
 myServo.write(180);
➋ digitalWrite(11, HIGH); //turn the fan on
 }
 else if(tempF < returnPoint)
 {
 myServo.write(0);
➌ digitalWrite(11, LOW); //turn the fan off
 }
 delay(1000);
}

/***/
float volts(int rawCount)
{
 const float AREF = 5.0;
 float calculatedVolts;
 calculatedVolts = rawCount * AREF / 1023;
 return calculatedVolts;
}
```

There are just a few new lines of code. The first is in the setup(). This sets pin 11, to which the motor is attached via the transistor, as an OUTPUT ➊. Next is the set of conditional if()–else if() blocks. Here, you add two commands to turn the motor on ➋ and off ➌. Remember that the motor will really be the greenhouse fan. With these few extra lines of code, the fan will turn on at the same time as the window opens, and it will turn off when the window closes.

After you've added these lines of code, upload this latest version to your Arduino. Open the Serial Monitor, and test it again. Try warming up the temperature sensor by squeezing it between your fingers or using your breath, and watch what happens. As soon as the temperature readings get to about 85 degrees Fahrenheit, the servo motor should move and the hobby motor should kick in. You might notice that as soon as the motor turns on, the temperature readings go all out of whack. There is a lot going on here, but we have a quick fix for it.

## Isolate the Motor Effect

When the motor turns on, the voltage of the Arduino drops down to about 4.1–4.5 V because of the extra current load of the motor. You may see that as soon as the motor spins up, the temperature readings start changing sporadically, and the motor may continue to turn on and off several times before the temperature readings settle down. Earlier we said that when you use `analogRead()`, 1023 is equal to 5 V, but that's only partially true. The full truth is that 1023 is equal to whatever the voltage from the source is, so if the source voltage drops to 4.1 V, 1023 is now equal to 4.1 V. This messes up the Arduino's ability to take accurate measurements.

To rectify this, add two lines of code at the very beginning of the `loop()`, right after the first curly bracket, to tell the Arduino to turn off the motor before reading the temperature sensor:

```
digitalWrite(11, LOW); //turn off the motor before
 //reading sensor
delay(1); //short 1 ms delay before
 //reading sensor
```

Now the Arduino will turn the motor off for exactly 1 ms before reading the voltage on the temperature sensor. This isolates the voltage drop from the motor and the `analogRead()` without adding too much extra code.

After adding these two lines, upload the new sketch to your Arduino, and try heating up the sensor again. Now it should behave much more predictably. With the circuits built and the code working smoothly, it's time to build the actual greenhouse structure.

## BUILD THE TINY DESKTOP GREENHOUSE ENCLOSURE

We provide a template for the greenhouse enclosure we created using cardboard, but you could use anything you want. In fact, IKEA sells a great little greenhouse called the SOCKER that you could easily modify to work with this project.

For the Tiny Desktop Greenhouse, the finished dimensions are roughly 4.5 × 4.5 inches for the base and 6 inches at the tallest point. In the resources available at *https://www.nostarch.com/arduinoinventor/*, we have two template options: one is broken out into three sheets of 8.5 × 11-inch cardboard (shown in Figure 7-18), and the other is on a single sheet of cardboard measuring 11 × 17 inches.

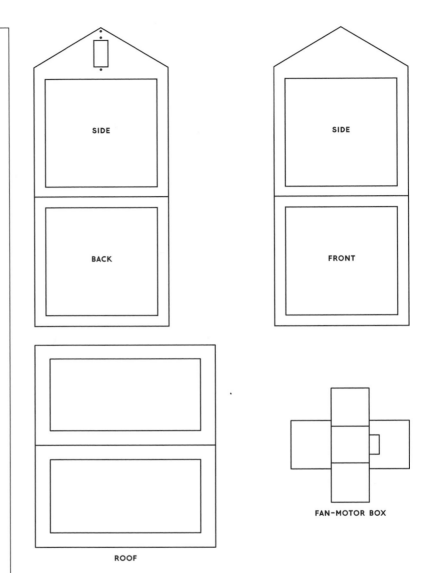

SIDE

SIDE

BACK

FRONT

FAN-MOTOR BOX

ROOF

Carefully cut out the pieces of the template from the cardboard. There are four unique pieces: the pentagonal side pieces, the front/back square walls, the roof window, and the fan-motor holder. Take one square side piece and one pentagonal front/back piece and lay them side by side, with the transparency side facing up. Use a narrow strip of masking tape to hold these two sides together, as shown in Figure 7-19. Repeat this process until you have all four of the side wall pieces attached, but don't tape the last two walls together; leave the enclosure lying flat until you've added the windows.

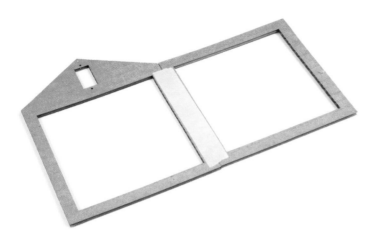

**FIGURE 7-19:**
Use a narrow strip of tape
to hold the pieces together.

Now you need to cut six pieces of transparency film to be slightly larger than the opening in each of the wall pieces and the windows. For the template we provide, you will need four squares that measure 4.25 × 4.25 inches and two squares that measure 4.25 × 2.5 inches. You should be able to cut these six pieces out of a single sheet of transparency film; it's a good idea to trace them on first to get the most out of the film. At this point, you only want to secure the windows for the side walls; you'll add the roof windows at the very end. Using a bead of glue or small piece of tape, secure these windows to the inside of the greenhouse on the same side as the tape, as shown in Figure 7-20.

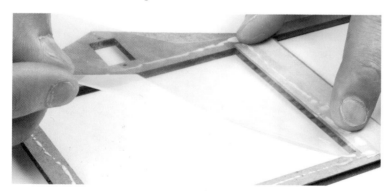

**FIGURE 7-20:**
Carefully line up the transparency film window to adhere it to the cardboard.

Once those transparency panes are in place, run one more piece of tape along the last exposed edge, and connect it so that you have a square base and a structure that resembles a small greenhouse, as shown in Figure 7-21. The top and bottom of the greenhouse should

still be open, and it may still feel a little unstable, but as soon as you add the roof, the entire structure will hold together.

**FIGURE 7-21:**

Four sides of the greenhouse complete

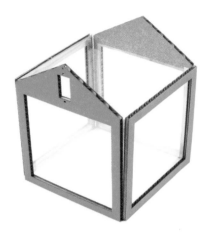

## Add the Autovent Window Servo

On our template, we made a small cutout for the servo motor as close as possible to the pivot point of the window, to maximize the amount the window opens when the servo horn moves. Disconnect the servo from your circuit, and attach a horn to the end of the servo if there isn't one already there. We'd recommend using the single-sided horn, because it's easier to tell where the servo is pointing. Gently rotate the servo clockwise with your fingers until it stops to set the motor at the 180-degree position. This is the position where the horn will be when the window is fully open. Remove and reposition the servo horn so that it is pointing up in the opposite direction from the wires that come out of the back of the servo, as shown in Figure 7-22.

**FIGURE 7-22:**

Servo horn in the 180-degree position—rotated clockwise

Now feed the servo through the hole in the template from the inside of the greenhouse so that the wires are pointing down and the servo horn is on the inside pointing up (see Figure 7-23).

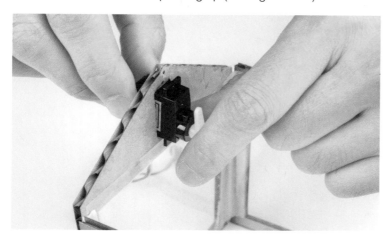

**FIGURE 7-23:**
Placing the servo into the greenhouse

The tabs of the servo should sit flush with the cardboard. You can screw in the servo using the screws that come with it and the two small screw holes in our template, or use a few dabs of hot glue to secure it in place.

## Create the Paper Clip Linkage

As in Project 6, you'll need a linkage to connect the servo horn to the window. Take a medium-size paper clip and straighten out all but the small hook on the end. Now, grab a ruler and add a sharp 90-degree bend about 1 1/8 inches from the small hook end, pointing away from the hook, as shown in Figure 7-24.

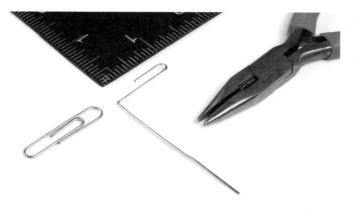

**FIGURE 7-24:**
Bending the paper clip linkage

## Add the Roof

The roof piece is a rectangular piece of cardboard. Cut out the windows, and score the centerline of the roof, as shown in Figure 7-25. The scored edge will form a hinge for the window flap to open and close.

**FIGURE 7-25:**

The roof piece

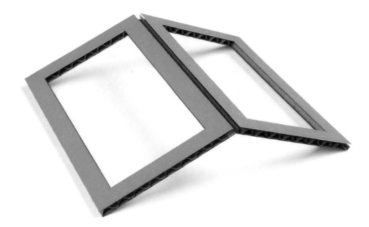

Position the greenhouse so that the servo is on the left side. One half of the roof will be secured down with glue, and the other half will form a window flap that opens and closes. Using a small bead of hot glue, attach one half of the roof structure to the greenhouse. Only glue down three edges of the roof (that is, one half of the six edges) so that there's still a flap that can open. Make sure that the side that opens coincides with the side that the servo horn moves against, as shown in Figure 7-26.

**FIGURE 7-26:**

Gluing in the roof. Be sure to only glue one half of the roof so that the other side can open.

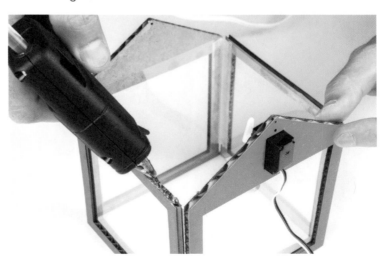

Hook the paper clip linkage around the last hole in the servo horn, as shown in Figure 7-27, with the rounded hook attached to the servo. Make sure that the opposing bend is pointing back toward the servo motor. This will hook into the frame of the roof piece.

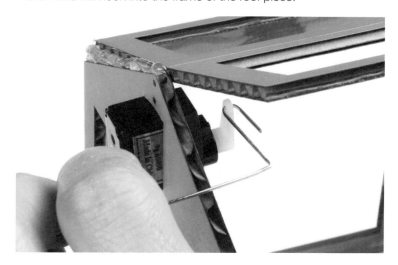

**FIGURE 7-27:**
Servo horn and paper clip linkage

Keeping the window flap open, rotate the paper clip until you can insert it into the side of the frame through the cardboard itself. If the paper clip isn't long enough to reach, you can either rebend it or reposition the servo horn at an angle rotated slightly higher to extend the reach of the linkage. It may be helpful to lift the greenhouse structure and reposition the servo horn from underneath. Once you've positioned the servo horn so it will reach, insert the end of the paper clip into the side of the window frame, as shown in Figure 7-28.

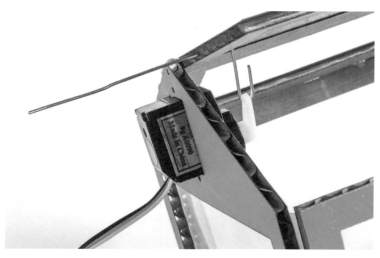

**FIGURE 7-28:**
Servo arm linkage connected to the window flap

Bend the portion of the paper clip that protrudes from the other side to create a hook so that the linkage does not fall out (see Figure 7-29), and cut the remaining end off. Now carefully move the servo back and forth; you should be able to open and close the lid of your greenhouse!

**FIGURE 7-29:**

Bending the hook in the
servo linkage

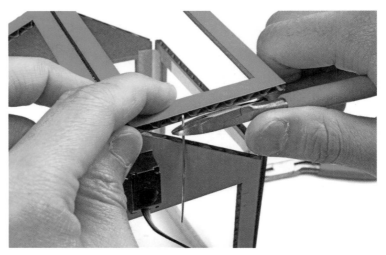

With the mechanism complete, you can glue or tape the transparency windows for the top of the greenhouse. A small dab of glue on the four corners will be just enough to hold the window pane down. The window panes should go on the outside of the greenhouse roof to allow room for the linkage to open and close the lid. Next, you'll build a box to hold the motor and fan.

## Build the Fan-Motor Box

The motor will serve as a fan to move air around when the greenhouse gets too warm. To prevent the motor from moving as it spins and vibrates, we designed a small cardboard box to hold it in. The template has a design for a five-sided box with a small hole to allow the motor wires to come through, shown in Figure 7-30.

Cut out this template from a piece of cardboard, and carefully score the dashed lines so that it can fold up into a box. Using either tape or hot glue, secure the four sides of the box so that it will hold the motor snugly (see Figure 7-31).

To build a fan blade, you'll glue a small piece of cardstock onto the end of the motor. Cut the fan blade so that it is no more than 1.25 inches wide. To help the fan move more air, fold the edges of the cardstock as shown in Figure 7-32.

**FIGURE 7-30:**
The fan-motor box

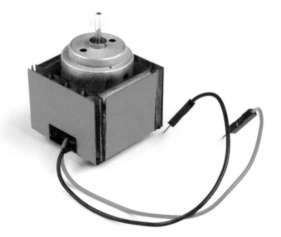

**FIGURE 7-31:**
Completely assembled
motor box with the motor
inside

**FIGURE 7-32:**
Final fan blade

This will ensure that the fan doesn't hit the plant or anything else inside the tiny greenhouse. Using a small dab of hot glue, attach the fan blade to the motor as shown in Figures 7-33 and 7-34.

**FIGURE 7-33:**

Securing the fan blade to the motor

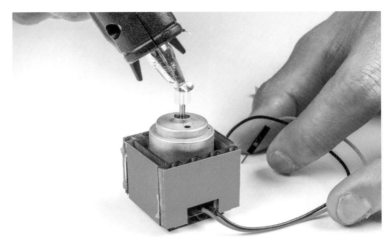

**FIGURE 7-34:**

Fan-motor assembly complete

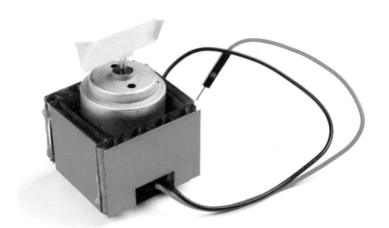

## Connect It Up

Now you have all of the pieces you need for your Tiny Desktop Greenhouse, so it's time to install the electronics. Remove the temperature sensor from the breadboard, and use three male-to-female jumper wires to extend the connections of the sensor, as shown in Figure 7-35. Pay attention to which wires you move, and connect

them up again using the extended wires. When you hold the flat side of the temperature sensor facing you with the pins to the left, the top pin is power, the middle pin is the signal, and the bottom pin is ground. We used red, yellow, and black wires to show the power, signal, and ground connections, respectively.

**FIGURE 7-35:**
Extending the temperature sensor with male-to-female jumper wires

You'll need to place the temperature sensor inside the greenhouse. Use a piece of masking tape to secure the temperature sensor directly to the plant before sticking it inside your new greenhouse, as shown in Figure 7-36. You can now feed the wires out under one side of the greenhouse, or you could also make a small hole to feed the wires through.

**FIGURE 7-36:**
Secure the temperature sensor directly to your plant

Similarly, move the fan-motor assembly so that it sits near the corner of the greenhouse. The motor wires should be long enough to reach the breadboard without extensions, but if you need to, you can add extra male-to-female extension wires to make wiring easier.

Now, you should still have enough room for a small plant to rest comfortably in this new cozy habitat. It's time to get your new exotic house plant and put it inside your brand new greenhouse! To test out how effectively our autovent system regulated the temperature, we created our own indoor sun with some really big floodlights to heat the air.

Figure 7-37 shows one of our tests on the Tiny Desktop Greenhouse.

## GOING FURTHER

There are a lot of opportunities to take this project to the next level.

### Hack

At the moment, your greenhouse is pretty darn small. To make space for more plants, find a large cardboard box like the ones used for copy paper. Cut some windows in it, line them with transparency film, and move the electronics into this bigger and better greenhouse. Or, take a look at the plastic greenhouses they have over at IKEA. Where can you mount the servo motor so that you can open and close the window on this greenhouse?

## Modify

The current set point is 85 degrees Fahrenheit, and although that was a good temperature for us to test because we could easily increase it with our own body heat, it's actually still pretty low for most plants. Look up the ideal growing temperature for your plant, and modify your code to use this new set point.

You can also modify how often the greenhouse samples the temperature with the delay. A delay of 1 second is pretty short. If your temperatures swing at all, the lid will be opening and closing every few seconds. This can quickly become annoying. Change this delay to something like 5 minutes, which would be 30,000 ms.

# DRAWBOT, THE ROBOTIC ARTIST

AS AN HOMAGE TO THE LOGO TURTLE PROJECT, IN THIS PROJECT WE'RE GOING TO MAKE A DRAWBOT: A ROBOT THAT YOU CAN PROGRAM TO MOVE AND DRAW. LOGO WAS A PROGRAMMING LANGUAGE CREATED IN THE LATE 1960S BY DANIEL G. BOBROW, WALLY FEURZEIG, SEYMOUR PAPERT, AND CYNTHIA SOLOMON. IT WAS LATER ADAPTED TO SUPPORT A ROBOT WITH A DRAWING PEN CALLED A <u>TURTLE</u> (SEE FIGURE 8-1).

**FIGURE 8-1:**

An early version of
a Logo turtle

Turtles were connected to a computer to receive movement commands in the Logo language, such as `fd 10` to drive forward 10 spaces. As the turtle moved, it drew with the attached pen. These Logo turtles were an early educational system designed to teach programming concepts in a visual way.

You're going to build your own Arduino-controlled turtle, the Drawbot (Figure 8-2), which was inspired by the work of Seymour Papert and his team.

**FIGURE 8-2:**

A completed Drawbot

## MATERIALS TO GATHER

Your robot will have two wheels, each with a motor that's controlled by the Arduino through a new component called an *H-bridge*. An H-bridge is a small modular circuit board similar to the transistor circuit you used in the last project, except that it will enable you to

control both the speed and the direction of the motor. This will give your robot the most flexibility and control. Gather your parts (shown in Figures 8-3 and 8-4), and let's get started!

## Electronic Parts

- One SparkFun RedBoard (DEV-13975), Arduino Uno (DEV-11021), or any other Arduino-compatible board
- One USB Mini-B cable (CAB-11301 or your board's USB cable)
- One solderless breadboard (PRT-12002)
- Two geared hobby motors (ROB-13302*)
- One TB6612FNG H-bridge motor driver (ROB-09457* unsoldered or ROB-13845* presoldered)
- Two rubber wheels fit for the geared hobby motors (ROB-13259*)
- Male-to-male jumper wires (PRT-11026)
- Male-to-female jumper wires (PRT-09140*)
- One 4 AA battery holder (PRT-09835*)

**NOTE**

*The parts marked with an asterisk (*) do not come with the standard SparkFun Inventor's Kit but are available in the separate add-on kit.*

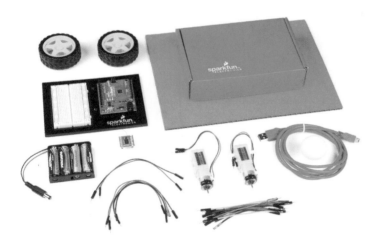

**FIGURE 8-3:**
Components and materials for the Drawbot

## Other Materials and Tools

- Pencil
- Craft knife
- Metal ruler
- Glue (hot glue gun or craft glue)
- (Optional) Drill and 3/16-inch drill bit

- (Optional) Soldering iron
- Cardboard (about 12 inches square) or a cardboard box
- Ping-pong ball
- Enclosure template (see Figure 8-12 on page 235)

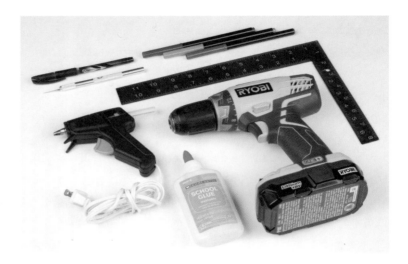

## NEW COMPONENTS

You'll be using two new components in this project: an H-bridge motor driver and geared hobby motors. Let's take a look at how these components work.

### The H-Bridge Motor Driver Integrated Circuit

In Project 7, you used a transistor circuit to control a single motor with Arduino, which allowed you to control the speed of the motor but not the direction of its spin. In this project, you'll use a new component called an *H-bridge motor driver* that will allow you to control both the speed and direction of the motor.

The H-bridge motor driver is an integrated circuit (IC) chip, made up of about a dozen transistors wired together internally inside a small plastic package. An *IC chip* is a prewired circuit that has been integrated into a single package to make building complex projects easier. There are many different ICs out there; one example is the brain behind the Arduino Uno, the ATMega328 chip. In this case, the H-bridge motor driver IC allows you to control a motor's speed and direction of rotation by connecting power and just a few signal wires to the Arduino.

You might recall from Project 7 that a transistor is simply a switch that can be controlled electronically. A standard H-bridge motor driver consists of four or five transistors (or switches) wired up in an H configuration, as shown in Figure 8-5. (The motor shown in the middle isn't included in the H-bridge IC; you'll add that in.) By controlling which of the four main switches (labeled A–D) are open or closed, you can control the direction in which the current flows through the motor. The fifth switch (E) controls the speed of the motor's rotation.

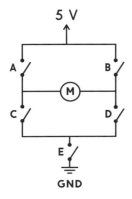

**FIGURE 8-5:**

H-bridge circuit for both direction and speed control

Remember that current flows from positive to negative. If you closed switches A and D, current would flow through the motor from left to right, turning the motor in one direction. If you instead closed switches B and C, current would flow through the motor from right to left, causing it to spin in the opposite direction.

Switch E is pulsed on and off rapidly through PWM (see "Create Analog Signals with PWM" on page 139). The duty cycle of this PWM signal will determine how fast the motor spins. On your robot, you'll have two motors, each with its own H-bridge circuit, and you'll attach a wheel to each motor so you can control its spin speed and direction.

The H-bridge motor driver you'll use in this project is the Toshiba TB6612FNG, shown in Figure 8-6. It comes as a breakout board with holes for pins that are spaced 0.100 inches apart—perfect for inserting into a breadboard.

VM (Motor Voltage)
VCC (IC Voltage)
GND
A01 (MotorA+)
A02 (MotorA–)
B02 (MotorB–)
B01 (MotorB+)
GND

PWMA (MotorA Speed)
AIN2 (MotorA Dir2)
AIN1 (MotorA Dir1)
STBY (Connect to VCC)
BIN1 (MotorB Dir1)
BIN2 (MotorB Dir2)
PWMB (MotorB Speed)
GND

**TOP**

**BOTTOM**

**FIGURE 8-6:**

TB6612FNG H-bridge motor driver breakout board (without pins soldered)

The Toshiba TB6612FNG is actually a *dual* H-bridge IC. This means it has two full H-bridge circuits built into a little package, allowing you to control the two motors on your robot with a single board. The H-bridge distinguishes the two motors as A and B, as you can see on the underside of the board in Figure 8-6. To control each H-bridge circuit, you use three signal wires: two for direction and one for speed.

You can buy the board either with or without pins already soldered on, so if you want to save yourself the trouble of soldering, make sure you get the presoldered board (ROB-13845). If you have the board without header pins already soldered on (ROB-09457), it's not a problem, but you'll need to solder male headers onto the pins; for soldering instructions, see "How to Solder" on page 302. In either case, before you start building this project you should have a board that looks like Figure 8-7.

## Geared Hobby Motor

The basic hobby motor that we used in Project 7 is great for simple mechanisms like spinning fans, but it doesn't offer a lot of *torque* (rotational force). In this project, we want to use a motor to move the entire project around, so we need to use a *geared motor*—a motor that's attached to a *gearbox* (see Figure 8-8).

MOTOR                                    GEARBOX

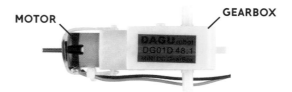

A gearbox essentially converts mechanical rotations into torque. This gearbox has a 48:1 gear reduction, which means 48 rotations of the motor equal one rotation of the output shaft. This slows down the motor by a factor of roughly 1/48 and results in a multiplication of the torque by a factor of 48. Basically, the output speed is slower, but the torque is a lot higher.

# BUILD THE DRAWBOT PROTOTYPE

Now, let's wire this up to see how it all works. You'll connect just one motor for now to test the H-bridge motor driver, so you'll use only one half of the dual H-bridge board. Figure 8-9 shows how the board and Arduino should be wired. The board is split horizontally, with the top half controlling Motor A and the bottom half controlling Motor B, though the power pins are used for both motors. Connect 5 V and GND from the Arduino to the power rails on the breadboard, and make sure to add a jumper wire to connect the two 5 V rails of the breadboard so you can use either rail to give power; this will save you from crossing too many wires and keep your board neat.

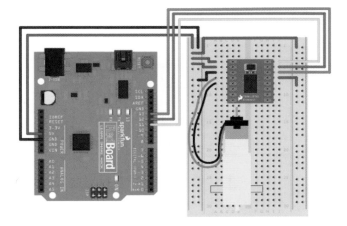

**FIGURE 8-9:**

H-bridge test circuit

Starting from the top left of the H-bridge, connect 5 V to the top two pins, VM and VCC. VM controls the power for the motors, and VCC controls the power for the chip. Next, use a jumper wire to connect one of the chip's GND pins to the GND rail of the breadboard. There are three pins available for ground on the H-bridge, as you can see in Figure 8-7, and you can use any of these.

Next you'll connect the motor. The motor has two wires: red and black. The orientation of the wires doesn't actually matter, but for consistency connect the red wire to the pin labeled A01 and the black wire to pin A02.

The remaining pins on the left side are those for controlling the second motor and another GND pin, so leave them for now. The pins on the top right of the H-bridge breakout board are for the signal wire connections for Motor A. The topmost pin, labeled PWMA, controls the motor's speed. Connect this to pin 11 on the Arduino. (Remember

that pins 3, 5, 6, 9, 10, and 11 all have PWM capability and can be used with the analogWrite() function.)

The next two pins, labeled AIN2 and AIN1, are used to control the direction and drive of Motor A, which you can do by setting these pins to different combinations of HIGH and LOW. Table 8-1 shows the combinations. Connect AIN2 to Arduino pin 12 and AIN1 to Arduino pin 11.

**TABLE 8-1:**

H-bridge motor controller functions

| AIN1 | AIN2 | FUNCTION |
|------|------|----------|
| HIGH | LOW | Clockwise |
| LOW | HIGH | Counterclockwise |
| HIGH | HIGH | Electronic brake (see note) |
| LOW | LOW | Stop/coast |

**NOTE**

*Setting both pins HIGH will employ* electronic braking. *The two wires of the motor are essentially shorted together, causing the motor's spinning to stop abruptly. By contrast, setting both to LOW would just stop actively spinning the motors, meaning the wheels would coast to a stop rather than stopping deliberately.*

Lastly you'll need to disable the STBY pin. As mentioned earlier, this H-bridge IC has a standby pin that allows you to put the chip into a low-power sleep mode, which is useful for applications where power consumption is a concern. For this project, you don't need this feature, so you'll disable it. This chip is designed with STBY as an *active low* input. This means that when this pin is LOW, it goes into standby mode. To disable standby, you'll connect this pin directly to 5 V on the power rail.

## PROGRAM THE DRAWBOT

Let's start the sketch with a little test. This simple example will spin the motor clockwise slowly for 1 second, change directions and spin counterclockwise quickly for 1 second, and then stop for 1 second before starting again. Open the Arduino IDE, and copy the code in Listing 8-1 into your window. When you're done, click **Upload** and watch what happens!

**LISTING 8-1:**

H-bridge motor controller example of speed and direction control

❶
```
const byte AIN1 = 13;
const byte AIN2 = 12;
const byte PWMA = 11;

void setup()
{
 pinMode(AIN1, OUTPUT);
 pinMode(AIN2, OUTPUT);
 pinMode(PWMA, OUTPUT);
}
```

```
void loop()
{
 //set direction to clockwise
❷ digitalWrite(AIN1, HIGH);
 digitalWrite(AIN2, LOW);
❸ analogWrite(PWMA, 50);
 delay(1000);

 //set direction to counterclockwise
❹ digitalWrite(AIN1, LOW);
 digitalWrite(AIN2, HIGH);
 analogWrite(PWMA, 255);
 delay(1000);

 //brake
❺ digitalWrite(AIN1, HIGH);
 digitalWrite(AIN2, HIGH);
 delay(1000);
}
```

The sketch starts with a new data type: const byte ❶. The keyword const is used to declare a *constant*, which is like a variable but with a value that can't be changed again later in the code. Thus, constants are useful for declaring things that will stay the same throughout the code, like pin numbers or configurations. In this case, these constants define the pin numbers that control the H-bridge. Since the pin numbers are numbers between 0 and 13, you can define these constants as the data type byte.

Next, you set the pins as outputs, and then set the direction you want the motor to spin using two digitalWrite() functions ❷ on pins AIN1 and AIN2. The first loop block sets AIN1 to HIGH and AIN2 to LOW, which spins the motor clockwise. To set the speed, you use an analogWrite() function ❸ on the PWMA pin. You may recall from Project 5 that you can use analogWrite() to set an analog pin to a PWM value from 0 to 255; the value given here, 50, is relatively slow. The motor will spin for 1 second because of delay(1000), and the next loop block changes directions with two more digitalWrite() functions ❹. Here the sketch simply swaps which pin is HIGH and which is LOW, sets the speed to 255 with analogWrite(), and adds another delay(1000) to set it to spin for 1 second.

The last part of the sketch sets both AIN1 and AIN2 to HIGH ❺, with another delay(1000). This applies an electronic brake and stops the motor for 1 second before the loop begins again and repeats the pattern.

**NOTE**

*Most of the time it doesn't matter too much whether you use a constant or a variable, but constants use less memory on the Arduino, so it's good practice to use them when you can, and you may see them used in other people's examples online. Also, while it's not a hard-and-fast rule, constant names are typically in all capital letters.*

Using this code as an example, you can now control both the speed and direction of a motor with just three lines of code! But we can make this even simpler. Let's clean up the code by using custom functions.

## Create a Custom Function

At the moment, every time you want to control the motor you're using three lines of code: two to control the direction and one to set the speed. In this section you'll make a custom function that will take just one number to determine both the direction and the speed of the spin. This number can be anything between -255 and 255 and will spin the motor clockwise if the number is positive and counterclockwise if it's negative. Add the code in Listing 8-2 to the very end of your sketch.

**LISTING 8-2:**

Custom function to set the motor speed of Motor A

```
void ❶setMotorA(❷int motorSpeed)
{
❸ if (motorSpeed > 0)
 {
 digitalWrite(AIN1, HIGH);
 digitalWrite(AIN2, LOW);
 }
❹ else if (motorSpeed < 0)
 {
 digitalWrite(AIN1, LOW);
 digitalWrite(AIN2, HIGH);
 }
❺ else
 {
 digitalWrite(AIN1, HIGH);
 digitalWrite(AIN2, HIGH);
 }
❻ analogWrite(PWMA, abs(motorSpeed));
}
```

Name the function setMotorA() ❶. This function uses a number as a single argument named motorSpeed ❷ to set the motor's speed. First, a simple if() statement determines whether the number is positive or negative by checking whether motorSpeed is greater or less than zero. If motorSpeed is positive ❸, the if() statement sets the direction pins so that the motor spins clockwise. If it's negative ❹, an else if() statement sets the direction pins to spin the motor counterclockwise. If it's neither positive nor negative (that is, if it's 0), a final else statement ❺ sets both direction pins HIGH to apply the brake and stop the motor.

The line at ❻ uses the `abs()` mathematical function to find the *absolute value* of `motorSpeed`. The `analogWrite()` function sets the speed of the motor, but it works only with values from 0 to 255. The `abs()` function makes sure that the positive part, or *absolute magnitude*, of `motorSpeed` is used to set the speed.

## Clean Up the Code

Now, let's clean up the `loop()` with this new function. You can see in Listing 8-3 that the `loop()` code is much shorter and easier to read. Make these changes to the `loop()` in your sketch and upload it to your board. It should behave the same way as before. Now, if you want to set the motor to a different speed or direction, you can do it with just a single line of code!

```
void loop()
{
 //set direction to clockwise
 setMotorA(100);
 delay(1000);

 //set direction to counterclockwise
 setMotorA(-255);
 delay(1000);

 //stop
 setMotorA(0);
 delay(1000);
}
```

**LISTING 8-3:**

Simplified version of the `loop()` using the custom function `setMotorA()`

This code sets a `setMotorA()` value and a delay to make each change in speed and direction. Now you have the beginnings of your Drawbot! Next, you'll wire the second motor.

## WIRE THE SECOND MOTOR

The DrawBot needs a second motor so it can zip around on two wheels. Figure 8-10 shows how the second motor will be wired. Plug Motor B in on the left side of the breakout board just below the connections for the first motor, with the red wire connected to B02 and the black wire connected to B01. Next, add the signal control lines to the H-bridge breakout board, just below the STBY pin on the right side. Connect the PWMB pin on the H-bridge to Arduino pin 10 for speed control, and connect the BIN1 and BIN2 pins to Arduino pins 8 and 9, respectively, for direction control.

**FIGURE 8-10:**

Wiring diagram for
the motor driver and
two motors

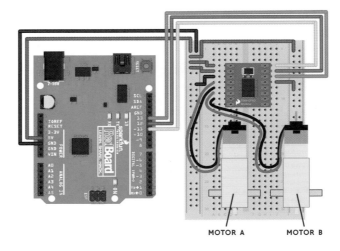

MOTOR A          MOTOR B

Now, you'll need to add code to control the second motor, as
shown in Listing 8-4.

**LISTING 8-4:**

Adding constants and
`pinMode()` functions for
Motor B

```
const byte AIN1 = 13;
const byte AIN2 = 12;
const byte PWMA = 11;

❶ const byte BIN1 = 8;
const byte BIN2 = 9;
const byte PWMB = 10;

void setup()
{
 pinMode(AIN1, OUTPUT);
 pinMode(AIN2, OUTPUT);
 pinMode(PWMA, OUTPUT);

❷ pinMode(BIN1, OUTPUT);
 pinMode(BIN2, OUTPUT);
 pinMode(PWMB, OUTPUT);
}
```

This code adds the three additional constants ❶ for the signal
control pins for Motor B, and sets each of these pins as OUTPUT ❷ in
the setup().

Next, you'll again write a custom function to control Motor B.
This code is so similar to the setMotorA() function that you can save
yourself some typing by highlighting the code for setMotorA(), copy-
ing it (CTRL-C), pasting it (CTRL-V) below the setMotorA() function,
and changing the As to Bs. This is a technique that programmers use
a lot, and it can save you a lot of time. You just need to make sure

you're careful to change all the As to Bs in this second custom function (Listing 8-5), or the code won't work.

```
void setMotorB(int motorSpeed)
{
 if (motorSpeed > 0)
 {
 digitalWrite(BIN1, HIGH);
 digitalWrite(BIN2, LOW);
 }
 else if (motorSpeed < 0)
 {
 digitalWrite(BIN1, LOW);
 digitalWrite(BIN2, HIGH);
 }
 else
 {
 digitalWrite(BIN1, HIGH);
 digitalWrite(BIN2, HIGH);
 }
 analogWrite(PWMB, abs(motorSpeed));
}
```

**LISTING 8-5:**
Custom function for
Motor B

The sketch will now need `motorSpeed` values for both `setMotorA()` and `setMotorB()`. Let's add those to test the motors out together.

## DRIVE BOTH MOTORS

To make your Drawbot drive forward, you'll need the right motor to spin clockwise and the left motor to spin counterclockwise. This may seem counterintuitive, but take a look at a robot base from the side. Figure 8-11 shows a robot frame from both sides with arrows indicating the forward direction.

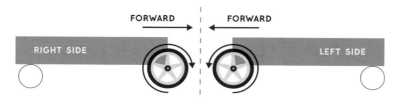

**FIGURE 8-11:**
Side views of the robot
from the right and left
sides. To move forward,
the right wheel must
spin clockwise and the
left wheel must spin
counterclockwise.

On the right side of the robot, the wheel needs to spin clockwise for the robot to move forward, but on the left side of the robot, the wheel needs to spin counterclockwise. Pay attention to the direction in which each axle is spinning. If you need to, attach a piece of masking tape to the spinning end of the motor so that you can see the axle's direction.

Now, to make the robot go backward, you just reverse those directions. After adding the custom function code for setMotorB() to your sketch, adjust your loop() to look like Listing 8-6, and then upload this code and watch your motors spin!

**LISTING 8-6:**

New loop() code to test both motors

```
void loop()
{
 //drive forward medium speed for one second
 setMotorA(100);
 setMotorB(-100);
 delay(1000)

 //drive backward quickly for one second
 setMotorA(-255);
 setMotorB(255);
 delay(1000);

 //stop for one second
 setMotorA(0);
 setMotorB(0);
 delay(1000);
}
```

You should see that Motor A (right side) is spinning clockwise and Motor B (left side) is spinning counterclockwise, and then after 1 second they flip. If you find that the motors are spinning in the same direction, swap the red and black wire connections on *one* of the motors.

With just a few lines of code, you can make your Drawbot move forward, turn right, turn left, move backward, and jiggle around!

Now it's time to build a frame or a *chassis* for your Drawbot. Because the code you wrote is all in the loop() part of the sketch, your motors will continue to spin, stop, spin, and stop. To stop the motors from spinning while you're building the chassis for your Drawbot, temporarily disconnect the USB cable from your computer.

## BUILD THE DRAWBOT CHASSIS

If you're using the SIK with the breadboard holder and Arduino baseplate, you'll need to make the chassis of the Drawbot at least as large as the baseplate itself. The baseplate measures 6 inches by 4.25 inches. Use a piece of cardboard or thin plywood to make your chassis. For our design, we made the chassis a rectangular 6 × 8-inch cutout, as shown in Figure 8-12. You can download a PDF of this template from *https://www.nostarch.com/arduinoinventor/*.

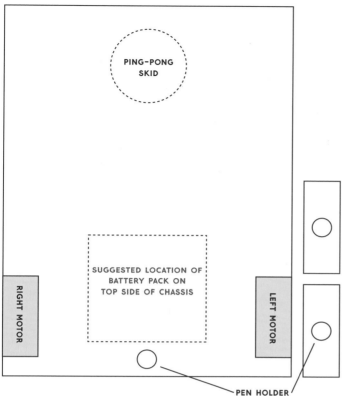

**FIGURE 8-12:**
Drawbot chassis,
bottom view
(not full size)

PING-PONG
SKID

SUGGESTED LOCATION OF
BATTERY PACK ON
TOP SIDE OF CHASSIS

RIGHT MOTOR

LEFT MOTOR

PEN HOLDER

Using tape or a hot glue gun, attach the motors to the under-
side of the chassis, oriented as shown in Figure 8-13, with the motor
hub near the back and the longer end of the motor body toward the
front. (Hot glue is a great semipermanent method for attaching things
because you can simply scrape it away with a craft knife and remove
the part if you want to reuse it later.) You may need to temporarily dis-
connect the motors from your breadboard circuit while you're attaching
them to the chassis, so just remember to reconnect them to the circuit
after you've glued them down. Refer back to Figure 8-10 if you need
help rewiring it.

**FIGURE 8-13:**
Attaching the motors to the
chassis with hot glue

We have a hole in our base template that's designed for a pen or marker. A Drawbot needs to be able to draw, after all! To give the pen more stability, we glued two smaller pieces of cardboard together to create a taller pen holder. Glue these pieces down right on top of the hole, as shown in Figure 8-14.

**FIGURE 8-14:**

Gluing the pen holder onto the chassis

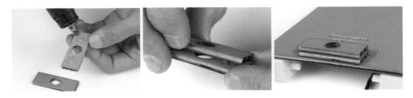

Finally, attach the wheels to the motors. You'll notice that the motor axles have two flat edges (Figure 8-15). Make sure you line these up with the flat edges on the axle holes of the wheels. The fit may be a little tight. Hold on to the entire motor while pushing the wheel on so that you don't accidentally rip the motor off your chassis.

**FIGURE 8-15:**

Profile of motor axle. Line up the flat edges with the flats of the opening on the wheel.

**NOTE**

*If you want to make your own wheels, use the shape and dimensions in Figure 8-15 for the axle holes.*

The Drawbot will move around using the two motor wheels as power and steering and a skid caster at the other end for balance. This method is called *differential steering*. This particular Drawbot is designed as a front-wheel-drive system, using a ping-pong ball as a skid caster in the back. As the Drawbot moves around, it will skid the ping-pong ball over the surface. Glue the ping-pong ball into place as shown in Figure 8-16, trying to center it as much as possible for the best balance.

**FIGURE 8-16:**

Attaching a ping-pong ball as a skid caster

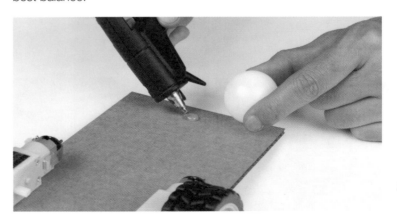

Now, set the breadboard holder, the Arduino, and a battery pack on top of the chassis, as shown in Figure 8-17. Use a little bit of tape or dabs of glue to make sure they don't move around.

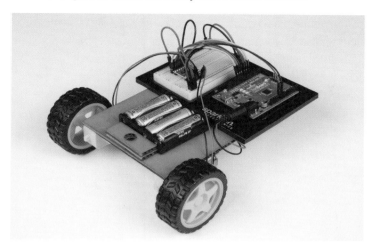

**FIGURE 8-17:**

The breadboard holder, the Arduino, and a battery pack on the cardboard chassis

## Test and Troubleshoot

Reconnect the USB cable to your Arduino board or plug in your battery pack and watch what happens. You might need to hold on to the cable so that it doesn't get tangled up. The robot should move forward slowly for 1 second, reverse direction quickly for 1 second, and then stop for 1 second. Because all of your code is in the loop(), the Drawbot will repeat this motion over and over again until you disconnect it from power. While you're working on tweaking your code, you may want to put the Drawbot's back end up on a few books to keep the wheels from touching the table.

Now, if your robot doesn't behave like you expect it to, you'll need to do a little troubleshooting to figure out what's going on. First, identify the problem. There are two common problems that we've seen with this bot: moving in the wrong direction and turning in circles. If it moves backward first instead of forward, switch the red and black wires for both motors going to the H-bridge. If your robot moves in circles instead of moving forward or backward, try flipping the motor wires on either Motor A or Motor B—don't flip both of them, or you'll get the same problem again. You should now have a Drawbot that moves forward and then backward, stops, and repeats this motion.

Before moving on, test how far the Drawbot moves in 1 second and make a note of this. You'll add a marker pen for it to start drawing lines, and you may need to adjust the speeds and the times

so that the Drawbot is easier to control. Slower speeds and shorter times might be best if you're working on a small table.

## Turn and Make Patterns: A Robot Square Dance

Now that you've mastered moving your robot forward and backward, see what fun patterns you can make with your new creation. Before you put a marker onto your Drawbot, try turning corners.

To turn the robot to the right, both motors need to spin counterclockwise, and to turn the robot left, they need to spin clockwise. See if you can get your Drawbot to do a little square dance! To draw a square, the basic steps are as follows:

- Move forward.

- Turn 90 degrees.

- Move forward.

- Turn 90 degrees.

- Move forward.

- Turn 90 degrees.

- Move forward.

- Turn 90 degrees.

Figure 8-18 illustrates the steps needed. You'll notice that you repeat the same steps four times. You already know you can use a `loop()` for repeated actions, but loops repeat forever, and you want your Drawbot to stop after four turns. Luckily there's a programming technique that's perfect for repeating a part of the code a set number of times: a `for()` loop.

**FIGURE 8-18:**

Steps to a simple square dance

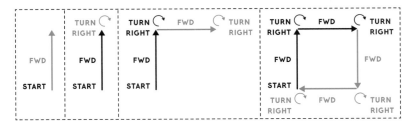

A `for()` loop starts with the command `for`, followed by a set of parentheses. Inside the parentheses there are three sections. See Listing 8-7.

```
for(❶int count = 0; ❷count < 4; ❸count++)
 {
 ❹ //insert code here that you want to repeat
 }
```

LISTING 8-7:

The for() loop

The first part ❶ is the declaration and initialization of a counter variable that keeps track of repetitions of the loop. You declare this variable as an integer, name it count, and initialize it to 0. You can name this variable anything you want, so long as you use the same variable name in the next two parts. The next part is the *condition statement* ❷, which controls whether the for() loop continues to repeat or stops. Here, you continue repeating as long as the condition statement count < 4 is true. Since count was initialized at 0, this condition is true on the first pass, and the loop will repeat. The third part is the *increment statement* ❸, which tells the for() loop what to do with the counter variable after each repetition. Here, count++ is a shorthand for count = count + 1. This increments the counter variable by 1 for each repetition. The final part ❹ is the code that you want to repeat or loop through, like any code you place inside curly brackets.

So in all, the for() loop's arguments are saying that the loop should continue to run until it's run four times, at which point the count will be incremented to 4, the condition statement will be false, and the loop will exit. The for() loop is a really handy way to clean up code and repeat instructions a particular number of times.

Now, use this new skill to write your square dance code. Replace the loop() in your sketch with the loop() in Listing 8-8. Everything else will stay the same.

```
void loop()
 {
❶ for(int count = 0; count < 4; count++)
 {
 //drive forward
❷ setMotorA(100);
 setMotorB(-100);
❸ delay(500);

 //turn right
❹ setMotorA(-100);
 setMotorB(-100);
 delay(250);
 }
❺ delay(1000);
 }
```

LISTING 8-8:

Square dance code

## SHORTHAND FOR QUICKLY MANIPULATING VARIABLES

Often you may want to increment, decrement, or just modify the value of a variable in code. The most common use is to increment the value of a variable by one for each repetition of a loop, which you can do with the code *variableName = variableName + 1*. But there are also a few shorthand methods to modify values of variables, shown in the following table.

| SHORTHAND CODE | LONGHAND CODE | DESCRIPTION |
|---|---|---|
| variableName++; | variableName = variableName + 1; | Increment by 1 |
| variableName += 2; | variableName = variableName + 2; | Increment by 2 |
| variableName += n; | variableName = variableName + n; | Increment by n |
| variableName--; | variableName = variableName - 1; | Decrement by 1 |
| variableName -= 2; | variableName = variableName - 2; | Decrement by 2 |
| variableName -= n; | variableName + variableName - n; | Decrement by n |
| variableName *= n; | variableName = variableName * n; | Multiply by n |
| variableName /= n; | variableName = variableName / n; | Divide by n |

To draw a square, the sketch uses the for() loop ❶ to repeat the steps four times. The robot first drives forward ❷ for just half a second ❸. You want to make sure that it doesn't go too far and draw all over your floors. Next, to turn the robot, the sketch sets both motors to spin counterclockwise ❹. To complete each square, you add a short, 1-second delay ❺. Notice that the delay is after the curly bracket for the for() loop. The Drawbot will repeat the steps—move forward and turn four times—and then wait for 1 second before the whole loop() repeats. This will give you a chance to manually move the Drawbot or reposition it if you need to. The values in this code worked well in our office, but you may need to fine-tune

and play around with the speed settings and timing for your own Drawbot. Tweak your sketch until you get your Drawbot moving in a square-like pattern. Don't worry if it's not perfect—just keep testing out the speeds of the corner turns. This is part of the art you'll be creating!

We've included the full sketch for the square-dancing Drawbot in Listing 8-9.

**LISTING 8-9:**

Complete Drawbot square dance code

```
const byte AIN1 = 13;
const byte AIN2 = 12;
const byte PWMA = 11;

const byte BIN1 = 8;
const byte BIN2 = 9;
const byte PWMB = 10;

void setup()
{
 pinMode(AIN1, OUTPUT);
 pinMode(AIN2, OUTPUT);
 pinMode(PWMA, OUTPUT);

 pinMode(BIN1, OUTPUT);
 pinMode(BIN2, OUTPUT);
 pinMode(PWMB, OUTPUT);
}

void loop()
{
 for(int count = 0; count < 4; count++)
 {
 //drive forward
 setMotorA(100);
 setMotorB(-100);
 delay(500);

 //turn right
 setMotorA(-100);
 setMotorB(-100);
 delay(250);
 }
 delay(1000);
}

void setMotorA(int motorSpeed)
{
```

```
 if (motorSpeed > 0)
 {
 digitalWrite(AIN1, HIGH);
 digitalWrite(AIN2, LOW);
 }
 else if (motorSpeed < 0)
 {
 digitalWrite(AIN1, LOW);
 digitalWrite(AIN2, HIGH);
 }
 else
 {
 digitalWrite(AIN1, LOW);
 digitalWrite(AIN2, LOW);
 }
 analogWrite(PWMA, abs(motorSpeed));
}

void setMotorB(int motorSpeed)
{
 if (motorSpeed > 0)
 {
 digitalWrite(BIN1, HIGH);
 digitalWrite(BIN2, LOW);
 }
 else if (motorSpeed < 0)
 {
 digitalWrite(BIN1, LOW);
 digitalWrite(BIN2, HIGH);
 }
 else
 {
 digitalWrite(BIN1, LOW);
 digitalWrite(BIN2, LOW);
 }
 analogWrite(PWMB, abs(motorSpeed));
}
```

As we mentioned earlier, the chassis template includes a notch on the front end to place a marker. We suggest using either a washable or dry-erase marker. Find a large piece of poster paper or dry-erase board that you can lay on the floor. Be really careful not to draw all over your floor! It might get you in trouble. (Trust us, we've made this mistake before, and we definitely regret it.)

Place your Drawbot on the drawing surface. Use a piece of masking tape to secure the marker in place, positioning it so that it makes good contact with the drawing surface. Move the Drawbot

around manually on the drawing surface to test the marker placement. Now, plug the USB cable in to your computer and watch what happens. Be quick to grab the Drawbot if it looks like it's going to run off your drawing surface and onto the floor.

To mix things up, change marker colors or modify your code to draw different size squares. See if you can make your Drawbot draw spirals and stars! Figure 8-19 shows some of the fun patterns our Drawbot made in our office.

**FIGURE 8-19:**
Drawbot in action—make sure you use a large piece of paper to keep it from drawing all over the floor!

If you want to add some style to your Drawbot, try digging through your craft supplies or finding some spare cardboard and see what you can come up with. We placed an old pretzel jar container on our Drawbot at the office. It's now called Pretzel Bot, and it drives around and gives away free pretzels (Figure 8-20).

**FIGURE 8-20:**
Pretzel Bot! The Arduino and breadboard are hidden inside the box.

## GOING FURTHER

The Drawbot is an introduction to basic robotics. The simplest robots are really just a controller and two motors, and that's what you have here. We'll give you a few ideas to take it to the next level.

### Hack

Preprogrammed motion is fun, but every time you want to change up the pattern, you have to reupload the sketch. But with some changes to the code, you can use the Serial Monitor to control your Drawbot while it's still going.

So far, you've used the Serial Monitor only to read data the Arduino sends back to the computer as the project is working, such as sensor data, but the Serial Monitor can also send data to the Arduino. Open the Serial Monitor window, and you'll see a small text box at the top with a button labeled Send, as shown in Figure 8-21. This box allows you to send data to the Arduino so you can control it from the Serial Monitor.

**FIGURE 8-21:**

Serial Monitor window

The *P8_DrawbotSerial.ino* sketch (downloadable from *https://www.nostarch.com/arduinoinventor/*) uses the Serial Monitor to send just three numbers to control Motor A, Motor B, and the driving time.

Take a look at the code. This new sketch declares three variables to hold the speed of Motor A, the speed of Motor B, and the delay time, which are the three numbers you send. You initialize communication with the Arduino with `Serial.begin(9600);` to send and receive data using the Serial Monitor. The Arduino reads the data you put into the Serial Monitor and assigns any integers to the three `speedA`, `speedB`, and `delayTime` variables, which are then used for the familiar `setMotorA()`, `setMotorB()`, and `delay()` functions. See the comments in the code for a more complete explanation.

Upload the sketch to your Drawbot, open the Serial Monitor, enter **100 -100 500**, and press ENTER or click **Send** (see Figure 8-22). The Drawbot should move forward for half a second and then stop. Now you can fine-tune your Drawbot routines without having to reupload the code each time! The code will run once and doesn't repeat unless you give it additional commands. What happens when you enter six numbers, such as 100 -100 500 -100 -100 250? See if you can choreograph a dance routine that is represented by a sequence of numbers.

**FIGURE 8-22:**

Choreographing a robo-dance

## Modify

What other shapes can you program your Drawbot to create? Use what you learned with for() loops and see if you can hack your code to make it draw a triangle or star. You'll have to do some experimenting to get the timing and speeds just right. What happens when you move just one wheel at a time?

## Bonus

There's a bonus script (at *https://www.nostarch.com/arduinoinventor/*) that will let you control the turtle with even simpler commands, like fd 10 and bk 10 to move forward or backward 10 spaces. Download *P8_BonusTurtle.ino* and load it into your IDE. Then open your Serial Monitor and enter a few of the following commands: fd 10 to move forward 10 spaces, bk 10 to move backward 10 spaces, rt 90 to turn right 90 degrees, and lt 90 to turn left 90 degrees. See if you can instruct your new turtle to do a square dance with these instructions!

# DRAG RACE TIMER

IN PROJECT 4, YOU BUILT A REACTION TIMER TO MEASURE HOW FAST YOU CAN HIT A BUTTON. IN THIS PROJECT, YOU'LL BUILD ON THE TECHNIQUES YOU LEARNED THERE TO MAKE A RACE TIMER FOR A HOT WHEELS-INSPIRED RACE TRACK (SEE FIGURE 9-1). WE'LL SHOW YOU HOW TO DISPLAY THE FINISH TIME ON A SMALL, PORTABLE LCD SCREEN SO THAT YOU CAN DETACH YOUR

project from your computer. We'll also show you how to hack this project to add a second track and indicator lamps (LEDs) to show which car has won. Are you ready?

**FIGURE 9-1:**

The completed
Drag Race Timer

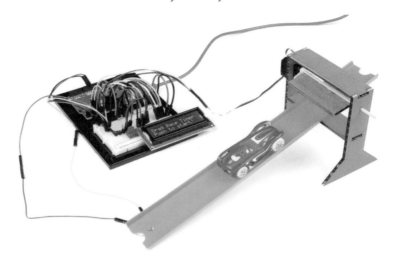

**NOTE**

*In "Going Further" on
page 273, we'll show
you how to modify your
Drag Race Timer so you
can race two cars and
display the winning time.
The standard SparkFun
Inventor's Kit includes one
photoresistor (SEN-09088),
but you'll need two for this
final hack. Thankfully, the
photoresistor is a pretty
inexpensive part, so you
could either buy another
one or partner with a friend
who has an Inventor's Kit
to build the two-player
version.*

## MATERIALS TO GATHER

Many of the parts used in this project will be familiar to you already (see Figures 9-2 and 9-3). We'll introduce only one new part: the 16 × 2 character LCD that you'll use to display your race time directly, rather than displaying it in the Serial Monitor on your computer screen.

### Electronic Parts

- One SparkFun RedBoard (DEV-13975), Arduino Uno (DEV-11021), or any other Arduino-compatible board

- One USB Mini-B cable (CAB-11301 or your board's USB cable)

- One solderless breadboard (PRT-12002)

- One 10 kΩ resistor, or two if you want to build the two-player version (COM-08374, or COM-11508 for a pack of 20)

- One photoresistor (SEN-09088), or two* if you want to build the two-player version

- One push button (COM-10302)

- One 10 kΩ potentiometer (COM-09806)

- One 16 × 2 character LCD (LCD-00255)

- One submicro size servo motor (ROB-09065)

- Male-to-male jumper wires (PRT-11026)

- Male-to-female jumper wires (PRT-09140*)

**NOTE**

*The parts marked with an asterisk (\*) do not come with the standard SparkFun Inventor's Kit but are available in the separate add-on kit.*

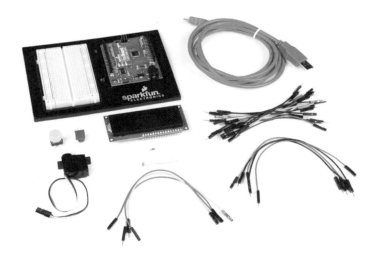

**FIGURE 9-2:**

Components for the Drag Race Timer

## Other Materials and Tools

- Craft knife

- Metal ruler

- Needle-nose pliers

- Wire cutters

- Masking tape

- Glue (hot glue gun or craft glue)

- Cardboard (about 8.5 × 11 inches), a small cardboard box, or thick cardstock

- Bamboo skewer

- Enclosure template (see Figure 9-15 on page 266)

- Hot Wheels or other small toy cars to race (not shown)

- (Optional) Toy car race track (not shown)

**FIGURE 9-3:**

Recommended tools
and materials

In previous projects, we've used the Serial Monitor to display information sent from the Arduino on your computer. In this project, we'll show you how to add an LCD directly to your project, a skill well worth learning. The LCD requires a lot of wires, but don't worry—we'll take it one step at a time. After you've mastered the use of this part, you can go back and add it to some of your past projects to make them fully portable!

## NEW COMPONENT: THE 16 × 2 CHARACTER LCD

*LCD* is short for *liquid crystal display*. Invented over 40 years ago, liquid crystal technology is used in digital watches, alarm clocks, projectors, televisions, computer monitors, and more.

The LCD you'll use in this project is a simple *monochromatic* display, meaning it displays only one color. Beneath the screen of the display is a layer of liquid crystal. This is a unique chemical that, when a small electric current is applied to it, changes from transparent to opaque. Combined with a backlight or a reflective mirror, liquid crystal is used to build very simple displays. Light comes through or is blocked depending on which areas of the liquid crystal electricity is applied to—which means you can make shapes if you can control the current.

The 16 × 2 character LCD displays up to 32 characters of information, each of which is broken down into a 5 × 8 pixel matrix. Each individual pixel can be made either opaque or transparent depending on the applied electric current, controlled by the Arduino. The letter *A*,

for example, will display on the LCD screen when the yellow pixels in Figure 9-4 are made opaque.

**FIGURE 9-4:**
The uppercase letter *A* represented on a 5 × 8 pixel matrix

There are 40 individual pixels in a single character, each controlled by the Arduino, meaning there are 1,280 different control lines! Thankfully, the LCD used in this project has a special parallel interface LCD driver IC by Hitachi called the HD44780. This chip allows you to display almost any character on the screen using just six control lines from the Arduino. Figure 9-5 shows the pins on an LCD.

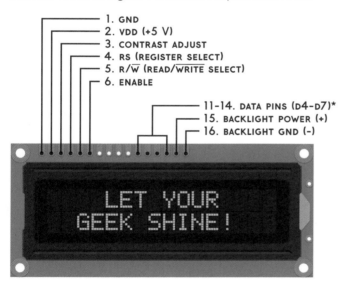

1. GND
2. VDD (+5 V)
3. CONTRAST ADJUST
4. RS (REGISTER SELECT)
5. R/W̅ (READ/WRITE SELECT)
6. ENABLE

11-14. DATA PINS (D4-D7)*
15. BACKLIGHT POWER (+)
16. BACKLIGHT GND (-)

**FIGURE 9-5:**
A simple 16 × 2 character LCD

**NOTE**
*The LCD can use up to eight pins for data (d0–d7), but the way we are going to use the LCD, it only uses four. These are labeled d4–d7.*

The LCD has a total of 16 pins, but this project uses only pins 1–6 and 11–16. The pins are numbered 1 through 16 from left to right (with the pins at the top of the screen). Table 9-1 describes each of the pins on the LCD. In some datasheets you might see a line over a label, as with the Read/Write label on pin 5. This line indicates that the feature is an *active low*, which means the pin is activated at low voltage. So, in this case, when you want to write

to the LCD, pin 5 needs to be set to LOW. We'll discuss this more in "Connect the Data and Control Wiring" on page 255.

"Connect the Data and Control Wiring" on page 255.

**TABLE 9-1:**

Pin descriptions for 16 × 2 character LCD

| PIN | DESCRIPTION |
|-----|-------------|
| 1 | Ground (GND) |
| 2 | VDD power for the LCD (5 V) |
| 3 | Contrast adjust (0–5 V) |
| 4 | Register select (RS) |
| 5 | Read/Write select (R/$\overline{\text{W}}$) |
| 6 | Enable |
| 7–10 | Data lines d0–d3 (not used) |
| 11–14 | Data lines d4–d7 (data transferred in 4 bits at a time) |
| 15 | Backlight power (5 V) |
| 16 | Backlight ground (GND) |

Rather than having to control each of the 40 pixels for each character separately, the HD44780 driver chip interprets data sent over by the Arduino using four data lines and two control lines and converts this into the character to display. To further simplify the interface, the Arduino community has written an LCD library for writing code to the LCD. We'll look at that in the code.

## DRAG RACE TIMER OPERATION

Before we start wiring the electronics, let's discuss how the sketch will function. We designed this race timer so that when we push a button the servo moves up, opening the starting gate that allows the car to roll down the track. At the same time, the Arduino records the starting time and waits to see when the car reaches the photoresistor at the bottom of the track, which uses the same light-sensor circuit used in the Night-Light in Project 5. You'll embed the light sensor in the center of the track so that when the car passes over it, it will create a shadow that the Arduino can detect. When the Arduino detects the shadow, it will record the stopping time and calculate the total time as the stopping time minus the starting time. If this seems similar to the Reaction Timer from Project 4, that's because it is!

# BUILD THE LCD CIRCUIT

You'll start by building the LCD circuit. The LCD has 16 pins in total, but you'll use just 12 of them. Figure 9-6 shows the schematic for the LCD wiring.

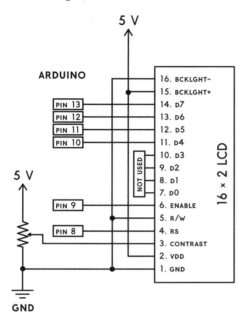

**FIGURE 9-6:**

Schematic diagram of LCD wiring

With 16 pins, the LCD will take up 16 rows on the breadboard, so you'll have to be careful about positioning with this project. You'll mount the LCD in the first 16 rows on the right side of the breadboard. Be sure to connect the power and ground from the Arduino to the power and ground rails on the left side of the breadboard.

Note that the pins on the LCD are not labeled. As we walk you through wiring it up, we'll refer to the pins on the LCD in order, starting with pin 1 at the bottom.

## Power the LCD

The LCD has two separate power supplies for the backlight and for the control logic. You'll need to wire these separately.

Connect pin 1 of the LCD to GND and pin 2 of the LCD to 5 V using the power rails on the breadboard. This provides power for the LCD's control circuitry and the HD44780 LCD driver chip. Next, connect pin 15 on the LCD to 5 V and pin 16 on the LCD to GND, again using the power rails. These two connections power the LCD's built-in backlight (see Figure 9-7).

**FIGURE 9-7:**

Connect the power
for the LCD and the
backlight.

## Control the Contrast

You can adjust the contrast on the LCD screen. To do so, you control the voltage on pin 3 of the LCD using a simple voltage divider circuit with a potentiometer, similar to what you did for the Balance Beam in Project 6. Recall that a potentiometer is the same thing as a variable resistor: it has three pins, and as you turn the knob the resistance between the center pin and either of the end pins changes. If you connect the top and bottom pins of the potentiometer to 5 V and GND, you have a variable voltage divider where the voltage on the center pin will vary between 5 V and GND depending on how far you turn the knob (see Figure 9-8).

Add the potentiometer to the breadboard just below the LCD. Connect the outside pins of the potentiometer to 5 V and GND, and connect the center pin to pin 3 on the LCD for the contrast control.

Now all you need to do is add the data and control wiring for the LCD.

## Connect the Data and Control Wiring

You need seven more wires to connect to the LCD, including four data lines and three control lines. Pin 5 on the LCD is the read/write functionality that allows the Arduino to read from and write data to the display. You're only going to use this read/write connection to send data to the LCD, or write to the device, so you can connect this to ground, known as "tying the pin low." If you look back at Table 9-1, you'll notice that the Read/$\overline{\text{Write}}$ label has a line over *Write*. As we mentioned earlier, this notation is often used in datasheets and documentation to indicate that a low signal will activate this feature. A low input is equivalent to ground, so add a wire to connect pin 5 of the LCD to GND, as shown in Figure 9-9.

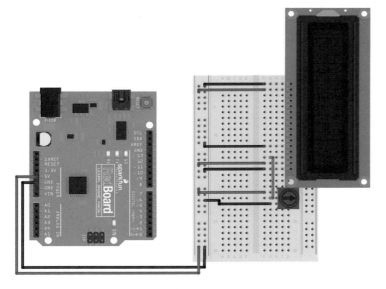

**FIGURE 9-9:**
Connect pin 5 of the LCD to GND for the R/$\overline{\text{W}}$ control.

The final six wires will connect the LCD to the Arduino. Pins 11–14 on the LCD are the four data lines the Arduino will use to send information to the LCD. Connect these to the Arduino pins 10, 11, 12, and 13, as shown in Figure 9-10. The wires should go straight across from the Arduino board to the LCD without crossing.

The last two connections are Enable at pin 6 and Register Select at pin 4. The Enable pin is used to signal the data transfer to the LCD, and the Register Select pin determines whether the data represents a character to display or an instruction, like clearing the screen or moving the cursor; this gives you greater control over what's displayed on the screen. Connect pin 9 on the Arduino to pin 6 on the LCD, and pin 8 on the Arduino to pin 4 on the LCD, as shown in Figure 9-10.

**FIGURE 9-10:**

Final wiring of the LCD
circuit

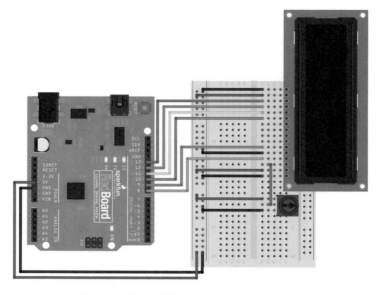

Table 9-2 shows the LCD screen connections to help you make sure you have everything connected correctly.

**TABLE 9-2:**

LCD pin connections

| LCD PIN | CONNECTION |
|---------|------------|
| 16 | GND |
| 15 | 5 V |
| 14 | Arduino pin 13 |
| 13 | Arduino pin 12 |
| 12 | Arduino pin 11 |
| 11 | Arduino pin 10 |
| 10 | N/A |
| 9 | N/A |
| 8 | N/A |
| 7 | N/A |
| 6 | Arduino pin 9 |
| 5 | GND |
| 4 | Arduino pin 8 |
| 3 | Middle pin of potentiometer |
| 2 | 5 V |
| 1 | GND |

## Test the LCD

Before you wire up more of the circuit, test it to make sure it's working as expected so far. Connect your Arduino to your computer.

As soon as you apply power, the backlight should turn on. Try turning the potentiometer knob. Even with nothing displayed on the LCD, you should see the contrast of the screen change as you twist, from all dark at its lowest to 32 brightly lit rectangles at its highest.

If you don't see this, double-check the wiring. Make sure that all of the power connections to the LCD match Table 9-2.

Once you have the LCD working, copy the code from Listing 9-1 into Arduino and upload it to your device. This simple example should display the text *SparkFun Arduino* on the first line and a running counter on the second line.

**LISTING 9-1:**

Test code to display text and a running millis() counter to the LCD

```
❶ #include<LiquidCrystal.h>
❷ LiquidCrystal lcd(8, 9, 10, 11, 12, 13);

 void setup()
 {
❸ lcd.begin(16, 2); //initializes interface to LCD
❹ lcd.clear();
❺ lcd.print("SparkFun Arduino");
 }

 void loop()
 {
❻ lcd.setCursor(0, 1); //move cursor to the 2nd line
 //(col 0, row 1)
❼ lcd.print(millis()/1000); //print the number of
 //seconds elapsed

 }
```

Let's take a look at what's going on in this example. First, it includes the *LiquidCrystal.h* library ❶ created by the Arduino community to simplify the six different control and data lines. This will make it easier for you to send instructions to the LCD.

Next, this code creates an object named lcd that uses the LiquidCrystal library ❷. Notice that this time when you create the object, you pass it a set of parameters that correspond with the LCD pins: the Register Select, Enable, and four data pins. This is where you configure which pin controls each function on the LCD. In some documentation, you may see this command as LiquidCrystal lcd(RS, Enable, d4, d5, d6, d7).

You may be wondering why we don't use four of the LCD pins. This LCD is able to transfer data on either four or eight data lines. According to the datasheet on the LCD, when you use four data lines, you use the top four pins on the LCD—the pins labeled d4, d5, d6, and d7. While it takes the Arduino twice as long to transfer data to the LCD this way, this helps to keep the circuit as simple as possible, and remember, the Arduino operates with a 16 MHz clock. That's really fast!

The LiquidCrystal library has around 20 different commands that simplify control of this LCD. In this example, we'll show you a few basic commands that allow you to configure the screen size, clear the screen, display information, and move the cursor.

The `setup()` part of the sketch has a few instructions that will run just once when the Arduino starts up. The first of these is `lcd.begin(16, 2);` ❸, which sets up the size of the LCD as a 16 × 2 character LCD, allowing the library to correctly wrap text and move from one line to the next.

The next instruction, `lcd.clear();` ❹, allows you to clear the screen before providing new text to display. It also resets the position of the cursor to the first character on the first line of the screen. Without this, the LCD would retain the last thing displayed.

Then, the command `lcd.print("SparkFun Arduino");` ❺ displays the text *SparkFun Arduino* on the LCD. Because the `lcd.clear()` instruction just cleared the screen, this text will appear on the first line of the display. This string of text is exactly 16 characters long and should fill the entire first line of the LCD. This command is similar to `Serial.print()`, but with `lcd.print()` you don't need to be connected to a computer or have the Serial Monitor open to see text and information from your device.

The `loop()` refreshes the screen with new information each time it repeats. First it moves the cursor to the second line of the LCD using `lcd.setCursor(0, 1);` ❻ so it doesn't overwrite the *SparkFun Arduino* text on the first line. The two numbers used in the `setCursor()` method indicate the position of the character (0) and the row (1). As is common in a lot of programming environments, Arduino counts starting with an index of 0, not 1.

Finally, the sketch prints a counter ❼ using another `lcd.print()` instruction. This counter uses the `millis()` function, which reports the number of milliseconds since the Arduino was powered on. Dividing this value by 1,000 shows a counter in seconds. We will use a similar technique for the race timer.

**NOTE**

*The LiquidCrystal library only works with character LCD displays. Graphic LCD screens are also available, but they use a different library called OpenGLCD, which allows you to display graphics such as lines, rectangles, and circles as well as text.*

Now, can you figure out how to change the text to display your name on the first line? How about changing the time display to show the time elapsed in minutes instead of seconds? Play around with the code example until you're comfortable with displaying data to the LCD. With just six GPIO pins from your Arduino, you can add an LCD readout to any project!

This example demonstrates the most commonly used instructions in the Arduino LiquidCrystal library, but if you want to check out the other commands that you can use, see *https://www.arduino.cc/ en/Reference/LiquidCrystal/*.

Now that you have the LCD circuit working, it's time to add the button, servo, and light-sensor circuit.

## ADD THE REST OF THE ELECTRONICS

The Drag Race Timer will use a few parts that you've already put together in previous projects: a push button to start the race, a servo to control the starting gate for the car, and a photoresistor to detect when the car reaches the end of the track. Figure 9-11 shows schematic diagrams of these three additional components.

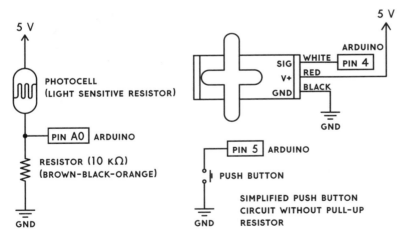

**FIGURE 9-11:**

Schematic diagrams for additional components in the Drag Race Timer

Place a push button on the breadboard so that two legs are on either side of the center divide, and connect two of the legs on one side to pin 5 on the Arduino and GND. The parts will fill up most of the breadboard, so pay close attention to the rows on the breadboard and how the components are connected. To save space, this project uses the push button without the external pull-up resistor used in Project 4 with the Reaction Timer. Instead, we'll enable a pull-up resistor in the code.

Next, connect the servo motor that will open the starting gate. Using three male-to-male jumper wires, connect the signal wire (either yellow or white) to pin 4 on the Arduino, the red wire to the 5 V rail, and the black wire to the GND rail.

Finally, add the light-sensor circuit with a voltage divider circuit. Connect one end of a photoresistor to the 5 V power rail and the other end to the GND power rail, via a 10 kΩ pull-down resistor placed directly in the power rail. Connect the row that has both the photoresistor and the 10 kΩ pull-up resistor to pin A0 on the Arduino. This circuit should look similar to the circuit you used in the Night-Light in Project 5.

There are a lot of components in this circuit, so take your time and double-check your wiring against the diagram in Figure 9-12.

**FIGURE 9-12:**

Complete electronics for the Drag Race Timer, including a starting button and gate

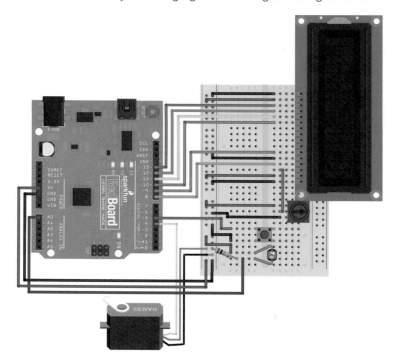

## PROGRAM THE DRAG RACE TIMER

Now let's put it all together. Start a new sketch, and enter the code from Listing 9-2 or download it from *https://www.nostarch.com/arduinoinventor/*. This example will bring together several concepts and ideas we've used separately in past projects.

LISTING 9-2:

Drag Race Timer sketch

```
❶ #include<LiquidCrystal.h>
 #include<Servo.h>

 LiquidCrystal lcd(8, 9, 10, 11, 12, 13);
❷ Servo startingGate;

❸ const byte buttonPin = 5;
 const byte servoPin = 4;
 const byte finishSensor1Pin = A0;
 const int darkThreshold = 500;

❹ int finishSensor1;
 boolean finishFlag = false;
 long startTime;
 long stopTime;
 float raceTime;

 void setup()
 {
❺ pinMode(buttonPin, INPUT_PULLUP);

 startingGate.attach(servoPin, 1000, 2000);
 startingGate.write(0);

❻ lcd.begin(16, 2);
 lcd.clear();
 lcd.print("Drag Race Timer");
 lcd.setCursor(0, 1);
 lcd.print("Push to start!");

❼ while (digitalRead(buttonPin) == HIGH)
 {
 }

 lcd.clear();
 lcd.print("Go!");

 startingGate.write(180);
 startTime = millis();
 }

 void loop()
 {
❽ finishSensor1 = analogRead(finishSensor1Pin);
❾ if ((finishFlag == false) && (finishSensor1 < darkThreshold))
 {
 finishFlag = true;
 stopTime = millis();
 raceTime = stopTime - startTime;
```

```
 lcd.clear();
 lcd.print("Finish Time:");
 lcd.setCursor(0, 1);
❿ lcd.print(raceTime / 1000, 3);
 }
}
```

Let's take a look at how all this works. First, the sketch includes two libraries using the #include directive ❶, *LiquidCrystal.h* and *Servo.h*. Next, it initializes a LiquidCrystal object named lcd, similar to Listing 9-1, and a Servo object named startingGate ❷.

Then, the sketch declares a set of constants for the pin connections used for the button, servo, and photoresistor circuits ❸. This means that, as you make changes and modifications, if you need to move a wire to a different pin on the Arduino, you'll only have to change a single number in the code. The last constant, a threshold value named darkThreshold, is used to set the light level to detect when the car is blocking the light sensor. Here it's set to 500, roughly in the middle of the range of 0–1023, but you may need to adjust this value to suit the environment of your own room.

Next, the sketch declares a few variables ❹. The finishSensor1 variable is used to store the raw value of the photoresistor sensor. The next variable, finishFlag, is a *state variable*, which is used to keep track of what state the sketch is in. The finishFlag variable is initialized to false and is used to indicate when the race is over (like the flag waved at the finish line to mark the winner of a Formula One race). We'll set it later in the code based on the input value from the sensor. The next three variables are used to calculate the race time using the built-in millis() timer in Arduino.

Now, the setup() part of the code sets up the button pin to use an internal pull-up resistor that's built into the Arduino by declaring the pin mode as an INPUT_PULLUP ❺. This trick removes the need for the external pull-up resistor used in Project 4.

Next, the sketch initializes the servo motor and sets its default position to 0. This will be the position of the starting gate when it's down.

The sketch then displays a little information to the LCD ❻ to let the user know how to start the race. These few lines of code set up the LCD, clear the screen, and display two lines of text. Be careful that your text is limited to 16 characters per line; any more than

16, and your characters will run off the screen to the right. The code then waits for a button press using the blocking `while()` loop technique ❼ used in the Reaction Timer; this blocks the sketch from proceeding until the button is pressed. When the button is pressed, `digitalRead(buttonPin)` will read `LOW` and the code will move the servo to the up position and set the `startTime` variable.

In the `loop()`, the sketch reads the light sensor and stores its current reading to the variable `finishSensor1` ❽. The sensor will be embedded at the end of the ramp. The car will roll over it as it crosses the finish line, covering the sensor and blocking most of the light. Similar to the Night-Light sketch in Project 5, the sketch will compare the value of the sensor to the `darkThreshold` value.

Remember that in the time it takes the car to pass the sensor, the `loop()` may repeat several times. Because we only want to look for the first moment the car crosses the finish line, the sketch uses a compound `if()` statement ❾ to capture the moment when the `finishFlag` variable is `false` *and* the finish sensor is blocked (that is, its value is less than `darkThreshold`). The && indicates a logical AND (see "Compound Logic Operators" on page 264). Pay careful attention to the number of parentheses used in the `if()` statement—they indicate order of operation and how the logic is used.

Now, inside the `if()` statement, the `finishFlag` state variable switches to `true`. Because the `finishFlag` state variable is now set to `true`, the compound `if()` statement will only catch the first moment the car crosses the sensor.

The sketch then records the stopping time and calculates the elapsed race time. Finally, the sketch prints the race time to the LCD.

The `raceTime` variable is declared as a `float` (floating-point variable) so it can store numbers with decimals. By default, the `lcd.print()` method will display two decimal places of precision for a floating-point value, but you can add a second parameter to the `lcd.print()` method to specify more or less. At ❿, the sketch calculates the number of seconds elapsed by dividing the millisecond count by 1,000. The extra 3 in the instruction `lcd.print(raceTime / 1000, 3);` tells Arduino to display three values past the decimal point, so the time will be accurate to the millisecond. Don't forget the last two curly brackets in the code. Double-check to make sure that your code matches Listing 9-2, and upload the sketch to your device.

**NOTE**

*Your sensor needs to be in a decently lit area so that the contrast between the sensor being lit and being shaded is great enough to cause that drop in voltage. Be aware that overhead lights can create a false detection if your body casts a shadow over the sensor. If you want to make sure that the sensor works well, get a small desk lamp and set it over the sensor.*

## COMPOUND LOGIC OPERATORS

In Chapter 4, we introduced simple logical comparison operators to compare two values. Recall that logic comparisons or expressions can only be either true or false. In programming, there are times when you need to compare multiple conditions together; for example, when you need to run some code only when a variable is false AND a sensor value is less than the threshold: ((finishFlag == false) && (finishSensor1 < darkThreshold)). Here, notice that the logic comparisons are grouped together in parentheses on either side of the compound AND (&&).

A combination of two or more logic comparisons is known as a *compound logic expression*. Expressions are *evaluated* (or read) from left to right. To keep everything together and observe the correct order of operations, it's a good idea to use parentheses to separate out the individual expressions. The two main operators used to combine logic expressions are AND and OR, which are described in the following table.

| SYMBOL | COMPOUND OPERATOR | DESCRIPTION |
|---|---|---|
| (*expression A*) && (*expression B*) | AND | Both *expression A* and *expression B* must be true. |
| (*expression A*) \|\| (*expression B*) | OR | Either *expression A* or *expression B* must be true. |

## A QUICK TEST

If you have everything wired up correctly and the code uploaded successfully, you'll hear the servo motor move to the 0 degree position and see a message displayed on the LCD, as shown in Figure 9-13. If the text is garbled or otherwise incorrect, double-check the wiring of the LCD, push button, and light sensor.

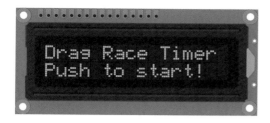

**FIGURE 9-13:**
LCD display text at the start of the race

Push the button and see what happens. The servo motor should move, and the display should change to the message "Go!" Now, cover the photoresistor with your finger. The LCD should display the time elapsed since you pressed the button and covered the photoresistor (Figure 9-14).

With the electronics all working properly, it's time to build the starting gate and track. If the sensor is not behaving as expected, try changing the darkThreshold value. If it's too sensitive or triggering immediately, reduce the value of darkThreshold. If it's not reacting when you cover up the sensor, try increasing the value. After you've made these changes, reupload your code and test it again.

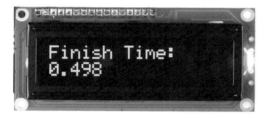

**FIGURE 9-14:**
LCD display with time elapsed

## BUILD THE DRAG RACE TRACK

The Drag Race Track includes a starting tower with a rotating gate that controls the release of the car onto the track. For the track, you can either use a section of a toy car race track or build your own from cardstock. The template for the tower is shown in Figure 9-15. You can download a PDF of this template from *https://www.nostarch.com/arduinoinventor/*.

**FIGURE 9-15:**

Template of cardboard
cutout pieces
for starting gate
(not full size)

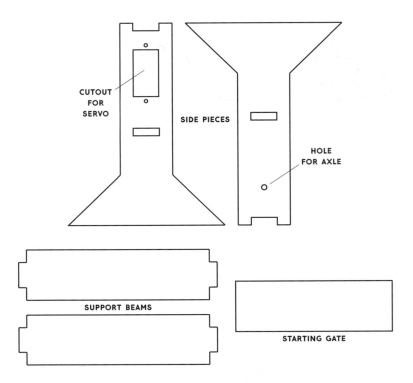

CUTOUT
FOR
SERVO

SIDE PIECES

HOLE
FOR AXLE

SUPPORT BEAMS

STARTING GATE

## Build the Starting Tower

Carefully cut the template out from a sheet of cardboard (see
Figure 9-16). The template has an opening for mounting the servo
on one side and a hole on the other to mount the bamboo skewer
axle for the starting gate. The other pieces are the support beams
and the starting gate.

**FIGURE 9-16:**

Trace the template and
carefully cut out the
pieces using a sharp
craft knife.

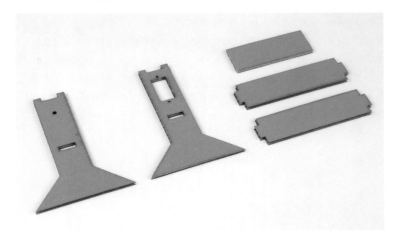

With the pieces cut out, first mount the servo in the opening, labeled in Figure 9-15. Insert the servo from the outside of the support beam so that the servo horn faces in toward the car. You can use the small screws included with the servo, or a small amount of glue, to secure the servo in place as shown in Figure 9-17. Don't attach the servo horn just yet. You'll attach that to the starting gate in the next step.

**FIGURE 9-17:**
Securing the servo using hot glue

Now, glue the two support beams in place. The lower support beam will insert into the slots cut into each of the side pieces. The top support beam should fit right into the notch on the top of each side piece. Use a small dab of glue to secure each of these pieces in place. When you're done, you should have a starting support tower like the one in Figure 9-18.

**FIGURE 9-18:**
Adding the support beams

## Assemble the Starting Gate

To build the starting gate, you'll need a piece of cardboard that is 2.5 × 1 inches and a short length of bamboo skewer or thin coffee stirring rod. This will serve as an axle for the starting gate. To start, add a small bead of glue to the edge of the starting gate piece, and glue the servo horn on so that the hub hangs just off the edge, as shown in Figure 9-19.

**FIGURE 9-19:**

Gluing the servo horn onto the edge of the starting gate

Cut down the bamboo skewer to 3.5 inches. Place a line of glue along the edge, and line the axle up with the hub of the servo horn, as shown in Figure 9-20.

**FIGURE 9-20:**

Gluing the axle to the starting gate

Plug in your Arduino and push the reset button to reset the position of the servo. Remember that the code will start off with the servo in the 0 degree position; this will be the down position, where the starting gate is holding the car in place. To place the starting gate into the support tower, first insert the axle into the hole on the side piece opposite of the servo, as shown in Figure 9-21. Keep in mind that when the gate opens, it will rotate clockwise.

**FIGURE 9-21:**
Inserting the axle into the side piece for the starting gate

The finished starting tower with the gate is shown in Figure 9-22.

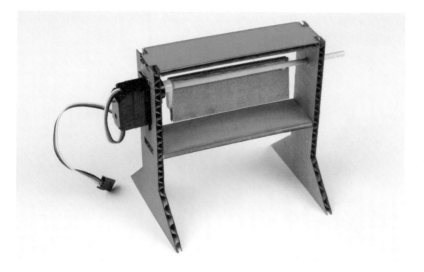

**FIGURE 9-22:**
Completed starting tower

Now you need a track. You can use a standard Hot Wheels track, which will fit on the lower support, or build your own track. If you want to use a Hot Wheels track, skip ahead to "Add the Photoresistor" on page 270.

## Build Your Own Track

To build your own track, you'll need at least one sheet of cardstock, cut down to 3.5 × 11 inches. You can make several lengths of track and tape them together for a longer track, but for our example, we'll just use a single track.

You'll fold two side rails on the track. On each side, measure and mark a line that is a quarter inch from the edge. Now, fold along the lines so that you have a quarter-inch lip on each side of your track. (It's often helpful to use a metal ruler or the edge of a table to make a nice straight fold in cardstock.) The lip will keep your car from flying off the track and also adds a small amount of structural integrity. Your track should look similar to the one pictured in Figure 9-23.

Now, using a small handheld hole punch, make a hole about a half inch from the end of your track for your photoresistor. If you don't have a hole punch, a craft knife or sharp pencil will also work. Just be careful when cutting through the paper, and always use a cutting mat when using a knife. The hole needs to be just large enough for the head of the photoresistor to fit inside.

**FIGURE 9-23:**

Completed track with two sides folded up

## Add the Photoresistor

Whether you're using a homemade track or a standard toy track, the next step is to add the photoresistor at the bottom of the ramp. The photoresistor will be your finish-line sensor. (There is a small hole at the end of a standard Hot Wheels track, slightly smaller than the diameter of the photoresistor sensor. Thankfully, the plastic track is flexible enough that you can simply press the head of the photoresistor through this hole.)

Remove the photoresistor from the breadboard and bend the legs at a right angle along the head so that it looks like Figure 9-24.

Insert the head of the photoresistor through the hole in your track. Make sure that the photoresistor does not stick out too much, or your car will catch on it; the car should be able to roll over the sensor without interference. With the legs bent at right angles, you should be able to tape them down securely to the bottom side of the track, as shown in Figure 9-25.

Reconnect the photoresistor to your breadboard using a pair of male-to-female jumper wires. If you extended the track too far and can't reach the breadboard, add more male-to-female jumpers to extend your wires as needed.

## FEEL THE NEED FOR SPEED?
## CALCULATING AVERAGE SPEED

With this project you can accurately measure how long it takes the car to roll down the ramp and cross the finish line, but you don't know how *fast* the car is moving—or do you?

Well, you have the total time it takes for the car to reach the bottom of the track, and you know the length of the track. With these two pieces of information, you can *estimate* how fast the car is moving. We describe this as an estimate because it's really an average speed, as opposed to the exact speed of your car when it meets the sensor at the bottom of the ramp. If you watch as the car rolls down, you'll see that it starts at the top of the ramp unmoving, then moves slowly, and then continues to speed up as it goes down the track.

Average speed is defined as distance traveled per unit of time. So, to find the average speed, you need to measure the length of the track and divide this value by the time elapsed.

$$\text{average speed} = \frac{\text{total distance}}{\text{time elapsed}}$$

Our track measures about 8.5 inches from the starting gate to the finish-line sensor, and in our last test we had a time of 0.581 seconds. If we divide these two numbers, we get an average speed of 14.6 inches per second.

$$\text{average speed} = \frac{8.5 \text{ inches}}{0.581 \text{ seconds}} = 14.6 \text{ inches per second}$$

Remember that this is the *average* speed of the car. For our simple setup with a straight ramp, this is roughly how fast the car is moving at the middle of the ramp, and since it wasn't moving at the top of the ramp, this means it was moving at twice this speed at the bottom of the ramp. How fast is your car moving?

## Test and Troubleshoot

Finally, rest the end of your race track without the photoresistor on the starting tower so that the ramp extends past the tower by about the length of your toy car (see Figure 9-26). This will be the starting position.

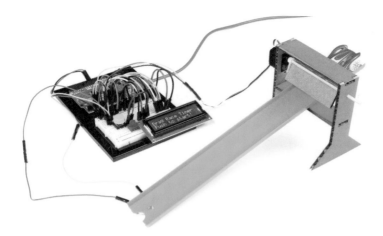

**FIGURE 9-26:**
Finished Drag Race Timer
with car ready to launch

If you haven't already done so, plug the Arduino back into your computer or into a power source. Push the reset button to make sure that the sketch starts over, and find your favorite Matchbox or Hot Wheels car and set it behind the starting gate. Push the starting button and watch your car go!

How long did it take to reach the bottom? On our track, our toy cars took just over 0.5 seconds. Try a few different cars, or invite some friends over to see whose car is the fastest. If you tape a few pennies to your car, does it go faster? Experiment and see how different things affect the drag race time of your car.

## GOING FURTHER

In this project, we introduced you to using the LCD to display information directly from your Arduino sketch. Here are a few ideas of how you can take what you've done in this project further.

### Hack

Racing against yourself is only so much fun. Let's look at how to add a second track and have two cars race against each other. (See Figure 9-27.) For this hack, you'll need an extra photoresistor, which isn't included in the standard SparkFun Inventor's Kit. Find a friend who also has a kit, buy one separately, or find one in the additional parts kit for this book.

First you need to create a separate finish-line sensor circuit. We were able to sneak in one more photoresistor and a pull-down resistor circuit near the bottom of the breadboard, as shown in Figure 9-28. Connect the second photoresistor circuit to pin 2 on

the Arduino through a 10 kΩ pull-down resistor, and connect the other leg to the 5 V power rail.

Place the photoresistor in the second track, and add male-to-female jumper wires to connect this to your circuit on the breadboard. Set your second track next to the first one on the starting tower. Now, it's time to upload some new code that will use both sensors. You only need to add a few extra lines to allow for the two cars to race. Download the *P9_TwoCarDragRaceTimer.ino* file from *https://www .nostarch.com/arduinoinventor/* and open it.

Let's take a look at the additions to this code. First, the code adds a new constant and variable for the second photoresistor finish-line sensor, `finishSensor2Pin` and `finishSensor2`.

Then, it checks which sensor was crossed first using a compound `if()` statement. If car #1 crosses first, `finishSensor1` will be 0 and `finishSensor2` will still be 1. Inside this `if()` statement, instructions display the winning information to the LCD and set the state variable, `finishFlag`, to `true`.

The `else-if()` statement checks whether car #2 crosses the finish line first; in this case, `finishSensor2` will be 0 and `finishSensor1` will still be 1. In the unlikely event that both cars do actually cross the line at the same time, this code does nothing. See if you can figure out how to add a draw feature in the event of a tie.

The code is full of comments to help explain more. Now, upload the code to your board and race! Whose car is fastest?

**FIGURE 9-27:**

Drag Race Timer with two race tracks

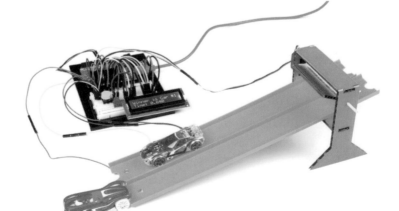

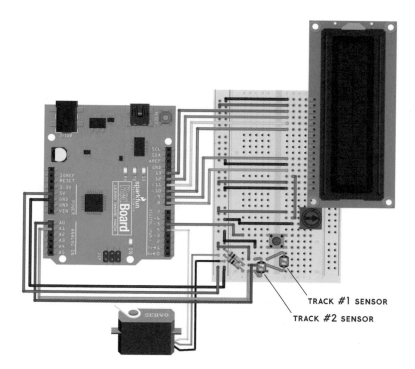

**FIGURE 9-28:**

Adding a second photo-
resistor for racing two cars
at the same time

TRACK #1 SENSOR

TRACK #2 SENSOR

## Modify

Now that you've seen how to use the LCD circuit, try going back and adding an LCD to one of the projects you've already built. In any of the projects where you used the Serial Monitor to display information, like the Reaction Timer from Project 4 or the Tiny Desktop Greenhouse in Project 7, you can replace the Serial Monitor with the LCD.

You'll need to check the wiring and the pin configuration used; you'll need six GPIO pins from your Arduino to control the LCD. If you want to see an example of the Reaction Timer project that uses the LCD, take a look at the tutorial we created on our InventorSpace at *https://invent.sparkfun.com/cwists/ preview/1145-sik-lcd-reaction-timer/*.

10

# TINY ELECTRIC PIANO

IN THIS PROJECT, YOU'LL USE A SPECIAL TOUCH SENSOR AND A PIEZO BUZZER TO CREATE AN ARDUINO PIANO (FIGURE 10-1). REGARDLESS OF WHETHER YOU HAVE ANY MUSICAL TALENT, THIS WILL BE A FUN PROJECT!

**FIGURE 10-1:**

A completed Tiny
Electric Piano

## MATERIALS TO GATHER

There are only a couple new parts in this project. One is the *soft potentiometer (SoftPot)*, which will act as your keyboard, and the other is the *piezo buzzer*, which will provide the sound. The supplies you'll need are shown in Figures 10-2 and 10-3. Grab your materials, and let's get started.

### Electronic Parts

- One SparkFun RedBoard (DEV-13975), Arduino Uno (DEV-11021), or any other Arduino-compatible board
- One USB Mini-B cable (CAB-11301 or your board's USB cable)
- One solderless breadboard (PRT-12002)
- One 10 kΩ resistor (COM-08374, or COM-11508 for a pack of 20)
- One 50 mm SoftPot membrane potentiometer (SEN-08680)
- One piezo buzzer (COM-07950)
- Male-to-male jumper wires (PRT-11026)

**FIGURE 10-2:**
Components for the
Tiny Electric Piano

## Other Materials and Tools

- Pencil
- Craft knife
- Metal ruler
- (Optional) Soldering iron
- Masking tape
- Cardboard or cardstock (about 4 × 5 inches) or a small cardboard box

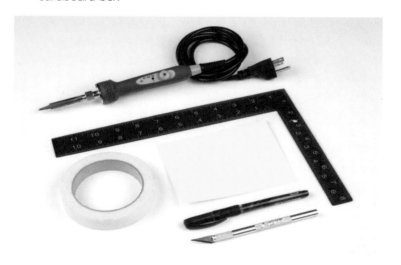

**FIGURE 10-3:**
Additional supplies

## NEW COMPONENTS

As we mentioned, this project will introduce just two new parts. The first is a SoftPot touch sensor: a special kind of potentiometer that is similar to the one used in Project 6 but reacts to pressure. The second new part is a piezo buzzer. Let's take a look at these two parts in more detail.

### The SoftPot Membrane Potentiometer

In Project 6, we introduced a simple potentiometer with a knob that you could turn to control the Balance Beam. The SoftPot, shown in Figure 10-4, works similarly but reacts to pressure instead of knob rotation.

**FIGURE 10-4:**

A 50 mm SoftPot

The SoftPot is a thin and flexible sensor that can detect where along its length pressure is applied. When you press down, the resistance between the middle pin and the closest end pin varies between 0 Ω and 10 kΩ, depending on how much pressure is detected. The SoftPot sensor has a thin membrane that separates the center pin connection from the outer ones. This sensor is very accurate and has a nearly infinite resolution. In industrial applications, the SoftPot is often used to identify the position of sliding parts, robot arms, and other components that make precision movements.

In this project, you're going to use this sensor as your piano keyboard. You'll divide the length of the strip into eight sections or "keys" that you can use to play various notes. The SoftPot is effectively the same as a knob potentiometer used in earlier projects. In schematics and circuit diagrams, you may recognize the symbol as pictured in Figure 10-5.

**FIGURE 10-5:**

The schematic diagram for the SoftPot is identical to that of the regular potentiometer.

10 kΩ ⟵ MIDDLE PIN

## The Piezo Buzzer

The piezo buzzer (Figure 10-6) is similar to a speaker and produces an audible click when you apply a voltage to the two leads; these clicks happen very fast, several hundreds or even thousands of times per second, and their frequency creates a tone. Inside a typical piezo buzzer is a special crystal called a *piezo element* that deforms when voltage is applied. The crystal is connected to a round metal disc, and when the crystal deforms, the disc vibrates the air inside a small cylinder, producing the clicking sound.

**NOTE**

*The buzzer that's included in the SparkFun Inventor's Kit actually uses a small magnetic coil instead of a piezo element, but it works the same. We still refer to it as a piezo buzzer.*

You've already seen how you can blink an LED at various rates with the Arduino. Now, if you "blink" the buzzer at a rate of hundreds of times per second, we can convert these clicks into tones! There are several different electrical symbols used to represent buzzers, speakers, and similar elements. The symbol we'll use in this chapter is shown in Figure 10-7.

**FIGURE 10-6:**

Piezo buzzer

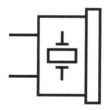

**FIGURE 10-7:**

Electrical symbol for a piezo buzzer

## BUILD THE CIRCUIT

This circuit uses only two electronic elements: the buzzer and the SoftPot, shown in Figures 10-8 and 10-9. When inserting the buzzer into the breadboard, you may notice that the legs are slightly closer together than the holes of the board. Just gently bend the legs apart so that the pins line up with the holes and insert the buzzer. The legs should be three holes apart.

The SoftPot has three legs like the potentiometer you used in Project 6. But unlike a regular potentiometer, the SoftPot requires a

pull-down resistor to ensure that, when there is no input or pressure on the sensor, the SoftPot defaults to a nominal state of 0. This will prevent the buzzer from making noise when you aren't pressing on the sensor.

**FIGURE 10-8:**

Schematic diagram of the Tiny Electric Piano circuit

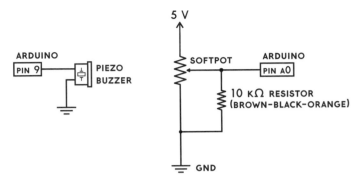

**FIGURE 10-9:**

Prototype of the Tiny Electric Piano circuit on the breadboard

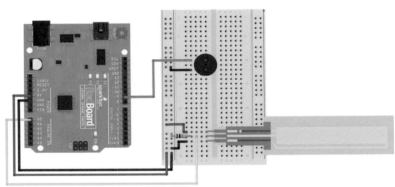

Assemble the circuit as shown in the diagram. The circuit is fairly simple. First, connect 5 V and GND to the power and ground rails on the left side of the breadboard. Next, add the buzzer roughly 10 rows down from the top of the breadboard. Connect one leg of the buzzer to pin 9 of the Arduino and the other leg of the buzzer to the ground rail. Then, insert the SoftPot near the bottom of the breadboard. Connect the top pin of the SoftPot to the 5 V power rail, the lower pin to the ground rail, and the middle pin to the analog input pin A0 on the Arduino. Remember that the SoftPot requires a pull-down resistor between the wiper pin (middle pin) and the ground rail. Finally, add a 10 kΩ resistor between the middle pin and the ground rail.

Once you have it built, it's time to try a couple of code examples.

# PROGRAM THE TINY ELECTRIC PIANO

First, you'll test the build by having the buzzer make noises and recognizable tones, and then you'll map those noises and tones to the SoftPot. Once you know how to get your code making sounds, we'll show you how to add functionality so that you can play up to eight distinct notes, like a small piano.

You've already seen that the Arduino can generate really fast pulses and react to split-second button presses. With your circuit wired up, you'll use these capabilities to make some fun sounds and test the frequency response of the buzzer.

## Test the Buzzer

Arduino has a few commands that make playing notes really simple. There are two functions that control making sounds with Arduino: tone(), which tells the buzzer to play a frequency you specify, and noTone(), which tells the buzzer to stop the sound so you can control the length of the note. Here's how you use these two functions.

```
//creates a tone of frequency on pin for a duration in ms
tone(pin, frequency, duration);

//stops the playing of a tone on the given pin
noTone(pin);
```

The tone() function needs to be called with three parameters: the pin number the buzzer is connected to, a frequency you want to play, and the duration to play the note. When called, tone() creates a square wave at the frequency you provided on the defined pin for a specific duration. This square wave triggers the vibration of the disc inside the buzzer connected to this pin, creating a sound at that frequency. Once started, tone() continues for the duration specified or until you call either another tone() command with a different frequency or the noTone() command to stop the Arduino from playing.

Copy the code from Listing 10-1 into the Arduino IDE or download the sketch from *https://www.nostarch.com/arduinoinventor/*. In this example, you'll use the Serial Monitor to choose a frequency, and the buzzer will play that tone for half a second.

**LISTING 10-1:**

Serial tone test code

```
//Serial Tone Test Example
//Upload this example and then open the Serial Monitor
int freq;
void setup()
{
❶ pinMode(9, OUTPUT);
 Serial.begin(9600);
 Serial.println("Type in a frequency to play.");
}

void loop()
{
❷ if(Serial.available() > 0) //wait for a serial
 //input string
 {
❸ freq = Serial.parseInt(); //parse out integer value
 Serial.print("Playing note: "); //user feedback
 Serial.println(freq);
❹ tone(9, freq, 500); //play the note for 500 ms
❺ delay(500); //delay for the note duration
 }
 else
 {
 noTone(9);
 }
}
```

Let's take a look at how this all works. In the setup(), the sketch sets the pinMode ❶ for the GPIO pin on the buzzer, initializes the serial communication on the Arduino, and prints a short message instructing the player on what to do.

Next, inside the loop(), the if(Serial.available() > 0) statement ❷ checks for data sent over serial communication like so: Serial.available() returns the number of bytes received from the Serial Monitor, and the if() statement compares that value to zero; if the number of bytes is greater than zero, it means data was received, and the script reads the data ❸. The Serial.parseInt() function converts the data into an integer, which is then stored in the variable freq.

The code plays the frequency stored in freq for 500 ms using the tone() function ❹ and then has a short delay() ❺. The delay() ensures that the note plays for the full 500 ms before starting another note. The tone() command is a *nonblocking function*: it executes and then continues to the next instruction without waiting.

After uploading this sketch to your device, open the Serial Monitor (CTRL-SHIFT-M or **Tools ▸ Serial Monitor**). Then, click the line-ending-character drop-down list (Figure 10-10), and select **No line ending**. When you send data between digital devices, an invisible *end-of-line (EOL)* character is sometimes used to indicate the end of a message. The two most commonly used EOL characters are the *new line (NL)* and *carriage return (CR)*. While the character may appear to be invisible, to the Arduino this character still reads in as a value. Selecting this option makes sure that it doesn't send any extra characters.

Now, in the box at the very top, you can type any number and press ENTER, and the buzzer will play that note for half a second (500 ms). The range of human hearing is about 20 Hz to 20,000 Hz, so play around with some different frequencies, but keep them within that range.

**FIGURE 10-10:**
Open the Serial Monitor, and change this option to **No line ending**.

The serial communication on the Arduino has a buffer 64 bytes long. A *buffer* is like a waiting line for the data as it goes into the device, and in this case it allows you to send several notes at a time using the Serial Monitor. For example, you can play the song "Twinkle, Twinkle, Little Star" by typing in the following numbers, separated by commas without spaces. The last comma is important, too. The Serial.parseInt() command looks for numeric characters that are separated by non-numeric characters like commas. The Arduino needs to see that last token (the final comma) to parse out the final note.

```
262,262,392,392,440,440,392,392,349,349,330,330,294,294,262,262,
```

Make sure to omit the spaces here. Each character is equal to 1 byte of data, and if you try to send more than the maximum 64 bytes at a time, the last few pieces of data will get cut off.

Lastly, the buzzer is optimized at 2,047 Hz. You may notice that when you try this frequency the buzzer is very, *very* loud and can be annoying, so be warned: people around you may not appreciate the high-pitched tones that come out of this buzzer at 2,047 Hz!

## Create Specific Notes

If you want to try something more traditional, you can correlate actual musical notes to frequencies. Many instruments use a reference point of middle C, which has a frequency of about 262 Hz. Table 10-1 shows a short table of frequencies for an octave of the C major scale.

**TABLE 10-1:**

Notes and frequencies of the C major scale

| NOTE | APPROXIMATE FREQUENCY |
|:---:|:---:|
| C | 262 |
| D | 294 |
| E | 330 |
| F | 349 |
| G | 392 |
| A | 440 |
| B | 494 |
| C | 524 |

Experiment and see if you can play a song. To start you off, "Twinkle, Twinkle, Little Star" begins with the notes CC, GG, AA, GG, FF, EE, DD, CC. You may notice that the sounds the Arduino makes aren't the most melodic. This is because the Arduino can only turn the pin either HIGH (on) or LOW (off). This creates a square wave, which has a tinny pitch. There are some tricks you can do using capacitors to create a noise filter to soften this sound, but that's a topic for another book!

## Generate Sound with the SoftPot

Making music with frequencies is fun, but typing them over and over gets really tedious. Instead, you can use the SoftPot as a sensor whose values will correspond to frequencies for the buzzer.

The SoftPot is wired up with a simple voltage divider so that a pressure on the length of the strip will be translated into a voltage

from 0 to 5 V. Remember that the Arduino can translate an analog voltage from 0 to 5 V to a value of 0 to 1023 using the `analogRead()` function. Using the simple sketch in Listing 10-2, you can send frequencies to the buzzer by pressing the SoftPot. When the SoftPot is not pressed, the value defaults to 0 because of the pull-down resistor, so no sound is produced.

Start a new Arduino sketch, copy the code example from Listing 10-2, and upload it to your device.

**LISTING 10-2:**

Noisemaker

example code

```
//Noisemaker Example
//upload this example, open the Serial Monitor,
//and then squeeze the SoftPot
❶ int sensorValue;
void setup()
{
 pinMode(9, OUTPUT);
 Serial.begin(9600);
}

void loop()
{
❷ sensorValue = analogRead(A0);
❸ if (sensorValue > 0) //if there's a press on sensor,
 //play note
 {
❹ Serial.print("Raw sensor reading: ");
 Serial.println(sensorValue);
❺ tone(9, sensorValue, ❻50);
 delay(❼50);
 }
❽ else
 {
 noTone(9);
 }
}
```

Let's take a look at what's going on in this sketch. You again start by declaring a variable to store the raw sensor reading ❶. In the loop, the `analogRead()` function reads the voltage on pin A0 ❷ and assigns this value to the variable `sensorValue`. This value will be 0 V when no pressure is applied. You use an `if()` statement ❸ to check if the input value is greater than 0, and if it is, the sketch prints the raw sensor value ❹ and uses the `tone()` command ❺ to play the value stored in `sensorValue`. If the sketch is getting stuck playing a note, try changing the 0 in the `if()` statement to a larger number

like 10 or 20 ❸. This is a technique called *setting a deadband range*. Some sensors don't always go back to a zero value, so this deadband sets a range of values that the program can still consider to be zero. Each sensor may be slightly different.

Notice that in this example we changed the duration the `tone()` is played ❻ and the `delay()` ❼ to 50 ms. This will allow you to create faster changes in notes. Otherwise, you would only be able to play notes that were half a second long! Finally, you want to make sure that the Arduino only plays a tone when the SoftPot is pressed. To do this, you use the `else()` statement to detect when the SoftPot is not being pressed ❽ and the `noTone()` command to turn the buzzer off.

Now, instead of using a frequency sent from the Serial Monitor, the Arduino uses the raw sensor value from the SoftPot. To play around, simply squeeze the SoftPot between your thumb and index finger, applying pressure at different points along the sensor. As you slide your fingers up and down the SoftPot, you can generate tones from 1 Hz to 1,023 Hz. What do you hear? Does it sound like aliens are landing? Pretty cool—now you have your very own special effects generator! Can you play anything that resembles a song? If not, take a look at the next example.

## Play a Song

Now that you have a feel for how the Arduino can make sounds, it's time to map the sensor readings of the SoftPot to real notes so you can make actual music. You'll break the sensor up into eight distinct sections (or keys) and map these to an index that you can use to play notes.

Copy the sketch in Listing 10-3 into the Arduino IDE, and upload it to your device.

**LISTING 10-3:**

Tiny Electric Piano

sketch

```
//Tiny Electric Piano Example Code
❶ int frequencies[] = {262, 294, 330, 349, 392, 440, 494, 524};
 int sensorValue;
❷ byte note;

void setup()
{
 pinMode(9, OUTPUT);
 Serial.begin(9600);
}
```

```
void loop()
{
 sensorValue = analogRead(A0);
 if (sensorValue > 0) //if it's a note, play it!
 {
 //map the key pressed to a note
 ❸ note = map(sensorValue, 0, 1023, 0, 8);
 ❹ note = constrain(note, 0, 7);
 Serial.print(sensorValue);
 Serial.print("\t");
 Serial.println(❺frequencies[note]);
 tone(9, ❻frequencies[note], 50);
 delay(50);
 }
 else
 {
 noTone(9);
 }
}
```

Let's look at the code. First, you declare a data structure referred to as an array. An *array* is a kind of variable that represents a list of values rather than just a single value. Arrays can be of any standard data type, including bytes, ints, longs, and floats, and you declare the data type before the array name.

Declaring an array is similar to declaring a variable except that the array name is followed by two square brackets, [ ]. When you initialize an array, you define the list inside two curly brackets, { }, and use commas to separate each value:

```
dataType arrayName[] = {val0, val1, val2, val3, val4... };
```

Listing 10-3 declares an integer (int) array named frequencies[] that stores a list of eight values for the frequencies of the musical notes ❶. You can access the values in the array using the index number of the value, placed between square brackets. The first value is referenced as frequencies[0], the second is referenced as frequencies[1], and so on. Notice, as usual, that the index starts at 0 rather than 1, as shown in Figure 10-11.

| frequencies[] Array | | | | | | | | |
|---|---|---|---|---|---|---|---|---|
| Index | 0 | 1 | 2 | 3 | 4 | 5 | 6 | 7 |
| Value | 262 | 294 | 330 | 349 | 392 | 440 | 494 | 524 |

**FIGURE 10-11:**

The frequencies[] array elements

The sketch then declares an index variable named note ❷. The array has only eight values, so you can declare this variable as a byte since it uses less memory space than an integer. Next, the sketch uses the map() function ❸ to translate the raw sensorValue reading in the range 0–1,023 to a 0–8 scale.

The map() function is a great tool for converting from one range of values to another. You pass it the input value, the range of the input, and the desired range, and it will scale your input value to the desired range, like so:

```
map(inValue, inMin, inMax, outMin, outMax);
```

The sketch assigns this scaled value to the variable note. This will be the index to reference the array. But while the map() function scales the 0–1,023 range to a range of 0–8, the frequencies[] array actually has only eight values and is indexed from 0 to 7.

We do this because map() rounds down when it scales from one range to another range, so to get eight equally spaced values, we actually need to give it nine values. Value 8 is produced only when the input is equal to 1,023. Because value 8 (the ninth value) is not a valid index for the array, we correct this using another command, constrain() ❹. This function constrains the value to a range of 0 to 7. Any value that is below 0 is constrained to a minimum value of 0, and any value greater than 7 is constrained to a maximum value of 7. The constrain() function is often used in conjunction with map() to scale and limit a value.

The constrain() function is used like so:

```
constrain(value, minValue, maxValue);
```

Finally, the sketch prints the frequency of the current note being triggered to the Serial Monitor ❺ and uses the tone() function ❻ to play the note.

To test it out, press or squeeze the SoftPot. As you move your finger up and down the length of the sensor, you'll hear the different notes. See what songs you can play.

Now, let's turn this prototype into a finished piano!

# BUILD THE PIANO

To convert the prototype into a more functional piano, you just need to apply it to a flat surface and mark out the eight keys.

Unfortunately, the pins on this sensor are not long enough or thick enough to simply insert into the male-to-female jumper wires, so if you want to remove it from the breadboard, we suggest that you solder three male-to-male jumper wires from the Inventor's Kit to the ends of the SoftPot, as shown in Figure 10-12. Alternatively, you *can* use male-to-female jumpers, but you'll need to crimp the ends using a set of needle-nose pliers. If you do this, insert the sensor pins into a set of male-to-female jumper wires and crush the plastic casing around the sensor pins. Make sure that the wires are in contact with the pins of the sensor.

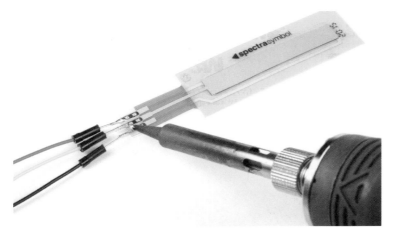

**FIGURE 10-12:**
Soldering wires to the SoftPot

The SoftPot has adhesive backing designed to be placed flat on a hard surface, so with the wires attached, apply the sensor to any portable hard surface (Figure 10-13), like a small piece of cardboard or even the breadboard holder itself.

**FIGURE 10-13:**
Options for mounting the SoftPot

The SoftPot sensor is 50 mm long (approximately 2 inches). You need to divide the length of the sensor into eight keys, which means each key should be roughly a quarter inch wide. Using a piece of masking tape or a sheet of paper, mark off eight quarter-inch keys, as shown in Figure 10-14.

**FIGURE 10-14:**

Marking off the keys

Next, position the masking tape or paper on top of the SoftPot to give you a guide for playing the notes. The completed keyboard should look like Figure 10-15. If you like, you can label the keys with the notes matching the frequencies in your code to help you play from sheet music.

**FIGURE 10-15:**

The finished Tiny Electric Piano keyboard

## GOING FURTHER

In this project, we introduced you to the piezo buzzer and SoftPot. Now that you know how to make some fun sounds, here are a few ideas for taking this project further.

## Hack

Play around with the code and see what other fun tones you can create. If you want to play a song in a different key or using a different scale, for example, you could change the frequencies in the array. Table 10-2 shows frequencies you can use to change the key of your piano. C major and G major are the two most common scales used in music. Find some sheet music online or just mess around. Can you play "Twinkle, Twinkle, Little Star" on your new SoftPot piano?

| NOTE | APPROX. FREQ. | NOTE | APPROX. FREQ. | NOTE | APPROX. FREQ. |
|------|------|------|------|------|------|
| $C_3$ | 131 | $C_4$ | 262 | $C_5$ | 524 |
| $C^\#_3/D^\flat_3$ | 139 | $C^\#_4/D^\flat_4$ | 277 | $C^\#_5/D^\flat_5$ | 554 |
| $D_3$ | 147 | $D_4$ | 294 | $D_5$ | 587 |
| $D^\#_3/E^\flat_3$ | 156 | $D^\#_4/E^\flat_4$ | 311 | $D^\#_5/E^\flat_5$ | 622 |
| $E_3$ | 165 | $E_4$ | 330 | $E_5$ | 659 |
| $F_3$ | 175 | $F_4$ | 349 | $F_5$ | 698 |
| $F^\#_3/G^\flat_3$ | 185 | $F^\#_4/G^\flat_4$ | 370 | $F^\#_5/G^\flat_5$ | 740 |
| $G_3$ | 196 | $G_4$ | 392 | $G_5$ | 784 |
| $G^\#_3/A^\flat_3$ | 208 | $G^\#_4/A^\flat_4$ | 415 | $G^\#_5/A^\flat_5$ | 831 |
| $A_3$ | 220 | $A_4$ | 440 | $A_5$ | 880 |
| $A^\#_3/B^\flat_3$ | 233 | $A^\#_4/B^\flat_4$ | 466 | $A^\#_5/B^\flat_5$ | 932 |
| $B_3$ | 247 | $B_4$ | 494 | $B_5$ | 988 |

**TABLE 10-2:** Selected approximate frequencies for notes across three octaves

## Modify

To make things more interesting, add a *distortion pedal* to this piano project. This button will switch up octaves to give you 16 notes for the price of 8. Connect a button to pin 2 on your Arduino as shown in Figure 10-16.

The sketch needs just few extra lines of code for the pedal, which will cycle a multiplier variable each time the button is pressed. This is known as a *state machine*, because each time the button is pressed, the state of a variable is changed. The code for this modification is in the book's resources at *https://www.nostarch.com/arduinoinventor/* in the file *P10_TinyPiano_v2.ino*.

**FIGURE 10-16:**

Adding a button to pin 2
for octave control

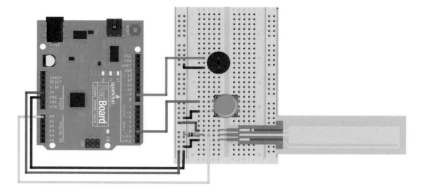

The new code lines declare a state variable, `octaveMultiplier`, and then add a `pinMode()` command to set up pin 2 as an `INPUT`. When the button is pressed, the state variable, `octaveMultiplier`, is incremented, altering the frequency so that the note goes up.

Try it out. When you press the button, the notes should all go up by an octave. You now can play up to 16 notes with this simple Arduino instrument!

### Bonus Project: Binary Trumpet

The SoftPot is a nice touch, but as a bonus we've built an Arduino instrument that uses actual buttons as keys instead of the SoftPot. This last project is called the Binary Trumpet. It uses three buttons to specify which note to play and the fourth button to play the note, like blowing on a trumpet. With three buttons, you can specify up to eight different combinations using the keypresses shown in Table 10-3.

**TABLE 10-3:**

Binary trumpet button
sequences

| BUTTON 1 | BUTTON 2 | BUTTON 3 | NOTE TO PLAY |
|----------|----------|----------|--------------|
| Up | Up | Up | C (262 Hz) |
| Up | Up | Down | D (294 Hz) |
| Up | Down | Up | E (330 Hz) |
| Up | Down | Down | F (349 Hz) |
| Down | Up | Up | G (392 Hz) |
| Down | Up | Down | A (440 Hz) |
| Down | Down | Up | B (494 Hz) |
| Down | Down | Down | C (524 Hz) |

You may recognize this pattern as a binary sequence. It counts in the order 000, 001, 010, 011, 100, 101, 110, and 111.

To make room for the four buttons on the breadboard, move the buzzer up a little and then add those buttons, as shown in Figure 10-17.

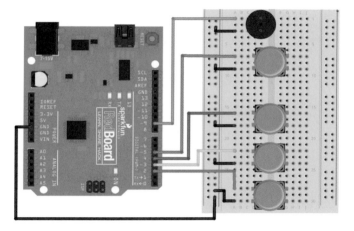

**FIGURE 10-17:**
Binary Trumpet wiring diagram

The complete code for this modification is in the book's resources at *https://www.nostarch.com/arduinoinventor/* in the file *P10_TinyBinaryTrumpet.ino*. Playing notes using the Binary Trumpet will take a bit of getting used to, but the sequence of presses in Table 10-3 should help you as you pick it up.

As it turns out, with four buttons, you can actually play up to 16 different notes. Can you figure out how to modify the example to do this? Take a look at the book's resources to see how.

Whether you use the Tiny Electric Piano or the Binary Trumpet, we hope this helps you on your way to a future career in making music. Now go forth and find an audience to show off your newest skills!

# APPENDIX

## MORE ELECTRONICS KNOW-HOW

THIS APPENDIX PROVIDES A HOW-TO ON USING A MULTI-METER AND SOLDERING, AS WELL AS A HANDY REFERENCE FOR READING THE COLOR BANDS ON RESISTORS.

# MEASURING ELECTRICITY WITH A MULTIMETER

A *multimeter* is an indispensable tool used to diagnose and trouble-shoot circuits. As its name states, it is a meter capable of measuring multiple things related to electricity—namely, current, continuity, resistance, and voltage. Let's take a look at how to use a multimeter. We will be using the SparkFun VC830L (TOL-12966; shown in Figure A-1) throughout the tutorial, but these methods should apply to most multimeters.

## Parts of a Multimeter

A multimeter has three main parts, labeled in Figure A-1.

**FIGURE A-1:**

A typical multimeter

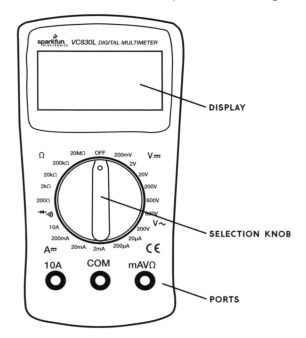

The display can usually show four digits and a negative sign. The selection knob allows the user to set the multimeter to read different things such as milliamps (mA) of current, voltage (V), and resistance (Ω). The numbers along the outside of the selection knob indicate the maximum value or range for any given setting.

On some multimeters, the display doesn't show the units. In these cases, it is assumed that the values displayed have the same units as the setting, so if you have the range set to 200 Ω, the number displayed will be in Ω. If you have the range set to 2 kΩ, 20 kΩ, or 200 kΩ, then the value displayed will be in units of kΩ.

Most multimeters come with two probes, which are plugged into two of the three ports on the front of the unit. The three ports are labeled COM, mAVΩ, and 10A. COM stands for *common* and should almost always be connected to ground, negative, or the – of a circuit. The mAVΩ port allows the measurement of current (up to 200 mA), voltage (V), and resistance (Ω). The 10A port is the special connection used for measuring currents greater than 200 mA.

Most probes have a banana-type connector on the end that plugs into the multimeter, allowing for different types of probes to be used. For most measurements, connect the red probe into the mAVΩ port and the black probe into the COM port.

## Measuring Continuity

Measuring continuity is possibly the single most important function for troubleshooting and debugging circuits. This feature allows us to test for conductivity and to trace where electrical connections have been made or not made. Set the multimeter to the continuity setting, marked with a diode symbol with propagation waves around it (like sound coming from a speaker), though this may vary among multimeters.

Touch the two probe ends together and you should hear a ringing tone—this is why checking for continuity is sometimes called "ringing out" a circuit. You can use this method to test which holes on a solderless breadboard are connected and which ones aren't. The probe tips are usually too big to insert directly into a breadboard, but you can stick two wires in the same row on a breadboard and touch the ends of the probes to each wire. You should hear the tone indicating that these two wires are connected through the row. You can also use this method to trace out a circuit. Because you often can't see where all of the wires go, this is a quick way to test whether two points are connected electrically. When you're checking for continuity, it doesn't matter which side of the probe you connect, because you're just checking that one side is connected electrically to the other.

## Measuring Resistance

The continuity setting simply rings a tone when the resistance is low, but to get an actual value for the resistance, you need to use a resistance setting. Turn the knob to one of the resistance settings marked by the omega symbol (Ω), which represents *ohms,* the unit for measuring resistance. Make sure that the resistor or the element

you're measuring is not powered or connected to your circuit.

A resistor, like many electrical elements, has two ends. To measure its resistance, simply touch the ends of the probes to the ends of the resistor. As with continuity, it doesn't matter which side you connect to red and which side you connect to black.

There are several possible resistance range settings available. These settings represent the maximum value you can measure. If you want to measure a small resistor to a high degree of accuracy, you would set the multimeter low—to 200 Ω, for example.

If you try to measure a resistance greater than the range, the multimeter will simply display [1.    ], with no zeros displayed. If the resistance is greater than your chosen range, try moving the range up a notch and measuring it again.

Give it a try! If you measure the resistance of the 330 Ω resistor (orange-orange-brown), what values do you record for each setting? All resistors have a tolerance band; most are typically 5 percent. What is the percentage error for your measurement? Is it within the tolerance?

Test the resistance of the photoresistor. Hold your hand or something else opaque above the photoresistor, and measure the resistance for various heights.

## Measuring Voltage

**V⎓ V~**

Voltage is a measurement of electrical potential between two points, sometimes also called the *potential difference*. Similar to the resistance settings, the various settings for measuring voltage specify the maximum value.

You'll notice that there are two range symbols, one with two straight lines and one with a squiggly line. The two straight lines indicate *direct current (DC)* measurements, which are most commonly used in electronics. The squiggly line represents *alternating current (AC)*, the type of electricity found in the walls of your house. Be sure that you have the knob turned to the right setting—you probably want DC. The 20 V setting is the best choice for the projects in this book, since all voltages are limited to 5 V on the Arduino.

Now, try to measure the voltage on an Arduino board. Plug your Arduino board into your computer using the USB cable for power. To measure voltage, connect the black probe to GND (ground). Now, use the red probe to test the voltage at various points or pins (with respect to GND). What does the 5 V pin show? How about the 3.3 V pin?

## Measuring Current

*Current* is the rate of movement of charges in a circuit and is measured in *amperes* (*amps*). In order to capture the rate of moving charges and thus measure current, you need to break the circuit and connect the meter in-line at the place where you want to measure current. Adjust the knob to the appropriate current range that you expect to measure. If you're measuring anything that might be above 200 mA, switch the selection knob to 10A and move the red probe into the port marked 10A on the body of the multimeter. If you're not sure, this is the safest range to start with, to avoid damage to your meter.

To measure the current going through a simple LED and resistor circuit, for example, you could splice into the circuit between the LED and the resistor (see Figure A-2). The current path must go through the meter. Because this is a series circuit, you could measure the current anywhere along this path: before the LED, after the LED, or after the resistor.

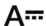

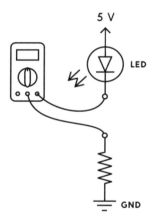

**FIGURE A-2:**

Splicing a multimeter into a circuit to measure current

When measuring current, be very careful not to exceed the limits of your multimeter—you should be able to find the range of current your multimeter can handle from its user manual. If you go beyond the current limits, you run the risk of also blowing a fuse on the multimeter. (Don't worry if you blow the fuse—a replacement is pretty inexpensive. In order to swap in the new fuse, you'll probably need to open the back of the multimeter with a screwdriver.) The standard mAVΩ port can usually handle up to 200 mA.

## HOW TO SOLDER

Soldering is one of the most basic skills used in prototyping electronics projects. It involves melting a special metal, *solder*, between two components to hold them together more permanently (see Figure A-3).

FIGURE A-3:

Soldering

Solder, shown in Figure A-4, is a metal alloy with a relatively low melting temperature. Modern solder melts at a temperature of around 180 degrees Celsius or 356 degrees Fahrenheit, about the temperature you need to bake cookies. Most solder used for electronics has a core of *flux*, a cleaning fluid. As the solder melts, the flux helps to clean the surfaces being soldered and helps the solder flow.

FIGURE A-4:

A roll of solder

To perform soldering, you use a *soldering iron*. Most soldering irons are about the size of a medium carrot and have two main parts: the handle and the hot end (see Figure A-5).

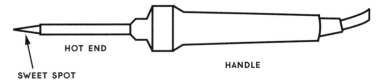

HOT END

SWEET SPOT

HANDLE

**FIGURE A-5:**

A typical soldering iron

There are many styles and types of soldering irons. Lower-cost irons can be about $10 and usually have a fixed temperature setting, but we suggest getting an iron with some type of temperature adjustment knob. The optimal temperature for an iron is about 650 degrees Fahrenheit. If it's too hot, the tip will oxidize and get dirty quickly. If it's not hot enough, it won't melt the solder. An adjustable iron will help you control this, so it's worth spending a little extra.

Be very careful when using a soldering iron: when you turn it on, the hot end will very quickly get hot enough to melt metal. That's really hot! Always hold a soldering iron from the handle—you should never hold it from the hot end even when it's off.

You should also protect the table surface you're working on with a piece of cardboard, a cutting mat, or scrap piece of wood. And, before you start soldering, you should always wear eye protection. Little bits of solder and flux do sometimes sputter off. It's best to keep your precious eyes safe!

## Heating the Iron

To use a soldering iron, first plug in your iron and let it heat up. Depending on the type of iron you have, this may take anywhere between 30 seconds and a couple of minutes. While the iron is heating up, make sure it's resting on a stand so that the hot end is not touching your table or work surface.

When the iron is hot, the solder should melt easily, so test this by touching a piece of solder with the side of the iron's tip. This is the hottest part of the iron, known as the *sweet spot* (shown in Figure A-6), and it is the part you should use to apply heat to components. If the solder melts immediately, your iron is hot enough to solder.

**FIGURE A-6:**

The side of the tip is
much hotter than the
very end of the tip.

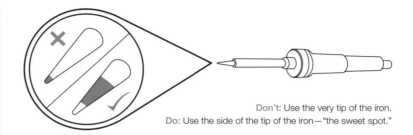

Don't: Use the very tip of the iron.
Do: Use the side of the tip of the iron—"the sweet spot."

## Perfecting Your Soldering Technique

Contrary to what you might assume, when soldering you don't actu-
ally touch the iron directly to the solder to melt it. The trick is to hold
the iron to the components you're intending to solder for around
2 to 3 seconds. Then you apply solder directly to the heated joint,
and the solder will melt. Solder will always flow toward the heat and
settle in the hottest part of the component. If you feed the solder
directly onto the iron, it may glob up on the iron and not go onto the
parts you want to solder. If this happens, simply clean the iron and try
again. Hold the iron the same way you would hold a pencil, with your
dominant hand, holding it from the handle. With your other hand, hold
a length of solder. Be careful not to hold the solder too close to the
end you're melting, as the heat may travel up the length of solder to
your fingertips.

Touch the sweet spot of the iron to the parts that you intend to
solder. Be sure that the sweet spot of the iron is touching both parts
that need to be soldered so that they heat up equally, as shown in
Figure A-3. Count for three full seconds: one one-thousand, two one-
thousand, three one-thousand.

Next, while holding the iron to the components, feed the end
of the solder into the joint. Remember, the solder will flow toward
the heat.

After you have fed enough solder so that the joint is filled,
remove the solder, but hold the iron in place for one more second.
This will allow the solder to flow and settle. Remove the iron from the
joint, and place it back onto its stand.

A good solder joint should be smooth and somewhat shiny. If
you're soldering onto a PCB, the joint often resembles a small vol-
cano or chocolate candy kiss. Soldering takes practice, so if your
solder joint doesn't look clean and smooth, try reheating the joint
to get the solder to flow and settle again, or add a bit more solder.

Figure A-7 illustrates some common mistakes and possible solutions for soldering.

 **A**  Solder flows smoothly all the way to the bottom.

 **B**  Error: Solder balls up on top of pad, not connecting pin to pad.
Solution: Reapply heat to the solder, the pin, and the pad.
You may need to add a small amount of solder.

 **C**  Error: Too little solder makes for a weak connection.
Solution: Reheat and add more solder until you have
a nice solder volcano.

 **D**  Error: Bad connection . . . and ugly . . . oh so ugly.
Solution: Reheat and add more solder. Move the soldering iron
around to ensure that all parts are hot and the solder flows all the
way around.

 **E**  Error: Too much solder; this is called a *jumper* because
it connects two pins.
Solution: Wick off excess solder.

**FIGURE A-7:**

Common soldering

mistakes and solutions

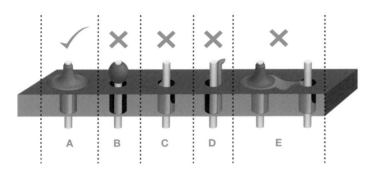

## Cleaning the Iron

Keeping the tip of the iron clean is one of the secrets to getting a good solder joint. We recommend cleaning it before each use by heating it up and using a brass scrubber or wet sponge to wipe off any excess solder and oxidation that may have built up.

If the tip is dirty and you can't wipe off the excess buildup, you can use Tip Tinner and Cleaner (TOL-13246); this is a mixture of a mild acid and solder. To clean with this, heat the iron, place the tip of the hot iron into the tip tinner, and let the tip tinner eat away at the oxidation and buildup for about 10 to 15 seconds at a time. Then, wipe the tip off on the sponge. Repeat this process if necessary. The tip of the iron should be shiny.

## Soldering Tips

Figure A-8 shows a few additional hints and suggestions for using the soldering iron.

**Do:** Touch the iron to the component leg and the metal ring at the same time.

**Do:** While continuing to hold the iron in contact with the leg and the metal ring, feed solder into the joint.

**Don't:** Glob the solder straight onto the iron and try to apply the solder with the iron.

**Do:** Use a sponge to clean your iron whenever black oxidization builds up on the tip.

Using a soldering iron is a skill that should be in any maker's arsenal. When you're ready to make your prototype projects more permanent and durable, soldering will ensure that the wires and connections between components don't get disconnected.

## ADDITIONAL SOLDERING TOOLS

Here are a few additional tools we'd recommend you use to help you make the perfect solder joint each time. These tools help hold your parts, clean up your solder joints, and remove extra solder.

### Third Hand

A *third hand* is basically a clamp to hold down the pieces you're soldering and will be one of your best helpers for soldering. There are many versions of third hands, but most are simply a couple alligator clips on a heavy stand that will hold your parts while you're using your hands to hold the solder and the iron. Many of the basic ones even come with a magnifying glass and a small soldering iron stand, too, as shown in Figure A-9.

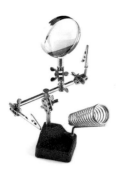

## Flux Pen

One of the tricks to getting a good solder joint is to make sure every-
thing is clean, which you can do with flux, a slightly acidic cleaning
fluid often made from tree rosin. A flux pen (see Figure A-10) works
a lot like a paint marker; you simply press the tip of the marker down
on the solder joint you're working on until a small puddle of liquid
comes out onto your board. Apply the soldering iron directly to the
joint and insert the solder and, using flux, the solder will melt a lot
faster and bond better to your components.

Flux does wonders for soldering, but it is somewhat corrosive, so
make sure you minimize contact with your skin and wash your hands
immediately after use.

## Solder Wick

You'll sometimes find when soldering that you've added too much
solder or gotten solder in places that you didn't intend. There are
two tools to keep around on your bench that help remove unwanted
solder. The first is *solder wick*, a finely braided copper mesh that
resembles a ribbon, as shown in Figure A-11.

To use solder wick, place the wick over the solder joint you wish
to remove, apply the heated soldering iron to the top of the wick to
heat the wick and the solder joint below, and as the solder melts, it
will wick away from your components into the copper mesh. Voilà!

Be sure to hold the iron on the wick as you remove both the wick and the iron from your board. If you pull the iron away too soon, the wick will be soldered onto your board. If this happens, simply reheat the joint to remove the wick.

### Solder Vacuum

The second tool that can remove unwanted solder is called a *solder vacuum* or *solder sucker*. This nifty tool creates a vacuum using a plunger (similar to a syringe) and releases with the press of a button.

To use a solder sucker, first push down on the plunger to preload the tool. Next, heat up the solder joint you wish to remove until it is completely melted and liquid. Place the tip of the solder vacuum against the solder (while still holding the iron to keep it melted), and finally push the release button to suck away the unwanted solder.

If it doesn't work, try again. It sometimes helps to add a bit more solder to the area you wish to remove solder from.

## RESISTORS AND BANDS

Resistors come in a wide range of values, but how can you tell what the value is by looking at the tiny component? There are no numbers or text!

Resistors use a color band system to show their values. Figure A-12 shows how the banding system works.

Most resistors have four or five colored bands. The last band on the resistor specifies the *tolerance*, or the degree of variance, allowed by the manufacturer. Most of the time, your resistors will have a gold tolerance band, for 5 percent. This means the manufacturer allows 5 percent error on the value of that resistor. For example, the resistance of a 10 kΩ resistor with a 5 percent tolerance can fluctuate up to 500 Ω and still be considered a 10 kΩ resistor.

When you're reading from left to right with the tolerance band (usually gold or silver) toward the right, the remaining bands specify

the resistance value. On a four-band resistor, the first two bands specify the base number, and the third band is the multiplier. On a five-band resistor, the first three bands specify the base number, and the fourth band is the multiplier.

For example, the first three bands on a 10 kΩ resistor are brown, black, and orange. Following the chart in Figure A-12, brown equals 1, and black equals 0, so brown-black means the base number is 10. The third band is orange, which specifies a multiplier of $10^3$, for a total of 10,000. Finally, the fourth band specifies the tolerance, which in this example is 5 percent (gold).

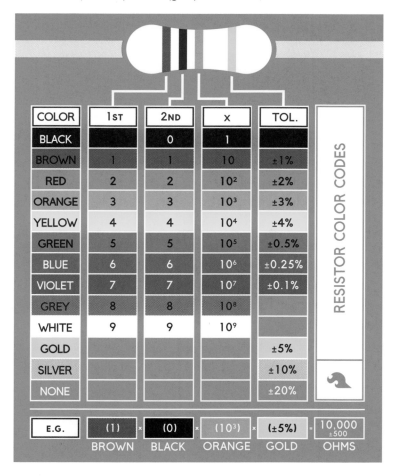

**FIGURE A-12:**

Resistor color cheat sheet

| COLOR | 1ST | 2ND | X | TOL. |
|---|---|---|---|---|
| BLACK | | 0 | 1 | |
| BROWN | 1 | 1 | 10 | ±1% |
| RED | 2 | 2 | $10^2$ | ±2% |
| ORANGE | 3 | 3 | $10^3$ | ±3% |
| YELLOW | 4 | 4 | $10^4$ | ±4% |
| GREEN | 5 | 5 | $10^5$ | ±0.5% |
| BLUE | 6 | 6 | $10^6$ | ±0.25% |
| VIOLET | 7 | 7 | $10^7$ | ±0.1% |
| GREY | 8 | 8 | $10^8$ | |
| WHITE | 9 | 9 | $10^9$ | |
| GOLD | | | | ±5% |
| SILVER | | | | ±10% |
| NONE | | | | ±20% |

RESISTOR COLOR CODES

| E.G. | (1) | (0) | ($10^3$) | (±5%) | 10,000 ±500 |
|---|---|---|---|---|---|
| | BROWN | BLACK | ORANGE | GOLD | OHMS |

In case you need to look up resistor color bands later, you may want to dog-ear this page for reference. It's okay—we won't tell the librarian.

# AFTERWORD

We hope you've enjoyed building the projects in this book. It was a lot of fun for us to come up with different project ideas that incorporated cardboard, paper, ping-pong balls, and other common materials, as well as the basic electronics. But the projects in this book are just a start. We hope they inspire you and help unleash your inner inventor! We encourage you to combine and mash up components and concepts from each of these chapters to create your own *Franken-duino* project! If you have comments or ideas that you'd like to share with us, please send us a note at *ArduinoInventorsGuide@sparkfun.com*.

    Best of luck, and happy building!

## ADDITIONAL RESOURCES

The community behind Arduino is vast. The Arduino IDE is downloaded nearly 600,000 times per month. While Google can find just about anything on the internet, here are a few other resources that we use regularly and recommend.

**Arduino Learning Community**  *https://www.arduino.cc/en/Guide/ HomePage*

**Arduino Language Reference**  *https://www.arduino.cc/en/ Reference/HomePage*

**SparkFun Education Tutorials**  *https://learn.sparkfun.com/*

**Adafruit Learn Arduino Community**  *https://learn.adafruit .com/category/learn-arduino*

## ACKNOWLEDGMENTS

We are grateful for the tremendous support we've received from the Arduino community, everyone at SparkFun, and our amazing editors at No Starch Press. The ideas and projects that we've assembled in this book are attributed to all of these people and the many whiteboard brainstorming sessions, emails, and side conversations that we've had over the past few years. We also want to thank our families—Zondra, Bear, Bridge, Mariela, Mia, and Maeva—for the support that they have provided during the testing, prototyping, and writing process. Thank you!

# ABOUT THE SPARKFUN SERIES

The SparkFun series is a collaboration between No Starch Press and SparkFun Electronics, an online retailer that sells bits and pieces to make your own electronics projects possible. Each title in the series is written by an experienced maker on the SparkFun staff and edited by the folks at No Starch Press. The result? The book you're reading now.

# THE SPARKFUN GUIDE TO PROCESSING

*The SparkFun Guide to Processing* shows you how to craft digital artwork that interacts with the world around you. With the Processing programming language and a little imagination, you'll scale detailed pixel art to epic proportions, record and sample audio to create your own soundboard, and create visualizations that reflect changes in sound, light, temperature, and time.

# RESOURCES

Visit *https://www.nostarch.com/arduinoinventor/* for project templates and sketches, updates, errata, and other information.

More no-nonsense books from  **NO STARCH PRESS**

## THE SPARKFUN GUIDE TO PROCESSING
Create Interactive Art with Code
*by* DEREK RUNBERG
AUGUST 2015, 312 PP., $29.95
ISBN 978-1-59327-612-6
*full color*

## ELECTRONICS FOR KIDS
Play with Simple Circuits and Experiment with Electricity!
*by* ØYVIND NYDAL DAHL
JULY 2016, 328 PP., $24.95
ISBN 978-1-59327-725-3
*full color*

## ARDUINO PLAYGROUND
Geeky Projects for the Experienced Maker
*by* WARREN ANDREWS
MARCH 2017, 344 PP., $29.95
ISBN 978-1-59327-744-4

## ARDUINO PROJECT HANDBOOK
25 Practical Projects to Get You Started
*by* MARK GEDDES
JUNE 2016, 272 PP., $24.95
ISBN 978-1-59327-690-4
*full color*

## THE MAKER'S GUIDE TO THE ZOMBIE APOCALYPSE
Defend Your Base with Simple Circuits, Arduino, and Raspberry Pi
*by* SIMON MONK
OCTOBER 2015, 296 PP., $24.95
ISBN 978-1-59327-667-6

## ARDUINO WORKSHOP
A Hands-On Introduction with 65 Projects
*by* JOHN BOXALL
MAY 2013, 392 PP., $29.95
ISBN 978-1-59327-448-1

1.800.420.7240   or   1.415.863.9900   |   sales@nostarch.com   |   www.nostarch.com